Bill Fortney's

Great Photography Workshop

Getting Serious About Outdoor Photography

For Barbara,
My Very Best!
Bill Fortney GAL 2:30

Front cover: large photo, Arches National Park, Utah; left inset photo, Central Florida; center inset photo, Acadia National Park, Maine; right inset photo, Oxbow Bend, Grand Teton National Park, Wyoming.
Back cover: Arches National Park, Utah.
Page1, Acadia National Park, Maine; page 2, Peggy's Cove Lighthouse, Nova Scotia; page 6, Herbert Lake, Banff National Park, Alberta; page 7, Zion Canyon, Zion National Park, Utah; page 8, Olympic National Park, Washington; page 10, Pennsylvania Dutch Country.

Edited by Barbara K. Harold
Designed by Russell S. Kuepper

NorthWord Press
18705 Lake Drive East
Chanhassen, MN 55317
1-800-328-3895
www.northwordpress.com

Library of Congress Cataloging-in-Publication Data

Fortney, Bill
 Bill Fortney's great photography workshop : getting serious about outdoor photography by Bill Fortney ; foreword by John Shaw.
 p. cm.
 Includes bibliographical references and index.
 ISBN 1-55971-876-5 (softcover)
 1. Outdoor photography--Amateurs' manuals. I. Title: Great photography workshop. II. Title

TR659.5 .F67 2003
778.7'1--dc21 2002043146

Printed in U.S.A.

10 9 8 7 6 5 4 3 2 1

Bill Fortney's

Great Photography Workshop

Getting Serious About Outdoor Photography

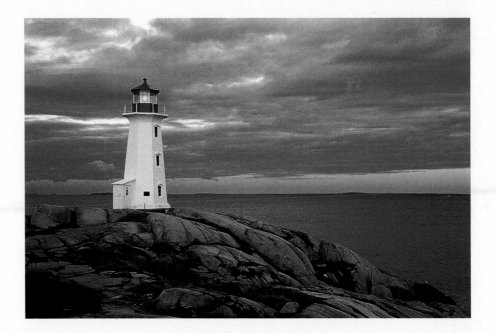

By Bill Fortney

Foreword by John Shaw

NorthWord Press

Chanhassen, Minnesota

In Memory of Galen Rowell
1940-2002

A true friend to photographers everywhere

WHEN I FIRST MET GALEN ROWELL, I was in awe of him, just as everyone else was. Here was this man who had done things I would not even think of doing! I soon learned that the "real" Galen was a jokester and prankster, who loved to have a good laugh and was never upset if the laugh was on him.

I once introduced him by showing how his work, especially the image of a rainbow going into a Tibetan temple, had influenced mine. For a couple of years I had been collecting images of rainbows coming down into things, like a Wendy's restaurant and a chemical factory. I'd give this long spiel about how much Galen had influenced me and then show my rainbow images.

He loved it! He always laughed harder than anyone else.

Galen always commanded a lot of attention, but he never forgot about others. A few years ago, I received a small envelope in the mail from him containing a single slide. The slide was of a sign that simply said "Fortney Rd." On the slide mount, he had written, "Shouldn't it be called Fortney's Way?"

I'll miss Galen's images and his words of wisdom, but most of all, his laughter and friendship. This book is written in loving and joyous memory of him.

TABLE OF CONTENTS

Foreword by John Shaw . 7

Preface . 9

Introduction . 10

Portfolio of Selected Amateurs 12

Chapter 1 Goals for Success 24

Chapter 2 Four Keys to Great Images 28

Chapter 3 The Art & Craft of Photography 34

Chapter 4 How the Camera Works 52

Chapter 5 Using the Creative Controls to be "Creative" . . . 72

Chapter 6 Exposure — Exposed 80

Chapter 7 The Importance of Light 92

Chapter 8 Composing for Dynamic Results 104

Chapter 9 The Right Equipment 116

Chapter 10 Film or Digital? Or Both? 140

Chapter 11 People and Travel 160

Chapter 12 What to Do with All My Great Photographs . . . 172

Chapter 13 Final Thoughts 178

Appendix . 184
 The Lists of Ten
 Photographic Resources
 Recommended Reading

Acknowledgments .189

Index . 190

Dedication

This book is for . . .

My Past
My father, William Pelle Fortney, who inspired me to want to be a photographer with his slide shows on our yellow kitchen door!

My Future
Hannah, Cassidy, Ben, and Cade, my wonderful grandchildren. May yours be the eyes to feel, see, and capture the future.

My Past, Present, and Future
Sherelene, the love of my life, my partner and my best friend, whose many sacrifices have made all this possible.

My Eternity
My Lord and Savior, Jesus Christ.

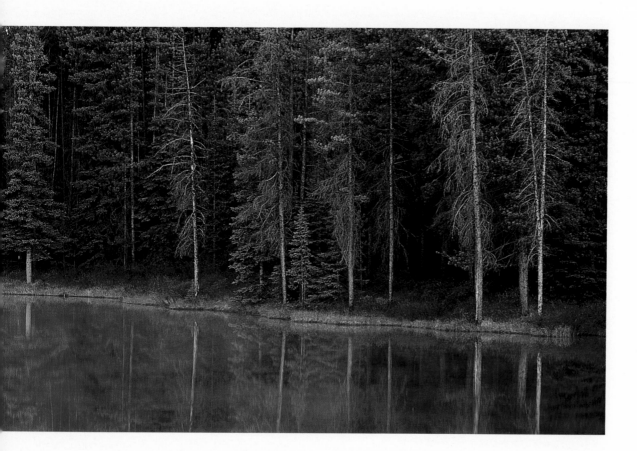

Foreword By John Shaw

I've known Bill Fortney quite a long time now. I can't tell you the exact year we first met—he called me to do a program for his local camera group—but I do recall we both were using Nikon F2 cameras, at the time the top camera Nikon offered. Today, older and grayer, we're both still taking pictures but with far newer cameras and lenses. Those old F2s have been retired for some time now.

What certainly has not retired is Bill's enthusiasm for photography. He's still excited about taking pictures, and also about teaching others how to do so. His enthusiasm is catching, as you will soon discover when you read this book. Go through these chapters, do his photo assignments, see your photo knowledge and confidence increase, and by the last chapter you'll be hooked on photography more than ever.

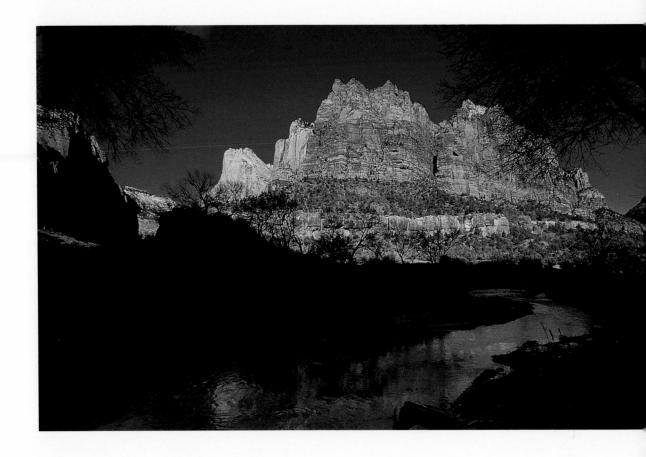

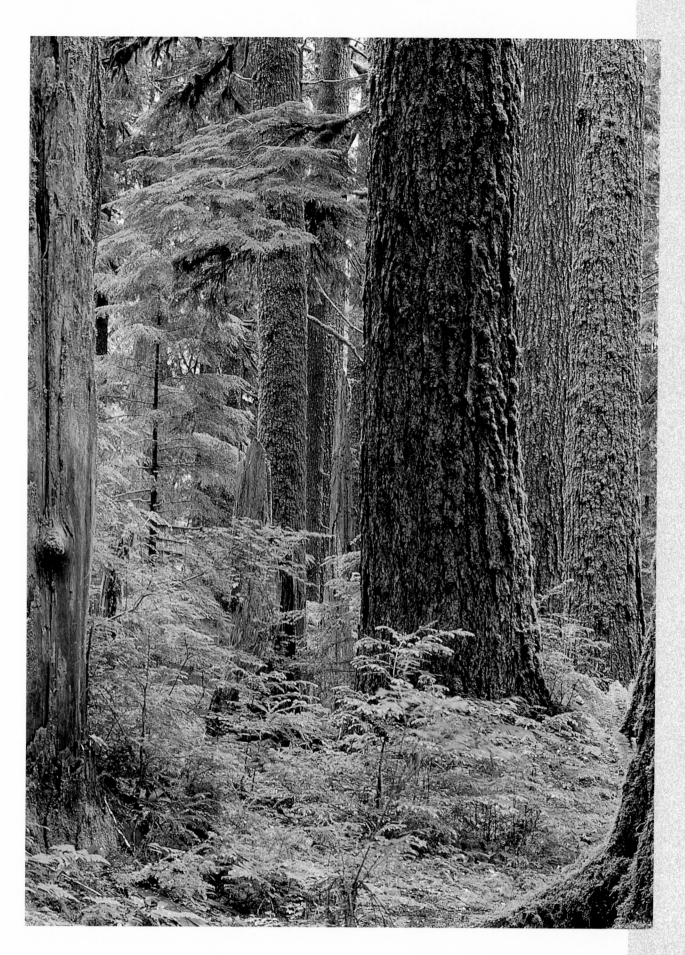

Preface

This is the book I have always wanted to write. Actually, I may be one of the most qualified people in America to write it. Before you think I'm the most conceited photographer you've ever met, it's not because of my vast knowledge and talent that I make that statement. No, it is that for the last twenty years I've had the honor of working with a virtual Who's Who of photography.

These fine photographers include Kevin Adams, Rod Barbee, Wayne Bennett, Tom Blagdon, Scott Bourne, Jim Brandenburg, Gary Braasch, Dr. Bill Campbell, Jim Clark, Bill Cox, Dick Dickenson, Bill Durrence, Jack Dykinga, Mike Ellison, Jeff Foott, Sam Garcia, Steve Gilroy, Ken Jenkins, Adam Jones, Bob Krist, Frans Lanting, George Lepp, Wayne Lynch, Don McGowan, Tom Mangelsen, David Middleton, the late Frank Miller, Carl Moser, Hugh Morton, David Muench, Marc Muench, Don Nelson, the late John Netherton, Boyd Norton, Pat O'Hara, Freeman Patterson, Bill Pekala, Bryan Peterson, Rod Planck, Wendland Rice, Galen Rowell, L.L. Rue, Len Rue Jr., John Shaw, Rob Sheppard, Bill Silliker, Fred Sisson, Neil & Susan Silverman, Dr. Charles Stanley, Gary Stanley, Ed Stawick, Jim Sugar, Dr. Chuck Summers, Tony Sweet, Steven Valk, Larry West, Lloyd Williams, Art Wolfe, and Cliff Zenor. In addition to these well-known photographers I've enjoyed and learned from the work of countless serious amateur photographers.

In the process of working side by side with these wonderful photographers and teachers I've learned more than I ever thought possible. I also have had the great opportunity to learn how each of them has solved the most common, and uncommon, photographic and logistical problems. Then it was easy to pick the best solutions for myself—and for you.

This book is in large measure dedicated to these great photographers, teachers, mentors, and friends from whom I've "stolen" most of this material!

It has always been my philosophy that if you're going to be the best, you should learn from the best. With this book, you will!

— Bill Fortney

Introduction

This book *can* help you to become the photographer you have always wanted to be.

The key word is, *can*, not will. The book can work for you if you use it properly and dedicate yourself to getting the most out of this study. The *will* part is up to you.

If you are a beginner, you will find all of the most basic and fundamental things you need to know to get started. If you're an intermediate photographer, it will serve as a great review and will help you to identify your weaknesses and strengthen your skills. If you are an advanced photographer, it can help you do some of the finish work—sanding and polishing—to make you really shine!

Many fine books have been written that go into very deep detail about every aspect of the technical points of photography. In fact, I recommend one of the best of these as a companion piece for your study, John Shaw's *Nature Photography Field Guide,* published by Amphoto in 2001.

But first, in this book, I will deal with the essential information you need to start making better photographs right away. For delving deeper into the topics covered in this book I will suggest additional resources. I believe the best way to learn is to master the basics and then build on them.

This book is based on some very well established principles of learning: First, lay out the underlying principles that must be understood, then learn how to use them and, finally, put them into practice.

1. **Theory**. These are the major points that our understanding of photography rests on. Without really understanding these areas you can't apply them in the field when it really matters. I will explain these principles in easy-to-understand terms so you can grasp them quickly and firmly.

2. **Application**. Once we understand the basics of the science involved and how they work, we need to explore how to use them to make good photographs. This is really one of the most important parts of becoming the photographer you want to be: knowing what to do with the knowledge you've acquired.

3. **Practice.** This is a critical step. To get a solid understanding of any principle, you have to apply that principle. The suggested "self-assignment" practice sessions will help you to exercise your new photographic knowledge. The more you apply one of the concepts, the more comfortable you will be with using it. These self-assignments also are an important part of your formulation of a working and learning plan.

When you go out to make photographs in the field and you find yourself looking at a wonderful subject, in fantastic light, with a foreground and background that really work and great conditions, only one thing matters: Do you know what to do to render a great image on film? Follow the plan presented in this book, and you will!

I hope you treat this book like a textbook. What you are about to start is a full-fledged course. To begin, I highly recommend that you assemble some materials. Get a notebook to keep some notes and records in for some of your self-assignments: a three-ring binder works well. I also recommend that you keep a few highlighters handy. It is helpful to mark specific points that you want to go back and review. I also highly recommend that you buy a copy of John Shaw's *Nature Photography Field Guide*. I will be referring to it later. After this book, it is the second one you will need in your nature photographer's library!

You will notice that throughout the book I am not shy about making recommendations regarding equipment and services. For the past thirty years I've bought almost one of everything you can buy in photography. And I have friends who have bought what I haven't bought! I've formed strong opinions about what camera, lens, bag, filter, computer, printer, scanner, and a lot more stuff a person should own. My recommendations are based on my experience and the experience of the hundreds of other photographers I've known, but remember, they are just our opinions; your experience will also guide your decisions.

When I founded my company, Great American Photography Weekends Workshops, I knew it would have a number of sponsors. But not one of the companies was chosen to be a part of our endeavor until we had determined that we would actually use their products and services. I could not in good conscious recommend something to you if I didn't honestly feel strongly about it myself. I take very seriously the recommendations I make.

I further want to mention that while I have been a lifelong user of Nikon (35mm and digital) gear, I certainly do believe wonderful images can be made with any of the other brands available on the market today. Throughout this book I often refer to Nikon, but most of my recommendations can and do apply to the other major brands of camera and equipment.

I once heard a story about a man who wanted his son to become a writer. When given the opportunity to meet Ernest Hemmingway, he asked, "You certainly are a great writer, what kind of typewriter do you use?" I think you get the point....

If you find yourself at the photographic crossroads and you've made the decision to become a truly good photographer, may I walk along with you for a while?

Over thirty years ago I was at the same spot in the road and made that same decision. Along the way I've had both wonderful and disappointing experiences. I now know where many of the potholes, bumps, and bruises are along the way. I have discovered, with a lot of help from others, some of the great treasures of such a journey, carefully hidden just off the trail. It is written that "to whom much is given, much is required." I've certainly been given a great deal, so it's now time for me to give back, through this book.

And if you really want to become the photographer you've always dreamed of being, it is within reach. It will not be easy; nothing worthwhile ever is. You must be willing to study, experiment, fail, and then learn from your failures—repeatedly! In your quest, some of the concepts and procedures will come easily, others will take more effort. With patience and persistence you will achieve your goal.

Life and learning is a journey, not a destination. When you learn how to find joy in the journey you will have unlocked one of the most important secrets to success.

I'm ready if you are. Let's head down the trail together.

PORTFOLIO OF SELECTED AMATEURS

One of the questions I'm most frequently asked as I travel and speak to photography groups is, "Who do you think are the best photographers in America today?" It would be easy to mention professionals such as John Shaw, Art Wolfe, David Muench, David Middleton, Jim Brandenburg, etc. All these people and many more could be on that list.

The truth is, though, some of the best photographers I know are people whose names you might not recognize. Since this is a book about becoming the photographer you've always wanted to be, I thought it might be fun to show you some great work from people just like you—people who wanted to become really good photographers and took the necessary steps to reach that goal. These photographers are not well-known pros yet, but they sure shoot like them. And you can too!

Steven Valk

While browsing in a bookstore, I noticed a book on an upper shelf titled *Maine* by Eliot Porter. Pulling it down and flipping through the pages I found myself captivated by his images. They were beautiful, and most fascinating; the images were of everyday subjects. They were the images that could be found in your own backyard, eliminating the need for extensive and expensive travel. This suited me perfectly. Having retired from the New York State police, I purchased an inexpensive second-hand camera and the adventure began. I dedicate my images in this book to the late John Netherton who inspired me, taught me, and became my friend.

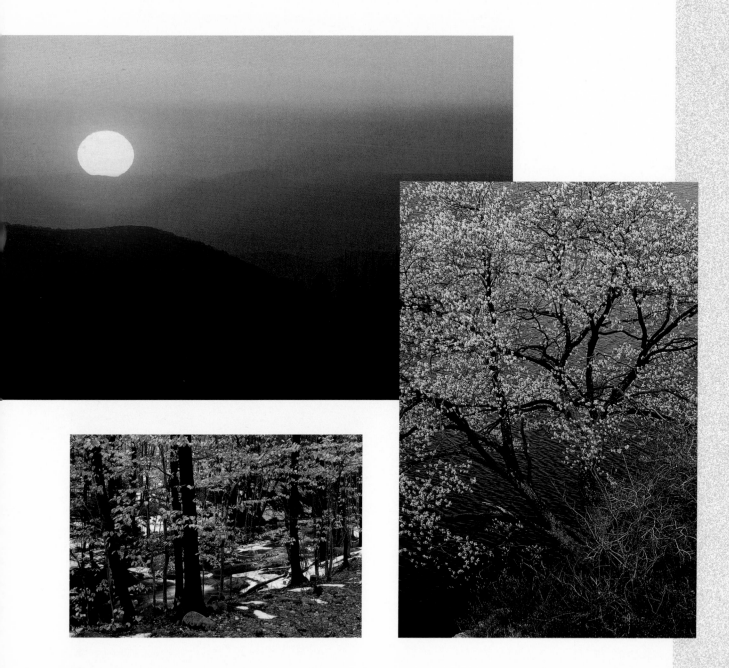

Steven & Sylvia Oboler

We love wandering the backroads of the West with our cameras and our dogs, and waiting for the perfect light. We discovered nature photography at our first workshop, when our goals were to learn to use a tripod and keep the horizon level. Since then, attending at least one workshop each year keeps us improving our skills and meeting new people. Working as a team often gives us two views of the same scene, a hand to hold a diffusion screen, and another opinion on the best composition. Our day jobs as internists on the University of Colorado medical school faculty keep us pretty busy, spending our free time watching the sun rise and listening to birds wake up is a great way to share our fun times together.

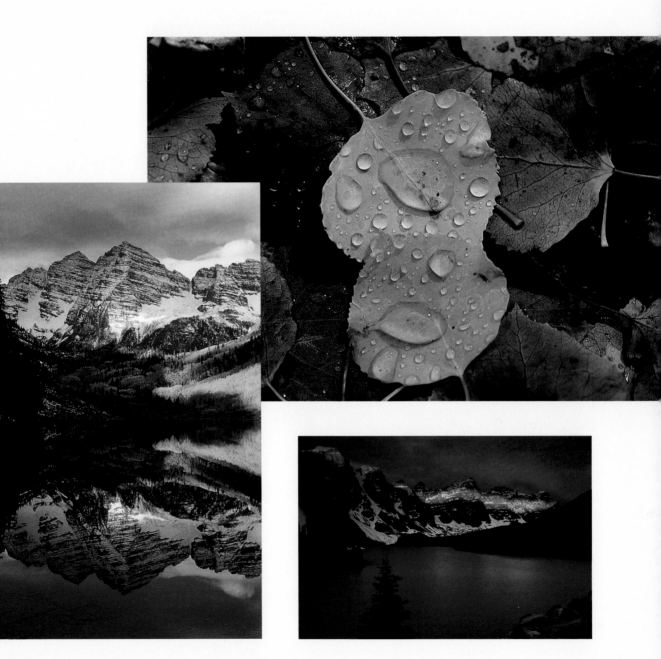

Jay Smith

I've been taking pictures for over forty-five years, and now have over 30,000 slides. I promised my wife that sorting through and eliminating some of these slides would be a top priority of retirement. In the sorting process I've come to an astonishing realization: I have become a much better photographer in the last ten years. After some soul searching I believe several things have accounted for this progress. I bought a tripod, which forced me to slow down and consider more thoroughly my compositions, exposure, depth-of-field, camera angle, etc. I started to attend photo workshops, read photography magazines, and joined a camera club. I've learned from great pros at the workshops, kept abreast of the latest technology in the magazines, and have made wonderful friends who have inspired me with their work in our club.

L. F. Van Landingham

I work for one of the largest homebuilders in the country and am a lawyer by education, but my passion is nature photography. For the past fifteen years I have immersed myself in nature, photographing wildlife and landscapes around the world. My skill level increased dramatically when I had the good fortune to become friends with Arthur Morris, one of the most celebrated bird photographers in the world. Along with Arthur and other workshops, including many with the Great American Photography Weekends, I've grown more in love with the natural world and nature photography. With my wife, Marbrey, we have started to market my work, but I still do it one-hundred percent because of the passion!

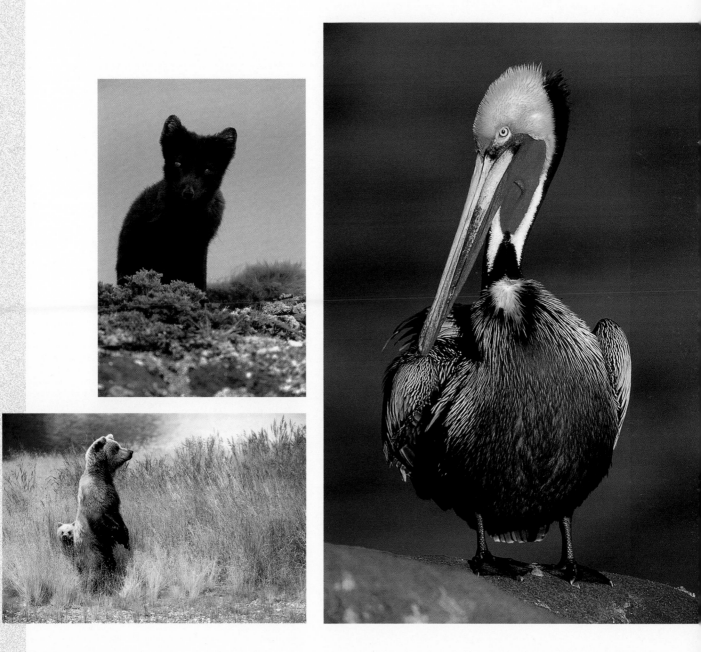

Bill Drury

After serving as a Family Practice Physician for twenty years, I left the medical profession to pursue a career in photography. I've only been a serious photographer for three years and my passion lies in nature, outdoor, and travel photography, though I find myself doing photography of people and architecture almost as frequently. I'm currently serving as director of Photo Imaging Center in Greenville, South Carolina, where I teach and lead photography workshops. Through encouragement and support from my wife, Jodi, and my sons, Scott and Brad, and a great association with the many quality people of photography I've been privileged to meet and learn from, my wonderful adventure is just the beginning.

Joanne Wells

Ten years ago when I purchased my first 35mm camera, I didn't realize that it would lead me on a journey to wonderful and captivating places across America. Along the way I met motivating photographers and teachers like John Shaw, Bill Fortney, Cliff Zenor, David Middleton, and Craig Tanner. I soon became part of a group simply known as nature photographers, and thereafter viewed the world in a different light. It has inspired me to become a better naturalist and to have a greater appreciation for the skill of photography. Improving my craft both technically and artistically has turned out to be a personal challenge, one that I look forward to with great enthusiasm.

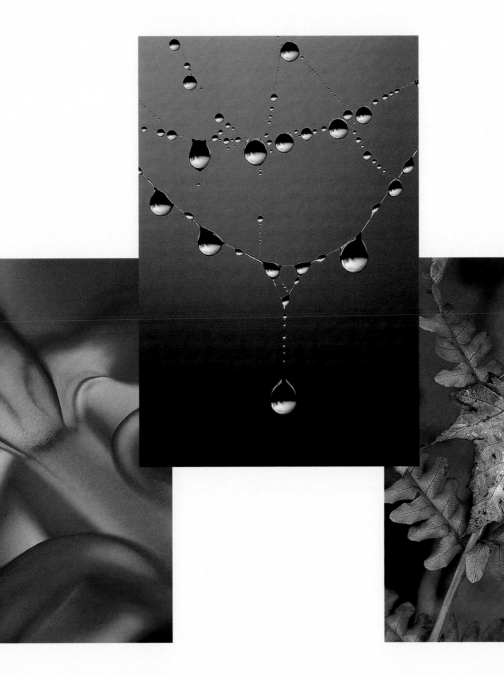

Bill Gamble

Nature and travel photography have improved the quality of my life over the last seven years. I owned a camera for five years before I knew how to use it! The pivotal event that led to passion for my hobby was my first workshop with the GAPW in Acadia National Park in the Fall of 1996. As a busy interventional cardiologist, I have not had much time to pursue a formal photography education. Workshops, slide critiques, and field work are responsible for eighty-five percent of what I have learned. Photography has taught me patience, provided me refuge from stress, and has truly enriched my life.

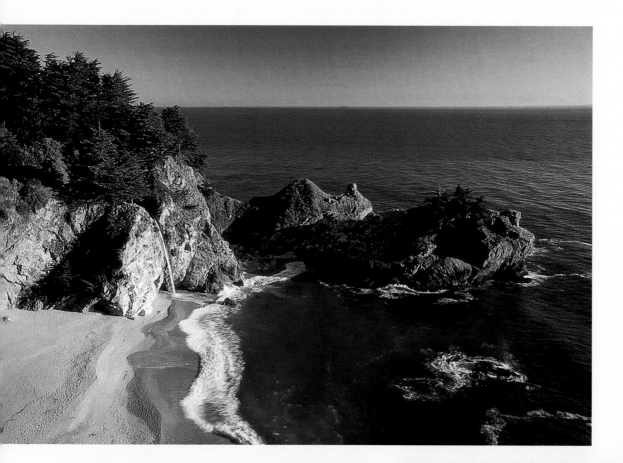

Craig Folse

I have been involved in pursuing nature photography for approximately five years. It began as a hobby and has now become a passion. It has become the most relaxing and enjoyable way for me to spend my leisure time. It has had to be a spare-time endeavor since I am a solo-practicing radiologist with a hectic, busy work schedule. I have attempted to improve my photographic ability by combining leisure travel with professional workshops and seminars, as well as reading and shooting as much film as I can. I have gradually improved and upgraded my equipment and now enjoy using some great gear. I'm constantly searching for ways to improve my abilities and creativity. I have become an avid conservationist, committed to protecting and preserving the environment for the present and into the future.

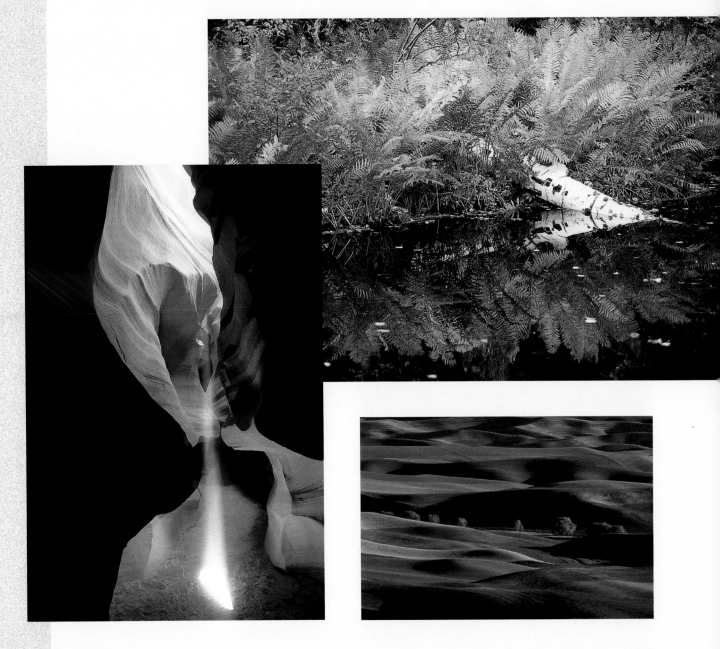

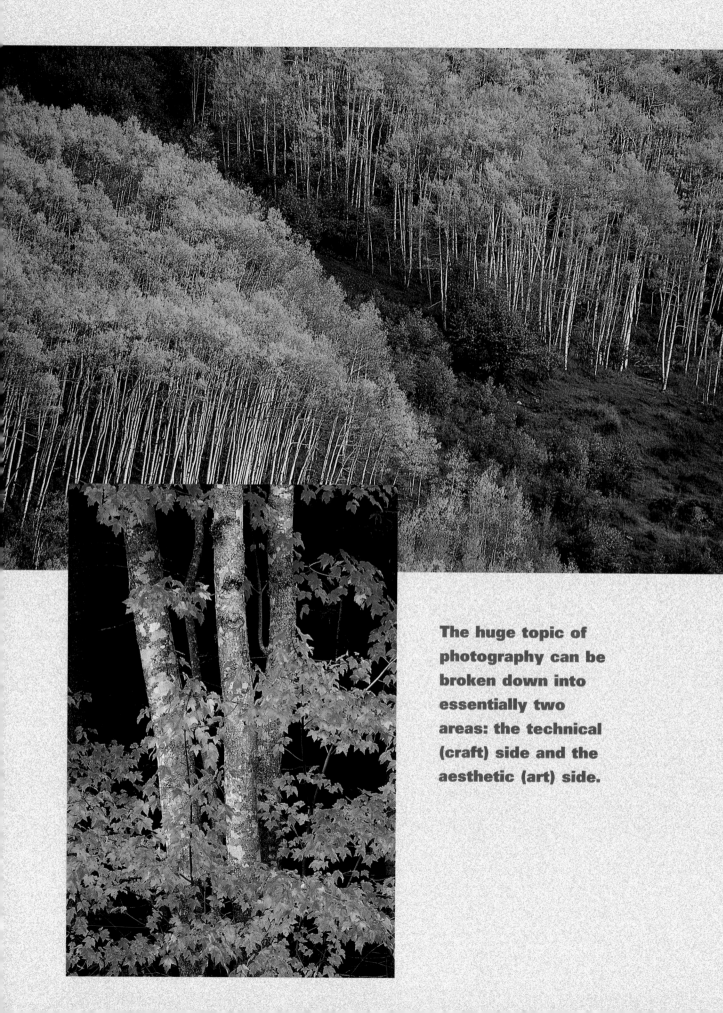

The huge topic of photography can be broken down into essentially two areas: the technical (craft) side and the aesthetic (art) side.

Goals for Success

CHAPTER

BEFORE YOU START to consider your goals as a photographer, let's talk about goals in general. The biggest thing that causes people to fail is the setting of goals that are too lofty. When they see they are not getting close to their goals, they get discouraged and often give up. If your goal is to be the next Ansel Adams I can assure you that you will have lots of disappointments along the way. After all, that is a pretty tall order for any of us! It's probably better to set a series of smaller goals. You'll have a sense of accomplishment at reaching each one.

I heard a story once that illustrates the value of setting incremental goals: A New Yorker stood amazed that a truck driver he met drove from New York to Los Angeles and back every ten days. He asked the truck driver, "How can you drive all the way to Los Angeles and back?"

The truck driver said, "I don't. I drive from New York to Pittsburgh, then I drive from Pittsburgh to St. Louis and then from St. Louis to Kansas City, etc, etc."

The truck driver had learned how to see a big journey as smaller, more manageable parts. That is how I want you to set your goals in the area of photography. Take one manageable area at a time. Before you know it, you'll be—figuratively at least—pulling into L.A.

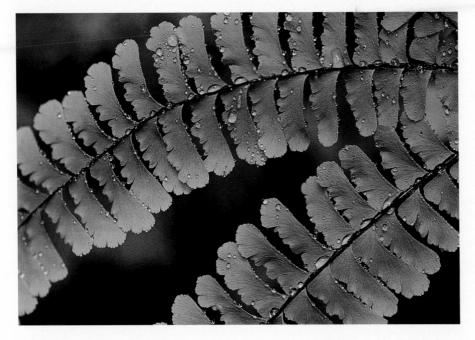

Opposite top: Aspens on a mountainside in Owl Creek Pass near Ridgeway, Colorado. *Nikon F5, 80–200 f 2.8 lens, polarizer, Velvia.*

Opposite bottom: Fall foliage in Acadia National Park, Maine. *Nikon F100, 80–200 f 2.8 lens, polarizer, A2 warming filter, Velvia.*

Left: Fern leaves with dewdrops, Olympic National Park, Washington. *Nikon F5, 200mm micro lens, polarizer, Velvia.*

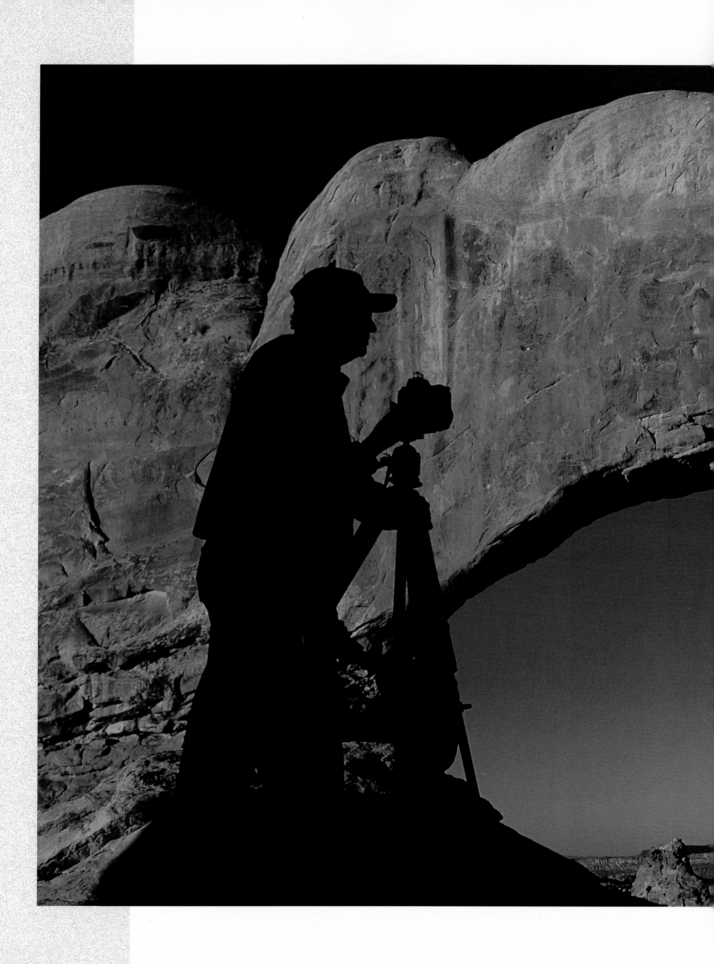

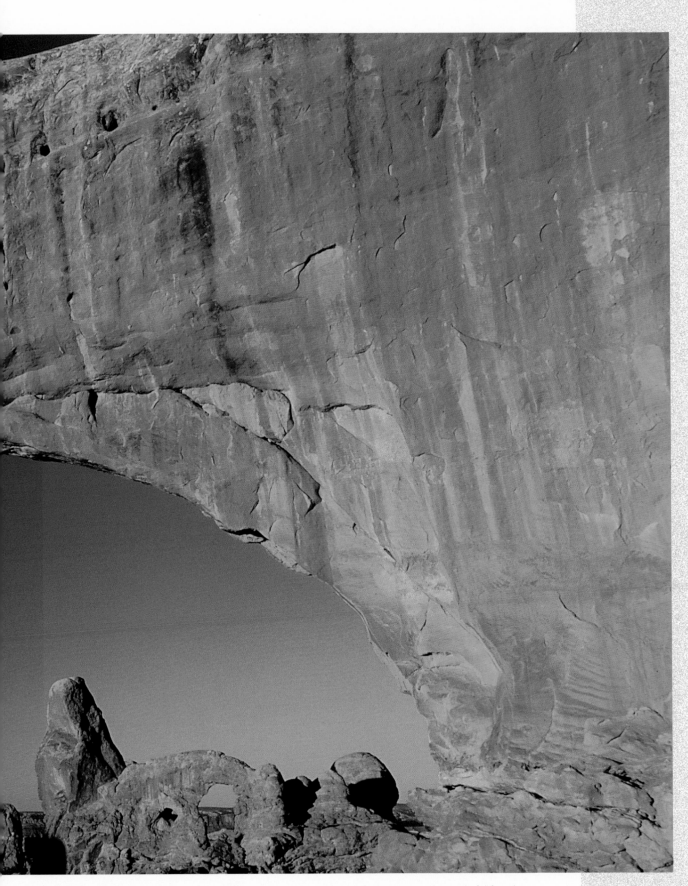

One of the greatest joys of outdoor photography is the time spent in beautiful locations with wonderful friends.
This silhouette shot of my dear friend Dr. Charles Stanley at North Window and Turrett Arch in Arches National Park,
Utah, was one of those great moments! *Nikon F5, 17–35 f 2.8 zoom lens, polarizer, A2 warming filter, Velvia.*

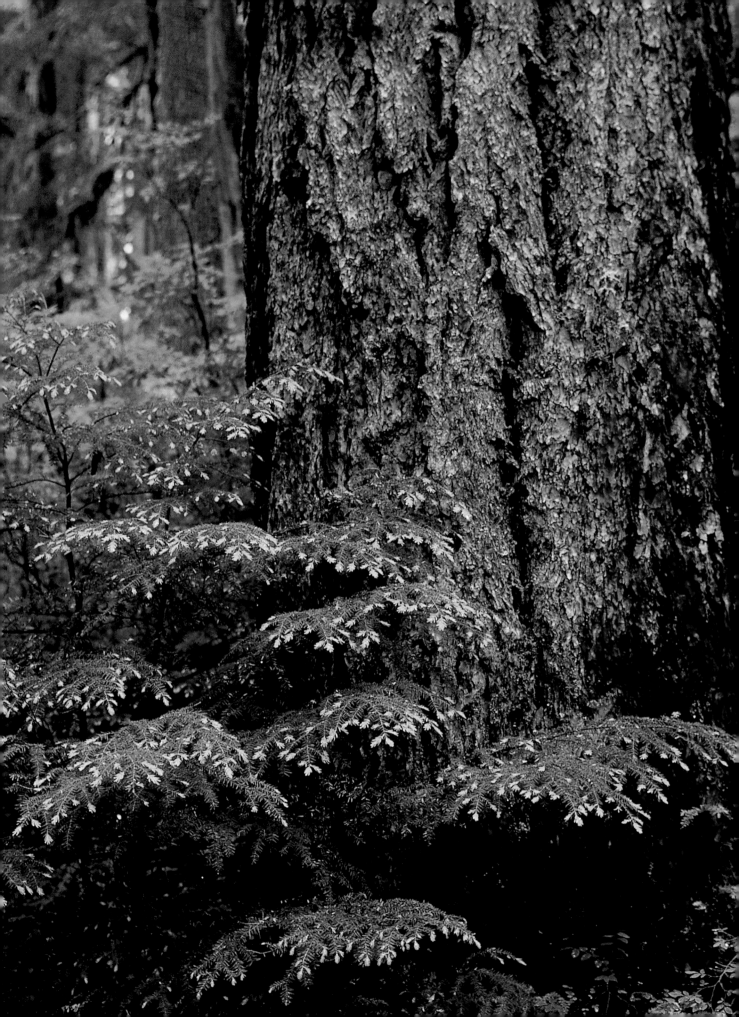

Opposite: Old-growth forest in Olympic National Park, Washington. *Nikon F5, 28–70 f 2.8 lens, Velvia.*

Left: Fall color along the side of Grandfather Mountain in western North Carolina's Blue Ridge Mountains. *Nikon F100, 300mm f 4 lens, polarizer, Velvia.*

The huge topic of photography can be broken down into essentially two areas: the technical (craft) side and the aesthetic (art) side. The technical side includes how the camera works, depth of field, exposure, point of focus, motion interpretation, sharpness, lens selection, filter selection, etc. The aesthetic side takes into consideration composition, use of light, subject selection, mood, color use, and so on. We will explore one of these important areas at a time and master it before we move on to another.

Now it's time for you to set your first goal—perhaps the most important one of all: to take your time, stick with it, and know that you only have to master one thing at a time.

SELF-ASSIGNMENTS

1. Find a great place to study and concentrate. A special place to read and study is a key to learning effectively. Tip: Don't use a chair that is too comfortable—remember, you are going to study not sleep!

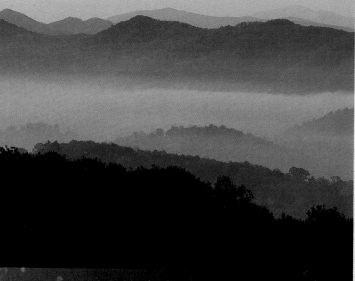

The subject must be apparent. If you can describe it in a single word or short phrase, you have it nailed!

Four Keys to Great Images

CHAPTER

2

OVER THE PAST two decades I've been in the classroom when lots of great information has been passed on by various teachers to our students at Great American Photography Weekends events. Probably the single most impactful teaching for me came from David Middleton.

In one of David's lessons he introduces his "Four Keys to Great Photographs." This concept and approach has made a dramatic improvement in my work, and I think it can in yours too. In a nutshell, the following is his philosophy.

Before you make any photograph you need at least four things to ensure that it will be successful:

1. Appropriate light for the subject. If you do not have light that really works with your subject or scene, you simply don't have a viable photograph.
2. A clearly defined subject. The subject must be apparent. If you can describe it in a single word or short phrase, you have it nailed! If you can't, you may not really be sure what you intend for your finished image, and you may not be pleased with it.

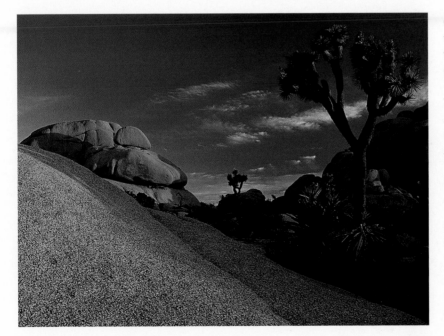

Opposite: All three images are examples of the four keys; simple definable subject, in the right light, with foregrounds and backgrounds controlled and in perfect conditions!

Top: One colorful fall leaf in a pine branch, Acadia National Park, Maine. *Nikon F100, 80–200mm lens, Fuji Provia F (pushed one stop).*

Middle: Fern leaves in fall. *Nikon F100, 200mm micro lens, polarizer, Velvia.*

Bottom: Sunrise. Foothills Parkway in the Tennessee Smokies. *80–200 AFS.*

Left: Easter morning, Joshua Tree National Park, California. *Nikon F100, 17–35 f 2.8 lens, polarizer, Velvia.*

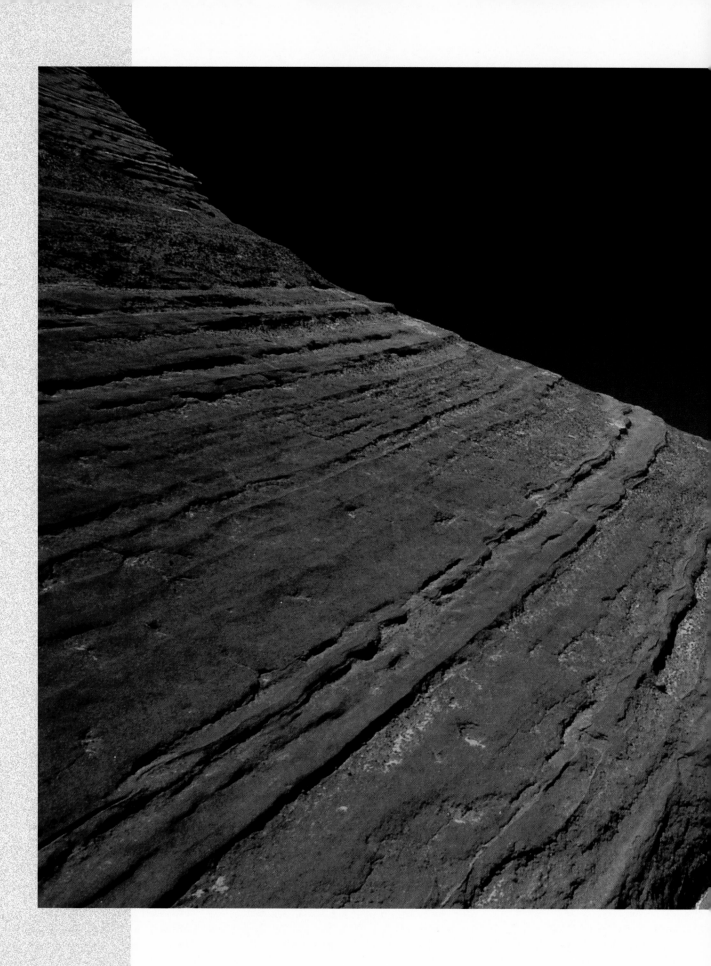

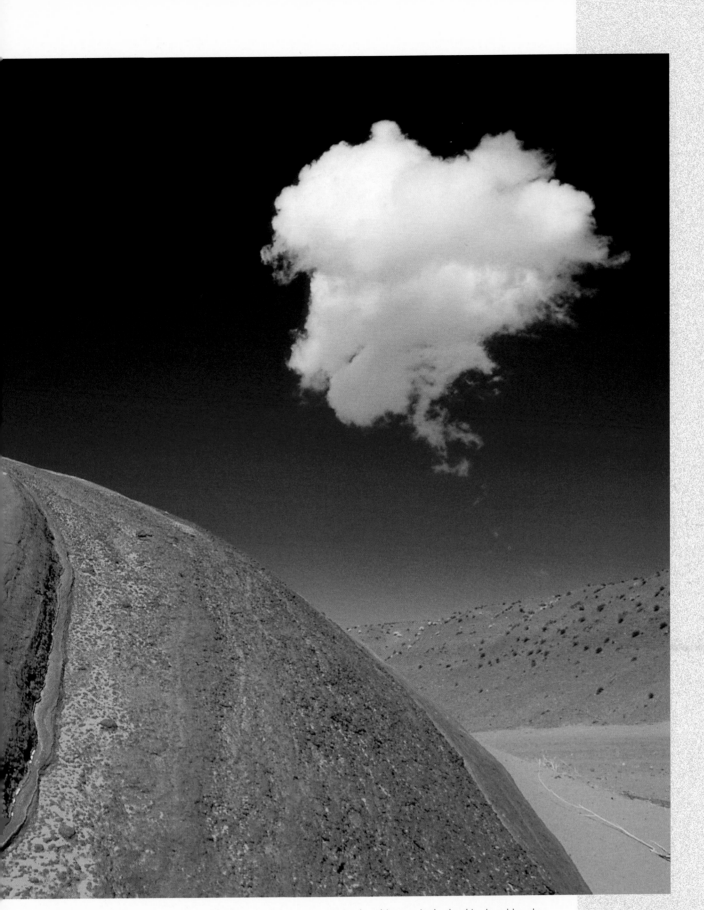

This image is an example of how well the four keys work in concert. A simple subject: a single cloud in deep blue sky. A perfect foreground: weathered lines in red rock leading your eye to the cloud. A simple non-distracting background: a desert hill and dead-calm wind for perfect conditions. Near Upper Antelope Canyon, Page, Arizona. *Nikon F5, 24mm f 2.8 lens, Kodak Ektachrome 100 VS.*

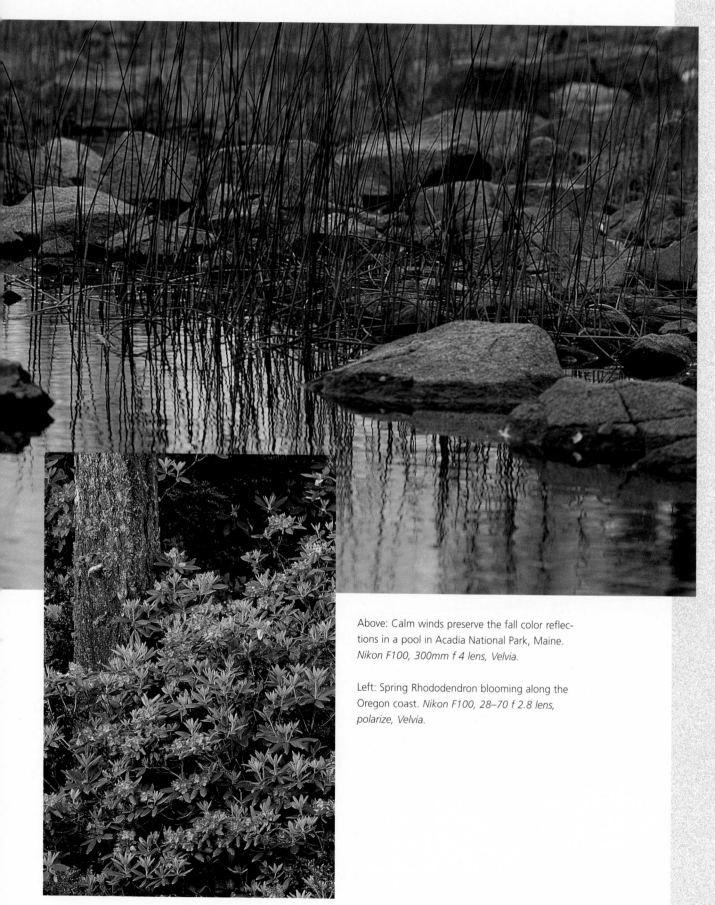

Above: Calm winds preserve the fall color reflections in a pool in Acadia National Park, Maine. *Nikon F100, 300mm f 4 lens, Velvia.*

Left: Spring Rhododendron blooming along the Oregon coast. *Nikon F100, 28–70 f 2.8 lens, polarize, Velvia.*

3. A background and a foreground that are used in the most effective way possible. They can be sharp and clearly a part of your composition, or thrown out of focus and not part of your image. Each gives a different interpretation—the choice is yours, but you must make the choice.

4. Conditions that are right for the photograph you're intending to make. For example, if you hope to do portraits of delicate wildflowers and the wind is blowing at gale force, the conditions are not right.

You can try to make a photograph without the four key areas above, but I'm afraid you'd be doomed to failure!

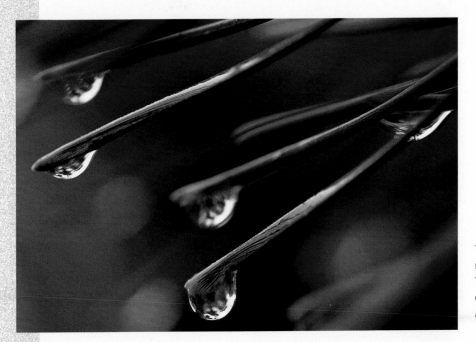

This shot could only have been made in perfect conditions; no wind! The pine needles with raindrops work only if it is very, very calm. *Nikon F100, 200mm micro lens, Velvia.*

SELF-ASSIGNMENTS

1. When working in a potential photographic situation, stop before making the image and review that list. Do I have a definable subject? Do I have the right light for the subject at hand? Can I control the foreground and background to make the most effective image? Are the conditions working for me or against me?

2. Sit at your light table or computer and review some of your images that you've never been very happy with. Ask these same four questions. Chances are, you'll start to discover what has been missing in those photographs!

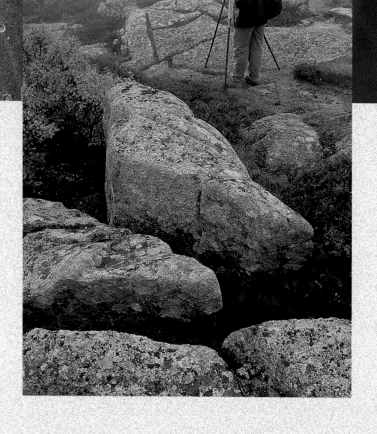

You can learn to see better photographically with concentration and practice.

Seeing is feeling.

The Art and Craft of Photography

CHAPTER 3

MANY YEARS AGO I bought a book that changed my photographic life. The book was *Developing the Creative Edge In Photography* by Bert Eifer. More than any other book I've ever owned—and I own hundreds—this book set the tone for learning with some wonderful thoughts on the art and craft of photography. If this book were still available today I would have suggested it for your "must-have" list.

Unfortunately, after two successful printings it is no longer available. Bert graciously gave me permission to use some of his material in this book. He also wished you the best of luck in your efforts to become the photographer you've always wanted to be.

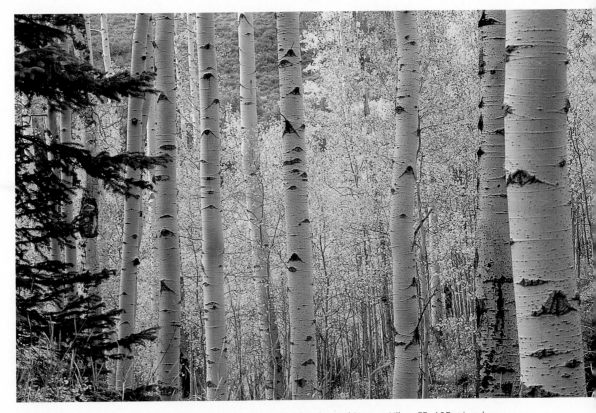

Opposite top: Wild Lupine leaves in light mist, Olympic National Park, Washington. *Nikon F5, 105 micro lens f 2.8, polarizer, Velvia.*

Opposite bottom: My friend, Ian Dicker, enjoying a rich deep fog bank over Cadillac Mountain in Acadia National Park, Maine. *Nikon F100, 28–70 f 2.8 lens, Velvia.*

Above: An Aspen grove in the Sneffles Range, Colorado. *Nikon F5, 28–70 f 2.8 lens, polarizer, A2 warming filter, Velvia.*

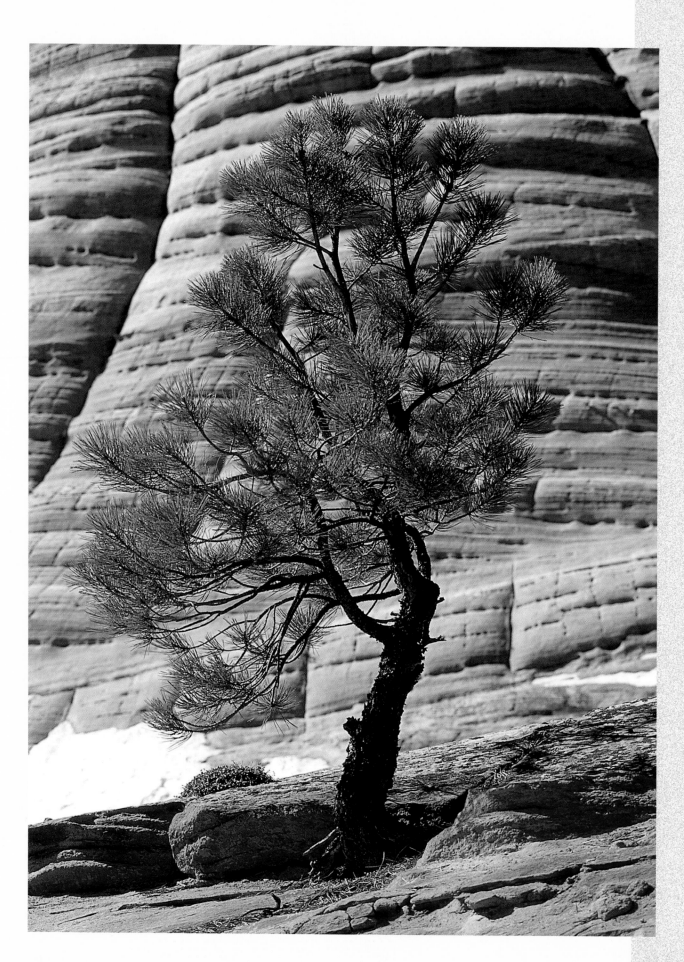

IS IT ART OR IS IT CRAFT?

Photography is a blend of both art and craft. Almost everything you've read focuses on craft, often to the exclusion of art. You use craft to capture an image on film—a relatively easy process once you have mastered the simple creative controls of your camera. But it does little good to have the skill to say what you want, but have nothing to say!

Most of the courses you take and the books and magazines you read, instruct you on the technical side, or craft, of photography—how to control depth-of-field, film selection, the use of filters, and so on. And they're great, as far as they go. The trouble is, they don't go far enough—not by a long shot.

The craft of photography is only half the story, the easy half that anyone can learn (although not everyone does). That is not to say the craft of photography is unimportant. Quite the contrary. The only way you can record your ideas and feelings—the art and aesthetics of photography–is to understand and use all the techniques of the craft.

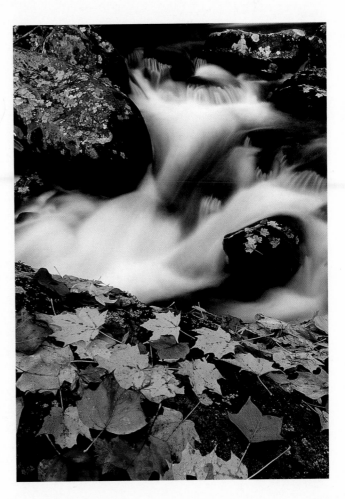

Opposite: One of the great things about nature photography is trying to recreate your own version of someone else's shot you have admired. John Shaw photographed this same Ponderosa Pine at checkerboard Mesa, in Zion National Park, Utah, for his book, *Landscape Photography*. He used a 24mm lens and his shot was great! I decided to try a compression effect with a 300mm lens. Same subject, two different treatments. *Nikon F100, 300mm f 4 lens, polarizer, Velvia.*

Right: Some of my favorite scenes in the Smokies are the wonderful stream shots along the Roaring Fork Motor Trail, just outside Gatlinburg, Tennessee. *Nikon F5, 20–35 f 2.8 lens, polarizer, A2 warming filter, Velvia.*

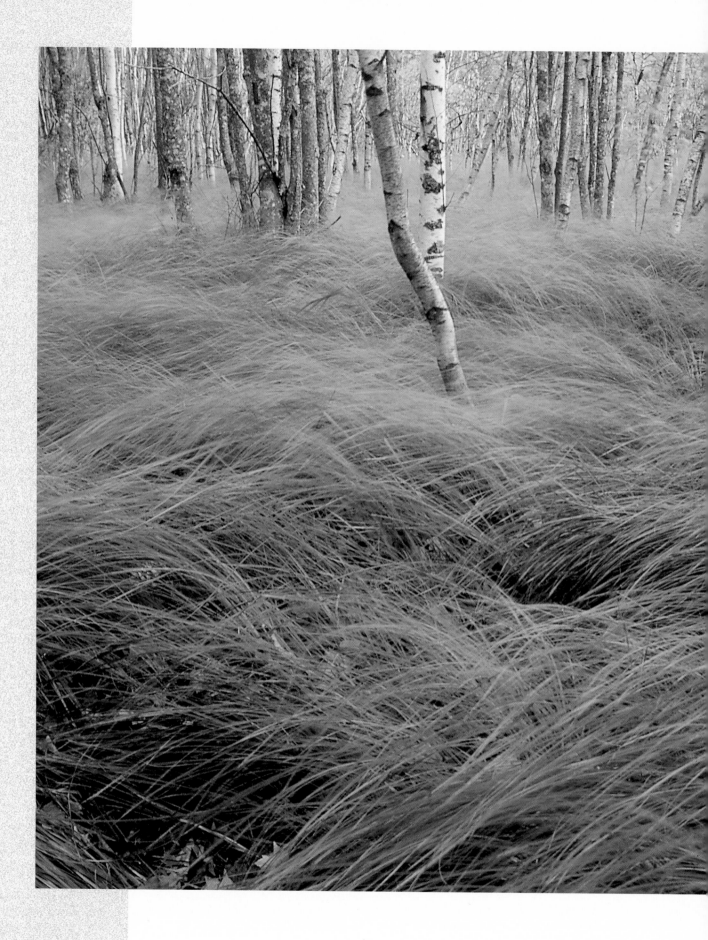

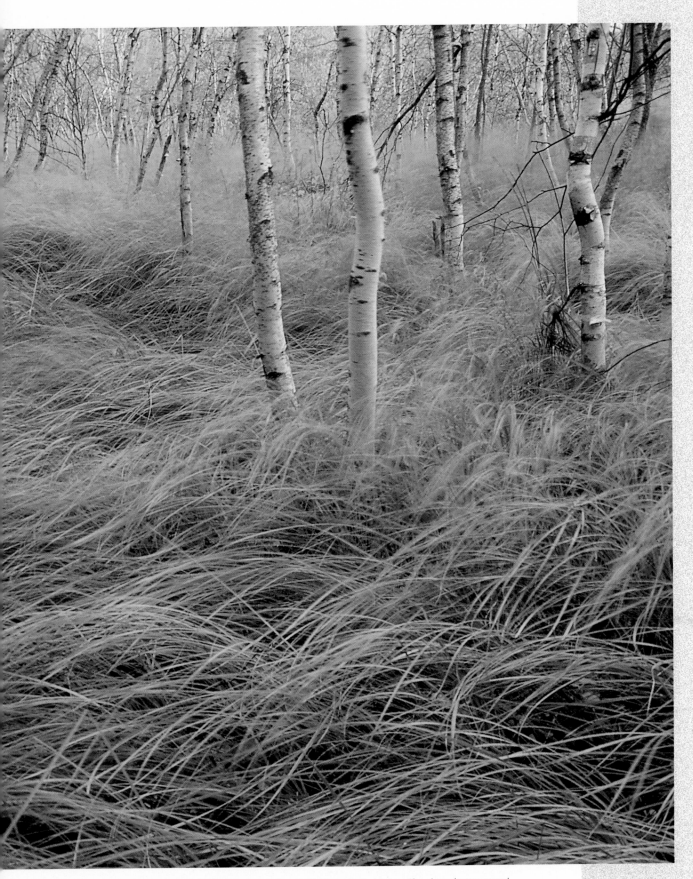

Wild, tall grasses blown by the breeze in The Garden at Acadia National Park, Maine. The slow shutter speed (1/2 second) was used to show the movement. *Nikon F5, 28–70 f 2.8 lens, polarizer, Velvia.*

SEEING PHOTOGRAPHICALLY

Very few photographers learn the art, which is why good photographers are such a rare and special group. Yet almost anyone can learn the art of photography to create remarkably better images. Seeing photographically is the starting point of the art—it's interpreting your feelings, previsualizing, and capturing those feelings on film. It requires visual sensitivity to feel something special about what you see. And you need an understanding of the differences between the camera lens and the eye.

Walker Evans reinforced the point when he said, "Your mood and message and point have to come through as well as possible. Your technique should be a servant to that purpose." Ansel Adams, in *Personal Credo* emphasized the concept and the craft when he wrote, "A photograph is not an accident, it is a concept. It exists at, or before, the moment of exposure of the negative. From that moment on to the final print, the process is chiefly one of craft."

Artist Frederick Franck, author of *The Zen of Seeing* was conducting a seminar for teachers and non-artists. After a certain point in the conversation, Franck suggested an exercise. He had the students select a leaf on a tree or a clump of grass, and then close their eyes for five minutes.

He then said, "Open your eyes and focus on whatever you observed.... Look it in the eye, until you feel it looking back at you. Feel that you are alone on Earth.... You are no longer looking, you are *seeing*....

"Now take your pencil...and while you keep your eyes focused [on the subject] allow the pencil to follow on the paper what your eye perceives. Feel it as if with the point of your pencil you are caressing the contours, the whole circumference of that leaf, that sprig of grass."

The experiment was a success. Many students, to their amazement, captured the impression of their subject—how they felt about what they had seen. It proved how much deeper you can see with a little concentration; how you can feel something special and unique, even about a random, mundane object.

You can learn to see better photographically with concentration and practice. Seeing is feeling. Ernest Braun put it succinctly, "Seeing is really recognizing and appreciating what's around us." Don't just look—see with fresh eyes. Don't just glance—immerse yourself in your subject. Caress it with your eyes. Let it embrace you, overpower your conscious senses. In nature this is often very easy to do!

When you are concentrating on making a photograph that is important to you, and feel something special about your subject (or at least a point of view), try to put into words what that feeling is. This act of verbalizing compels you to focus on and sort out all possible feelings, narrowing them, to one you can work with. As you will learn later in our composition discussion, it will also help you to clearly define what your subject is. If you cannot state in a very short sentence or phrase what your subject is, you still have not defined the resulting photograph.

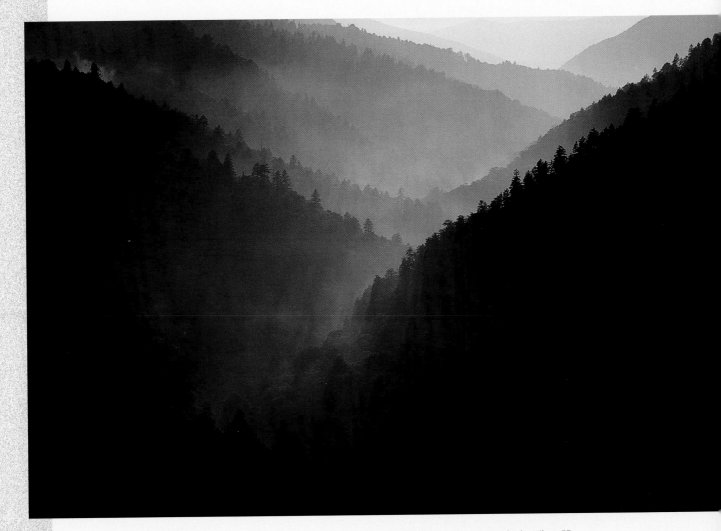

Great Smoky Mountains National Park, Tennessee. Rising mist at sunset from Morton's Overlook. *Nikon F5, 80–200 f 2.8 lens, Velvia.*

CONQUERING THE TECHNICAL

In this book, as part of studying the craft side, you will learn to master the creative controls of your camera. You will see the technical aspects of photography in a new light and find them easy to perfect.

Let's consider *making* photographs instead of *taking* them.

What is the most important factor in creating a good photograph? Truly great photographers make photographs, others take them. A snap-shooter takes pictures, simply accepting what is before his or her eyes without any thought of self-expression.

Making photographs means taking the time to appreciate and feel, to express those feelings, to attain creative fulfillment, to use the creative options that are at your fingertips.

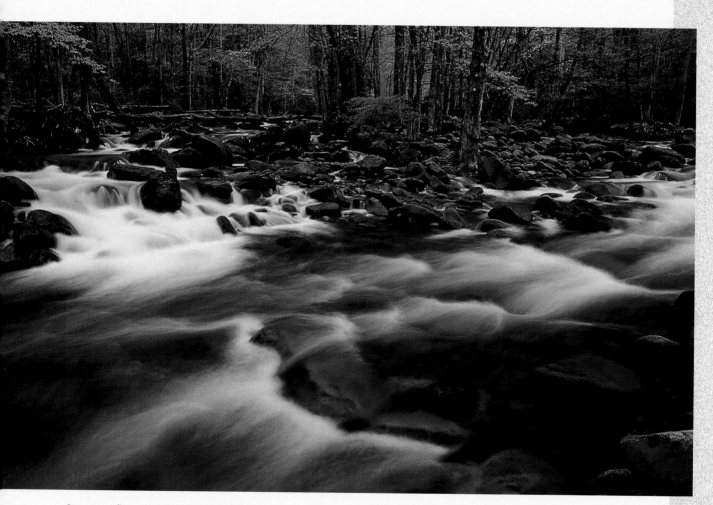

Stream confluence at Greenbrier, Tennessee, in the Great Smoky Mountains National Park. I used a long shutter speed (6 seconds) and a small aperture (f 22) to get the maximum depth-of-field and to give a silky appearance to the water flowing past. *Nikon F5, 20–35 f 2.8 lens, polarizer, A2 warming filter, Velvia.*

Here are some guidelines to help you make great photographs:

- Photograph the subjects you like best. If you love flowers, you will find you do well photographing them. If you don't care for reptiles you probably won't be very successful trying to capture them on film.

- Prepare yourself to make photographs. Think in advance about your outing. Consider carefully what equipment to carry, what film to use. Think about what kind of conditions and light you think you may encounter so that you can be both technically and aesthetically prepared.

- Involve yourself thoroughly. When you are finally confronted with your subject, get into the act of truly seeing. Allow yourself to be absorbed in the scene or subject.

- Shoot thoughtfully. Slow down. Think about each shot. What effect do you want? What feeling does the scene evoke? Can you capture it on film?

- Shoot a series of images. After you shoot the overall scene, step into the scene visually and find the other interesting parts of the scene that could be stand-alone photographs. Don't walk away with just one photograph when you could have made several more successful ones.

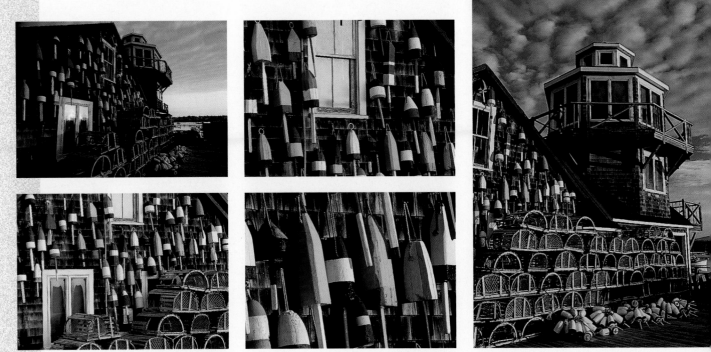

Fishing pier in Bernard along the Maine coast near Acadia National Park. A group of students did this exercise at one of our Great American Photography Weekend workshops: Pick a scene and photograph the entire scene, then by moving around or using longer zoom lenses, pick out parts of the scene as individual images. The results can be fascinating and produce a number of nice images from the same location. *Nikon F100, 17–35 f 2.8, 28–70 f 2.8, and 80–200 f2.8 lenses, polarizers, A2 warming filters, Velvia.*

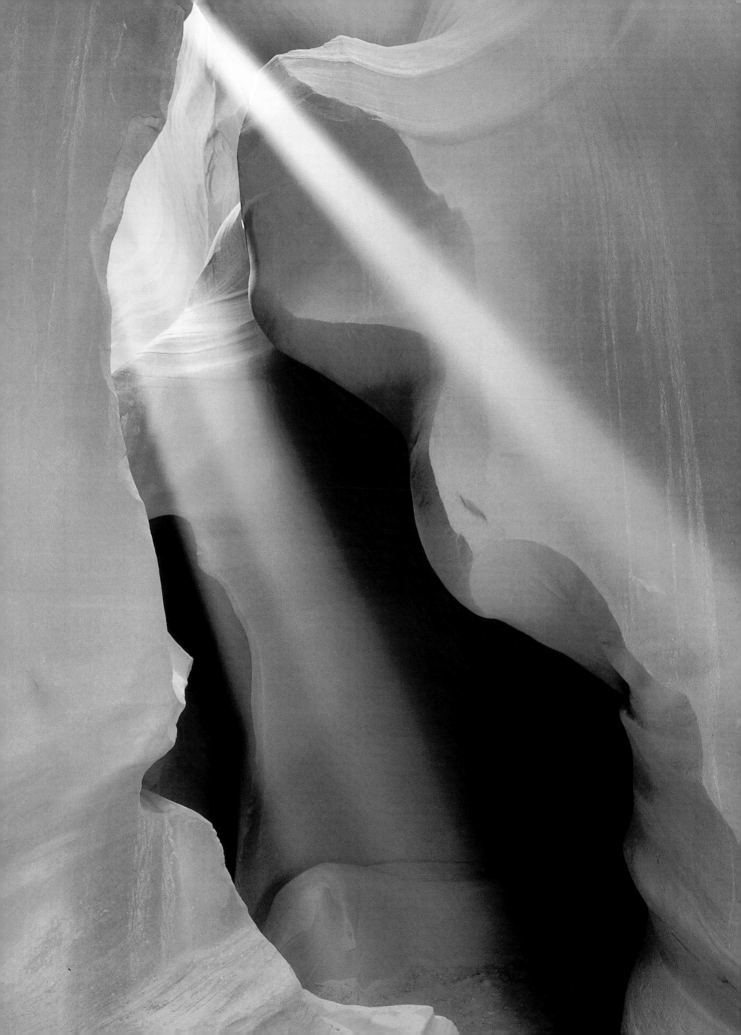

- Bracket your exposures if you think you could capture that once-in-a-life time shot. Today's camera meters are so good that you usually get perfect exposure on the first try, but it is not a bad idea to shoot 1/3-stop brackets over and under, just to have one slightly darker and one lighter. Of course, this is only necessary when shooting slides because when using print film the exposure will be corrected by the lab when it makes your prints, and with digital imaging you can make slight exposure adjustment in the computer.

- Keep good notes. Having a reminder about what you did will help you later when you edit your film and decide which images you like best. It's also a good help in learning from your mistakes.

These steps will help you to think more clearly about your photography and will help you to focus on making more effective and more pleasing images for both you and your viewer.

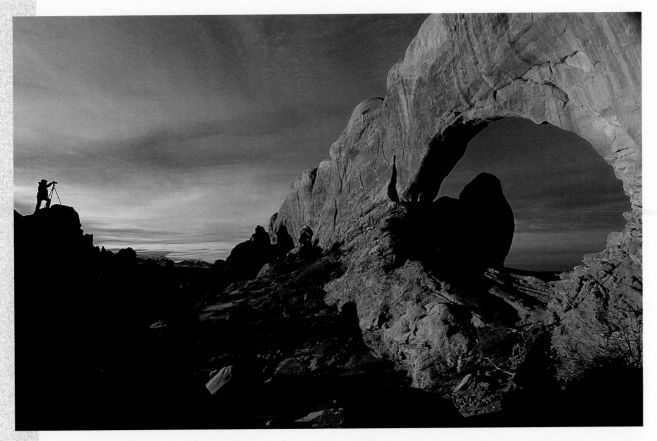

Opposite: Twin shafts of light in Lower Antelope Canyon, near Page, Arizona. I set the camera at F 22 for 40 seconds. *Nikon F100, 20–35 f 2.8 lens, A2 warming filter, Velvia.*

Above: Silhouetted photographer shooting the North Window in Arches National Park, Utah. *Nikon F100, 17–35 f 2.8 lens, polarizer, A2 warming filter, Velvia.*

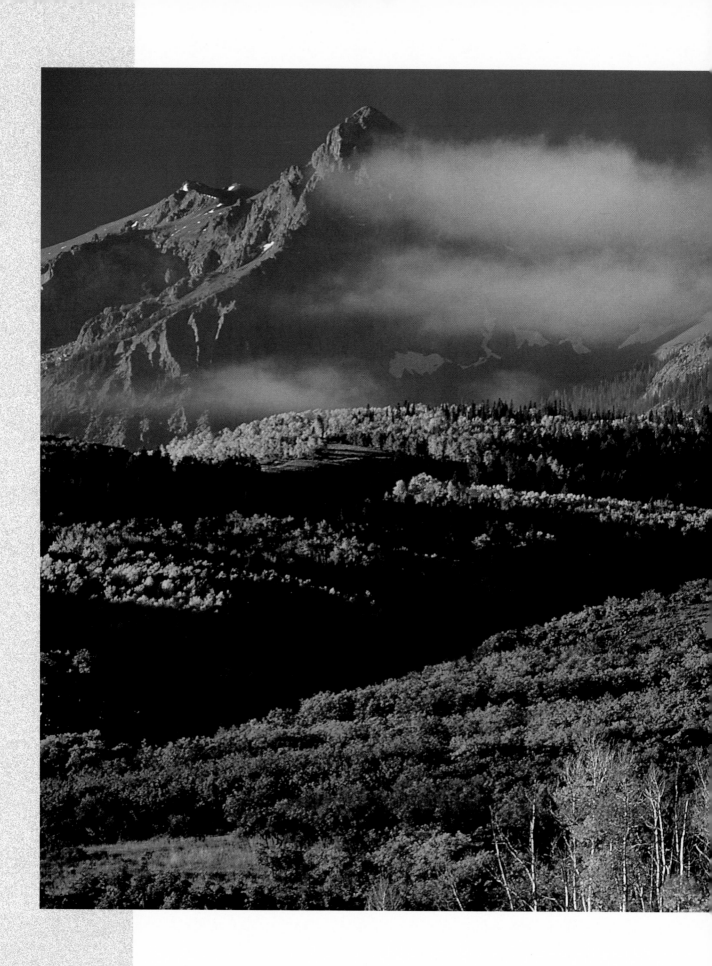

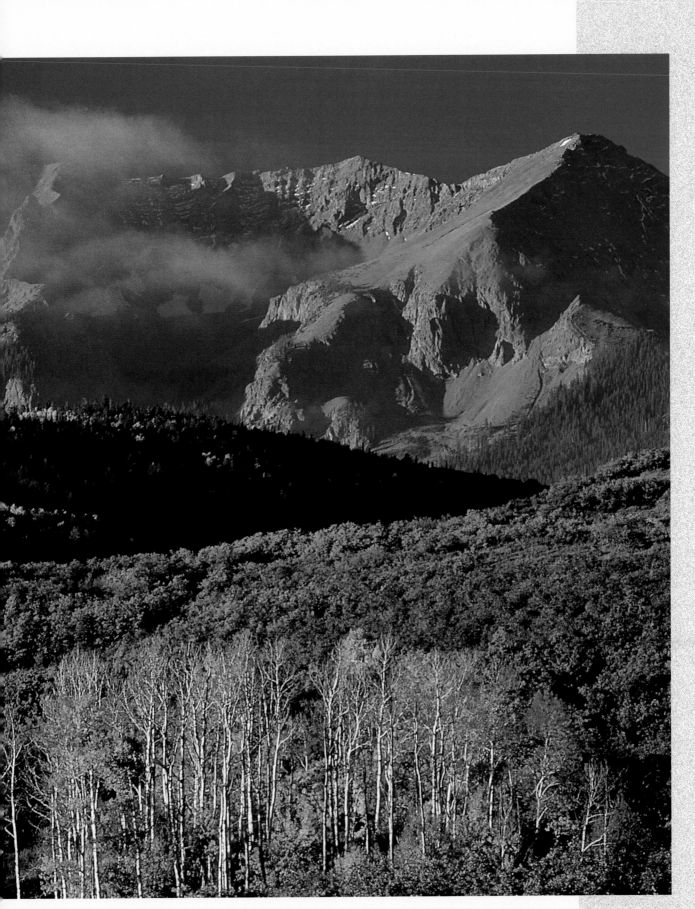

The Rockies in morning clouds from Dallas Divide near Ridgeway, Colorado. *Nikon F5, 80–200 f 2.8 lens, polarizer, A2 warming filter, Velvia.*

CRITIQUING YOUR OWN WORK

Some years ago Time-Life Books selected 250 photographs for the volume *Great Photographers* in the Life Library of Photography series. These photos represented the work of sixty-eight photographers selected from among thousands.

The editors based their definitions of "great" on a combination of factors. Intent was the first criterion. What did the photographer have in mind, and did he or she achieve it?

Skill was the next factor. Did the photographer have mastery over the tools of the trade to execute his or her intentions?

Consistency followed. Did the photographer fulfill his or her intention time and time again? A single great picture—or even several—do not a great photographer make. He or she must produce a body of outstanding work, demonstrating that great photography is no happenstance, ruling out luck or accident.

You can use the same criteria for assessing your own efforts. Measure yourself against the best. It is the only way to ever become the photographer you've always wanted to be.

So, step number one is to set high standards. When you review your work—slides, prints, or digital images—you should be asking yourself these questions:

- Is my image sharp (if that was your intention)?
- Is my image well-exposed or exposed in the best way to convey my intention?
- Does my image have a clearly defined subject?
- Have I eliminated all distractions and unimportant details?
- Is the subject in clear focus?
- Does this image have a clear center of interest?
- Have I created the illusion of depth?
- Is my perspective the best for the most impact?
- Have I used motion rendition to capture the most compelling photograph?
- Is this image most successful as a vertical or horizontal composition?
- Have I used color effectively for my photograph?

I can assure you, whether they realize it or not, other people will be asking themselves most of those questions when they view your work. The answers will reveal how effective they think your photograph is.

Avalanche Creek in Glacier National Park, Montana. *Nikon F5, 20–35 f 2.8 lens, polarizer, A2 warming filter, Velvia.*

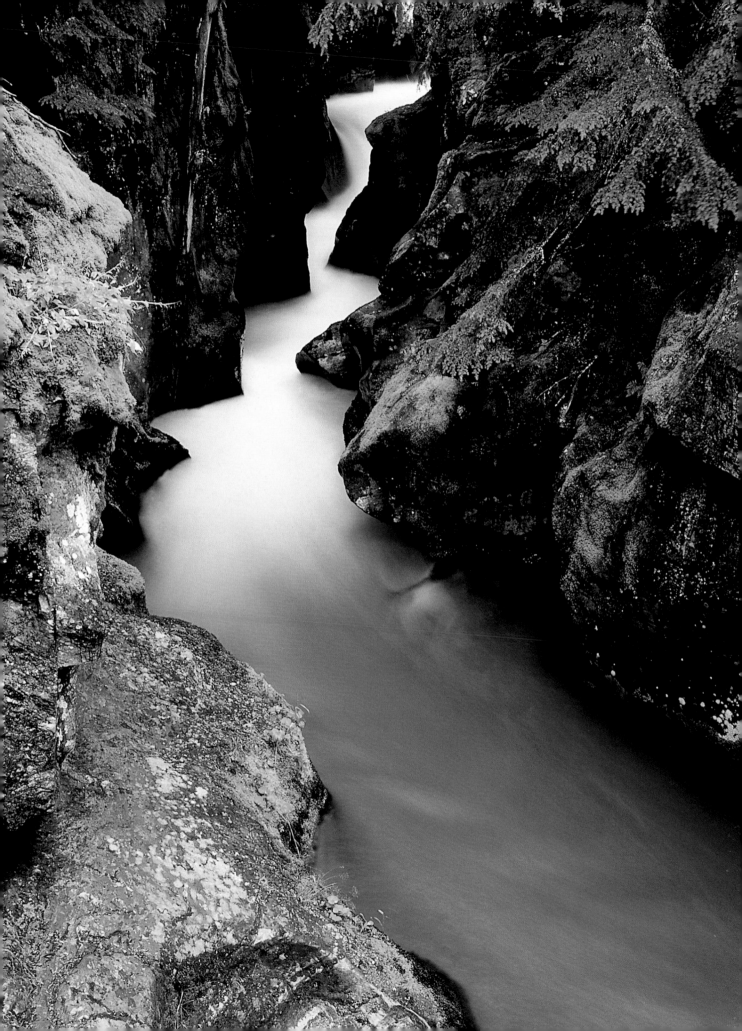

EVOLVING YOUR TALENT

The reason so few successful people are found in any field is because so few make the effort to evolve their latent talent. Everyone who has made it to the top has this in common: They worked hard, even if they were born a genius. With effort your talent will evolve. The key is taking it step-by-step. Mastering photography is a progressive thing. You start with a foundation and build, and build.

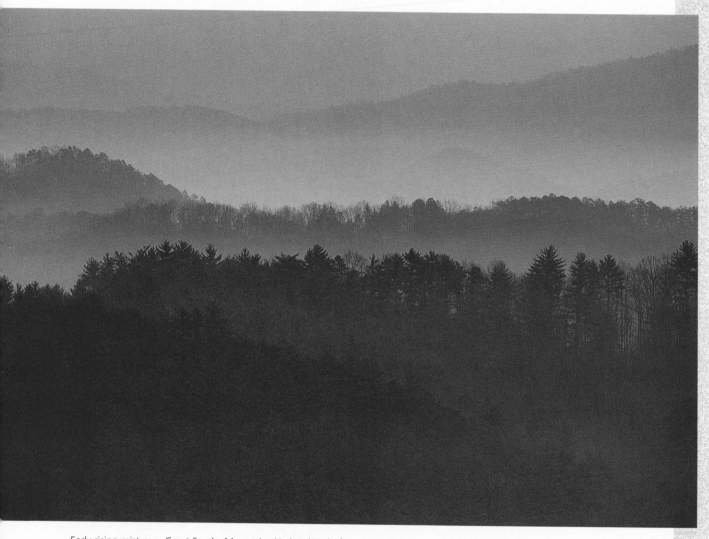

Early rising mist over Great Smoky Mountains National Park, from Foothills Parkway near Townsend, Tennessee. *Nikon F5, 300mm f 4 lens, TC-14B converter, polarizer, Velvia.*

SO, WHAT'S THE SECRET?

Everyone wants to know the secrets of the pros. O.K., here is the number-one, most-important thing of all: If you want to really get great at this, it takes hard work, study, and practice. But, "What about luck?" you ask. Let me tell you a little story.

It is said that many years ago when Arnold Palmer was at the peak of his career as a professional golfer a young reporter asked him, "Mr. Palmer, you win so many tournaments. To what do you attribute your good luck?"

Arnold smiled and, in his always gracious way, shyly said, "Well, I've always found that the more I practice, the luckier I get."

In other words, there is no shortcut to success, there is no free lunch. If you want it to happen, *you* have to *make* it happen.

If one secret to success is hard work, what else is involved? One key to being successful at anything is the level of your expectations. Alexander Pope was so right when he said, "Blessed is the man that expects nothing for he shall never be disappointed." Unfortunately most of us are so blessed. The lowest order of motivation is what others expect of you; the highest is what you expect of yourself.

Another very important key to success is changing your vocabulary by one word—from I *might* to I *will*. It really can make a difference!

SELF-ASSIGNMENTS

1. Write down your photographic goals. Keep them simple; in fact, they should fit on a 4 X 5 index card. Keep them in your camera bag and look at them often. It is important to remember your goals if you ever hope to accomplish them!

2. Assemble a selection of your photographs—some early examples and some recent. For each shot, ask yourself the eleven "critiquing" questions. You will see the evolution in your work as you applied what you learned about photography over the time span.

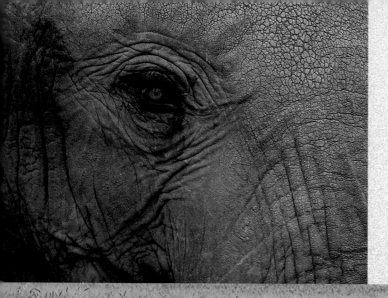

The key is to decide whether depth-of-field or motion rendition is most important, then make changes to the settings to get what you want.

How the Camera Works

CHAPTER 4

THE BASICS OF MAKING a photograph can be really simple. Light is reflected from a subject, and the lens gathers and focuses that light. With a film-based camera, the light is directed onto film. Then the film reacts to the light capturing an image, and development brings out a positive or negative image (slide or negative). With a digital camera, the captured light is directed to the CCD (charged-coupled device). Then that electronic information is transferred to a computer, where it can be viewed, processed, e-mailed, or printed.

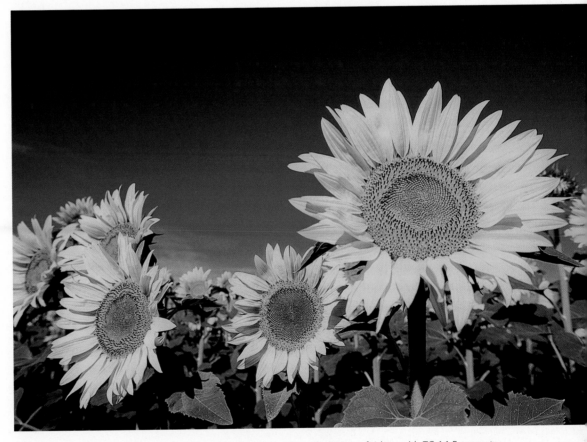

Opposite top: Elephant's eye, Kenya, Serengeti Plain, Africa. *Nikon F5, 500mm f 4 lens with TC-14 E converter, polarizer, Velvia.*

Opposite middle: Field of wheat, Provence, France. *Nikon F100, 70–300 f 4.5–5.6 ED lens, polaizer, Velvia.*

Opposite bottom: The Totems in Monument Valley Tribal Park, Utah. *Nikon F5, 20–35 f 2.8 lens, polarizer, Velvia.*

Above: Sunflowers against lovely blue sky in the South of France. *Nikon F100, 28–70 f 2.8 AFD lens, polarizer, Velvia.*

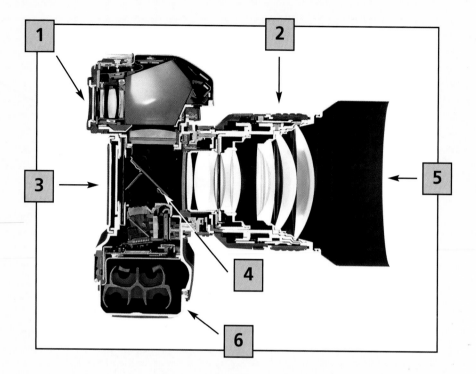

1. Eyepiece
2. Lens focuses light on film or CCD
3. Shutter and film or CCD
4. Mirror
5. Light source
6. Power source

Of course, the science behind this process is a little more complicated, but from the perspective of becoming a good photographer, these are the most important things to understand. To find out more about how the camera works (both film-based and digital), let's look at the three major creative controls that all advanced cameras have: the aperture openings or f-stops, the shutter speeds, and the focusing control.

APERTURE

The aperture is one of two controls (along with shutter speed) that determines exposure, which is the amount of light that reaches the film. The aperture refers to the concentric circle—well, almost a circle—in the lens that can be made larger or smaller. When you open up (make the aperture larger), more light can get to the film. When you close down (make a smaller opening), less light gets to the film.

Here's an analogy: Imagine that you have a large metal bucket sitting on a stool and it is completely full of water. If you were to punch a small hole with a screwdriver into the lower side of the bucket, what would happen? Water would come out! How much water would come out? A stream the size of the hole would form. And how long would it take for the bucket to become completely empty? Probably several minutes if the stream is very small. Take the same bucket and punch a hole in the side with the point of a pick. Let's assume for the sake of our experiment that the hole now is about the same size as your fist. What will happen? Obviously the larger hole would allow much more water to escape and it would not take as long for the bucket to become completely empty.

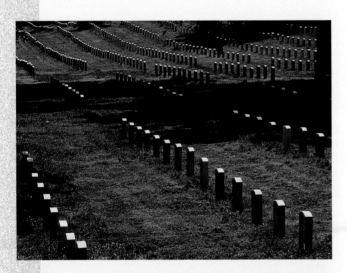

This is the principle behind the aperture. The larger the opening the more light gets in; the smaller the opening, less.

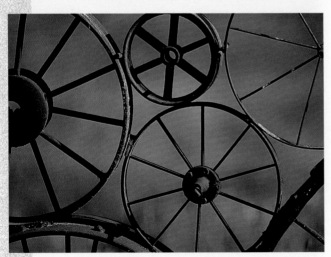

Top: Great depth-of-field shows the rows of headstones well into the distance in Arlington National Cemetery, Virginia. *Nikon F4, 80–200 f 2.8 lens, polarizer, Velvia.*

Bottom: A fence made of welded implement wheels in the Palouse Region of Washington State. Shot wide-open (f 4) on a 300mm lens to give very shallow depth-of-field to throw the background fields completely out of focus. *Nikon F5, 300 f 4 lens, Velvia.*

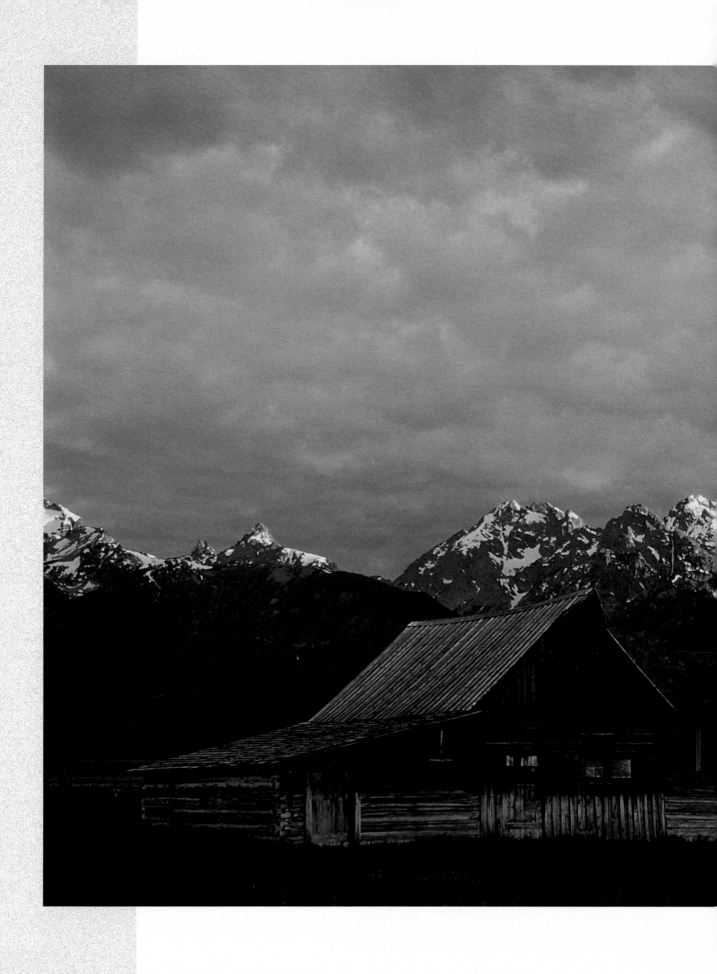

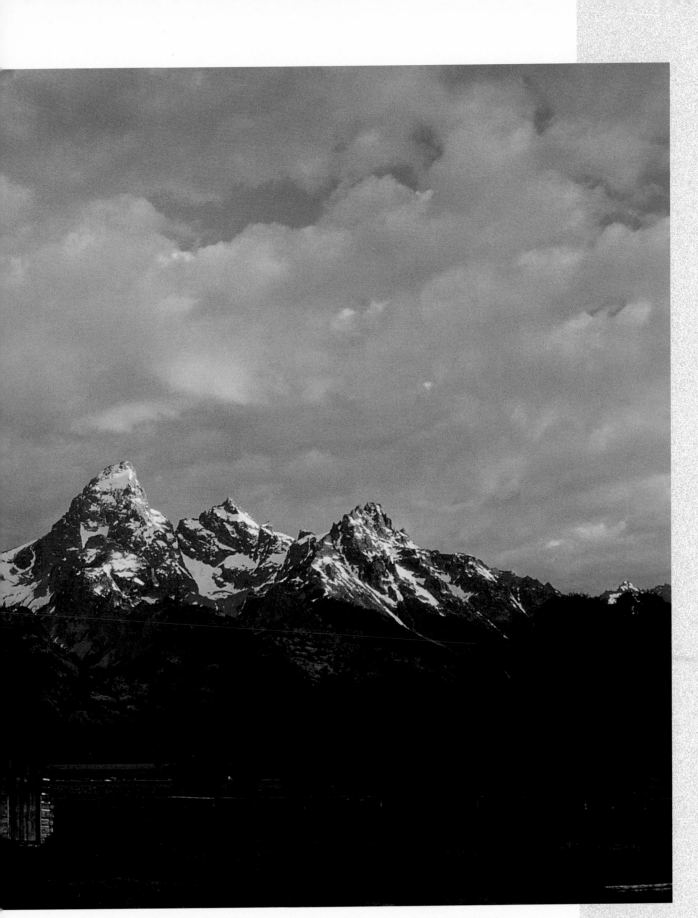

Barn off Antelope Flats Road in first light, Grand Teton National Park, Wyoming. *Nikon F100, 28–70 f 2.8 lens, polarizer, A2 warming filter, Velvia.*

Besides being a factor in determining exposure, the size of the aperture also determines depth-of-field, which is the amount of area in a photograph that is sharply detailed, or in focus. For instance, if you have a scene with flowers right in front of the camera and snow-capped mountains miles away and you want both to be sharp and clearly defined, you want what we call great depth-of-field, or extended depth-of-field. You would close the lens to a small opening to get everything in focus. By contrast, if you want to just show the flowers sharply and you want the mountains in the background to be an out-of-focus blur, you would open the lens to a larger aperture setting, focus on the flowers, and the depth-of-field would now be shallow or limited.

The size of an aperture opening is measured by a numbering system: 1.4, 2, 2.8, 4, 5.6, 8, 11, 16, 22, 32. These numbers are actually the bottom half of a fraction, so 1.4 is actually 1/1.4. This fraction tells you how much of the aperture is open. You can see that 1/1.4 is actually a much bigger number than 1/32. So, the smaller the number you see, the bigger the opening.

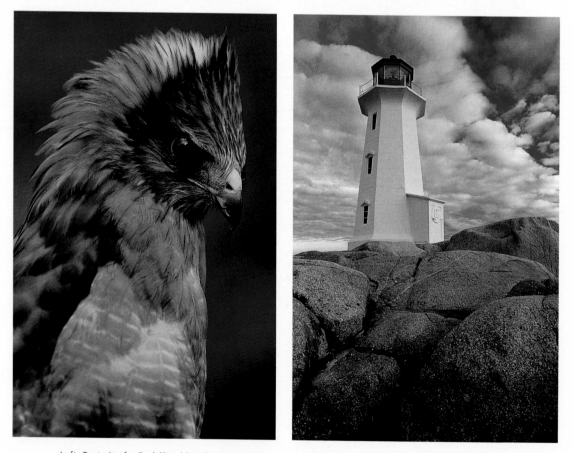

Left: Portrait of a Red Shouldered Hawk residing in a rehabilitation center. Shot at f 5.6 to produce very shallow depth-of-field, throwing the background completely out of focus. *Nikon F5, 400mm f 3.5 lens, Velvia.*

Right: Lighthouse at Peggy's Cove, Nova Scotia, Canada. Shot at f 22 to give extended depth-of-field from the rocks in the foreground to the clouds at infinity. *Nikon F100, 28–70 f 2.8 lens, polarizer, Velvia.*

From our flower example above, you know that 1.4, 2, 2.8, and 4 are the larger openings and will give you shallow depth-of-field. Likewise, 11, 16, 22, and 32 are smaller opening settings and thus will give you extended depth-of-field. The numbers in the middle—5.6 and 8—are, well, in the middle, and will give you moderate depth-of-field.

Because these aperture openings are called f-stops, you will hear the numbers referred to as f 2.8 or f 8 or f 16. An important thing to remember is that the f-stops have a doubling and halving relationship to one another. If you change the f-stop from f 2.8 to f 4 (we call that stopping down or getting a smaller opening), you actually cut by half the amount of light that reaches the film. If you stop down from f 4 to f 5.6 you would cut the light in half again, and give your shot even less light and more depth-of-field. The opposite is true when you open up from say f 8 to f 5.6. Now you have doubled the amount of light reaching the film, providing less depth-of-field for the image.

A great tip is to memorize the f-stops so that you can repeat them in order, forward and backward. This will really help you while working out those photographic math problems we so often need to do on the spur of the moment in the field!

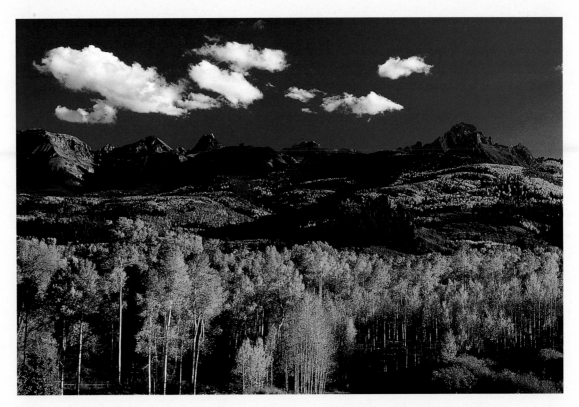

Sneffels Range, San Juan Mountains, Colorado. Sadly this image can no longer be made without special permission. The location from which this shot was made is now on private property; it was formerly a county road. The lens was set at f 22 to get maximum depth-of-field. *Nikon F5, 35–70 f 2.8 lens, polarizer, A2 warming filter, Velvia.*

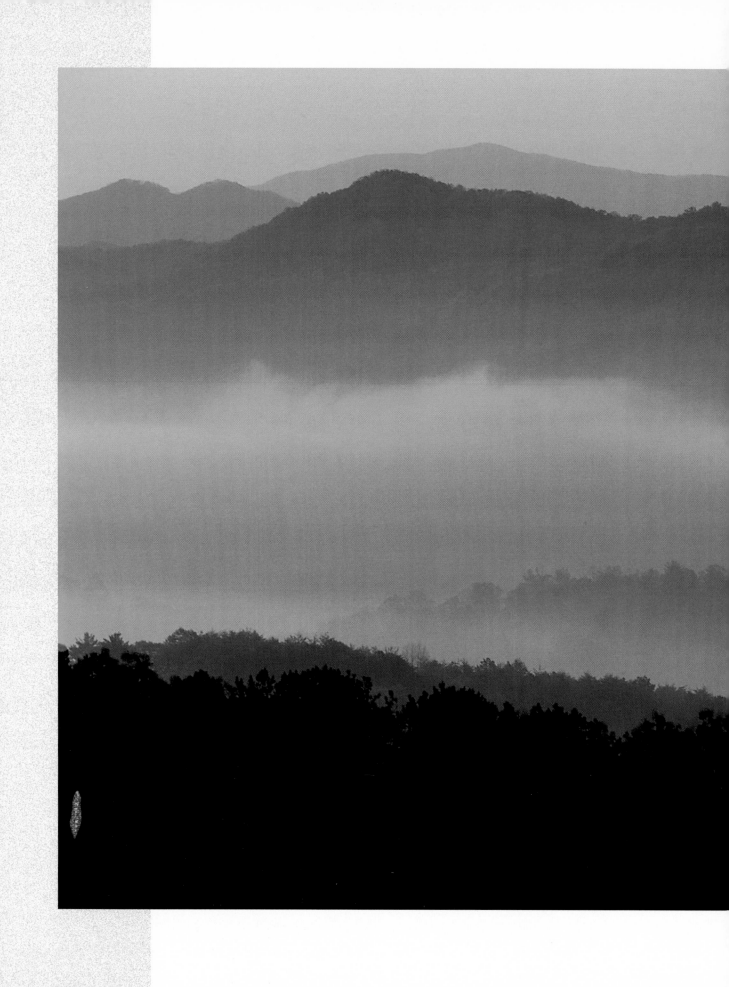

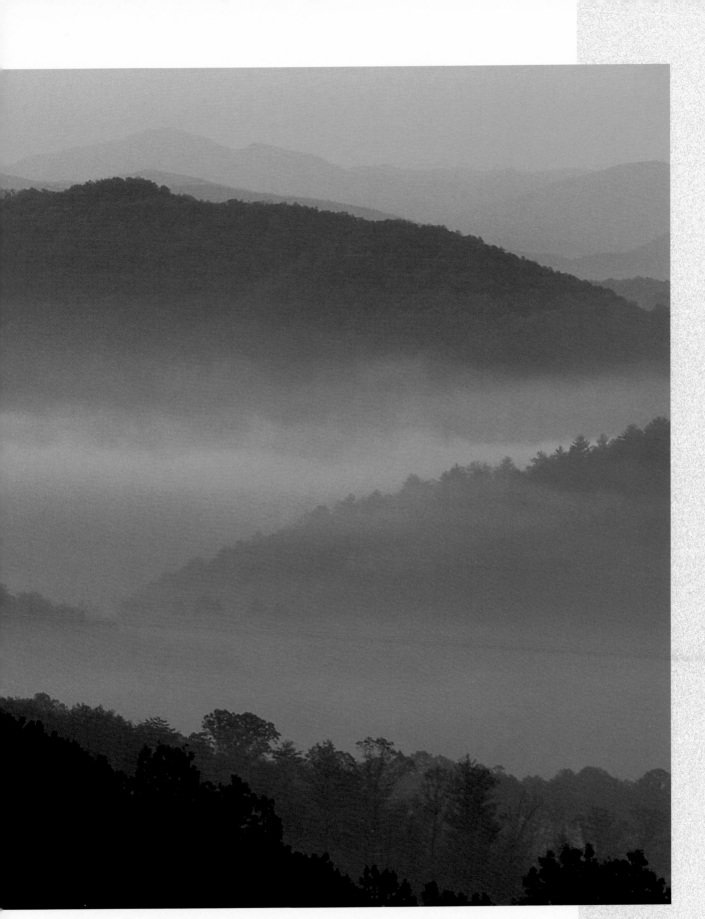

Great Smoky Mountain National Park from the Foothills Parkway. *Nikon F5, 300mm f 4 lens, A2 warming filter, Velvia.*

SHUTTER SPEED

The other control that determines exposure (besides aperture) is the shutter speed. The shutter on your camera is very much like a door opening and closing. The length of time it stays open is the second factor in determining how much light gets to the film.

For example, imagine that it is snowing very hard outside your home. If you open the front door and snow starts blowing in, how much snow will pile up in the hallway? Right! It depends on how long you leave the door open. If you leave it open for hours the house will become cold and lots of snow will collect on the floor. If you shut the door immediately, very little snow will get in.

The shutter in a camera works the same way, with light. And since light travels at 186,000 miles per second it doesn't take long for light to get to the film.

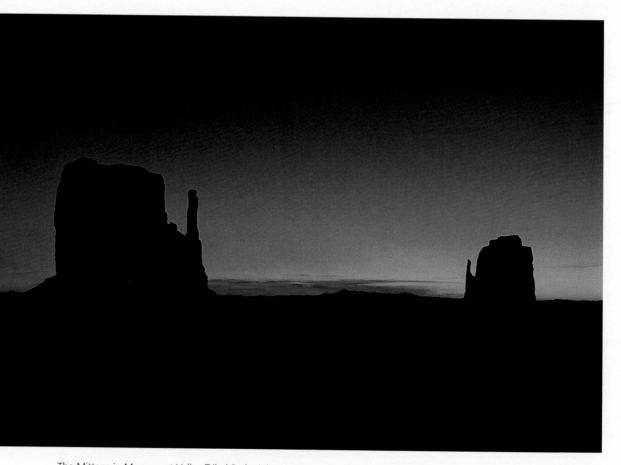

The Mittens in Monument Valley Tribal Park, Arizona, pre-sunrise. Since nothing in the scene was moving I opted for a small aperture (f 22) to get the most depth-of-field. *Nikon F5, 28–70 f 2.8 lens, Velvia.*

Just as the aperture had two functions, the shutter does as well. Besides determining exposure, the shutter also determines the rendition of motion, or how much "blur" you get if the subject is moving. Remember the opening- and closing-door example? Well, the shutter in a camera usually has settings for it to be open from around 30 seconds to just 1/8000 of a second. Different cameras may have a slightly different range of speeds, and you can actually hold the shutter open for hours. But the usual shutter settings are measured in seconds: 30, 15, 8, 4, 2, 1, 1/2, 1/4, 1/8, 1/15, 1/30, 1/60, 1/125, 1/250, 1/500, 1/1000, and so on.

Here's a good example to help you see what the numbers mean: If you make a photograph of a child running at a shutter speed of 1 second you will get a blur of the child on film. If you photograph the same running child with a shutter speed of 1/250 second you will "freeze" the action, and the child will seem to be suspended in time.

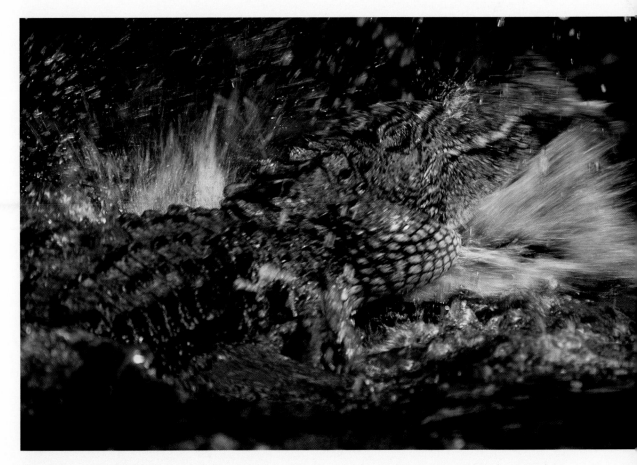

Even with a shutter speed of 1/125 second the explosive speed of the alligator attacking its prey could not be stopped!
Nikon F5, 300mm f 4 lens, Kodak Ektachrome SW.

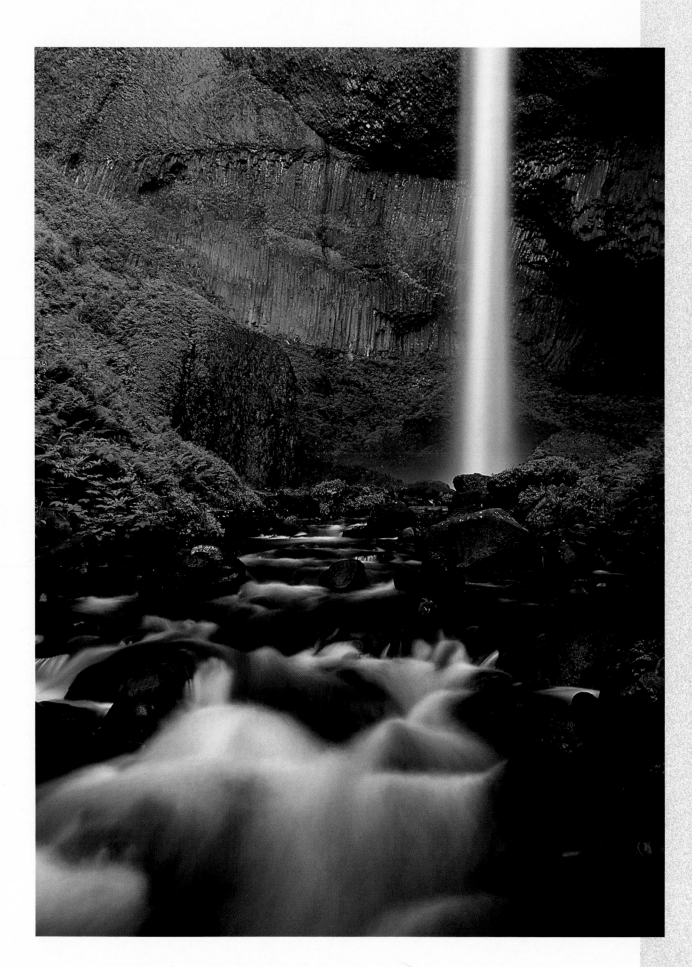

Both slow and longer shutter speeds are very useful. For example, I like to photograph waterfalls and streams, and I love the silky smooth patterns of the water when the shutter is left open for several seconds. In sports you may want to pan (follow the subject with the camera) using a slow speed to give the illusion of motion. Or you may want to stop the action for a different impact. This is an artistic decision of the photographer.

Now for more pesky math. Actually, it's easy to remember because shutter speeds have a doubling and halving relationship, just like the aperture. The same terms apply as well. Going from 1/125 second to 1/250 second, for instance, is stopping down one stop (or step) and you have closed the shutter more quickly—reducing the amount of light that reaches the film. By opening up, perhaps from 1/60 second to 1/30 second you have held the shutter open longer, doubling the amount of light reaching the film.

Since the shutter speeds and aperture settings (f-stops) both have a doubling and halving relationship they can be used together in a variety of settings that still yield the same exposure (the amount of light that reaches the film).

For example, 1/125 second at f 16 gives the same amount of light to the film as 1/2000 at f 4. While both are equal in exposure they will yield very different images.

The photo shot at 1/2000 at f 4 will have shallow depth-of-field and great motion-stopping power, while the shot made at 1/125 at f 16 will have less motion-stopping power, but much greater depth-of-field.

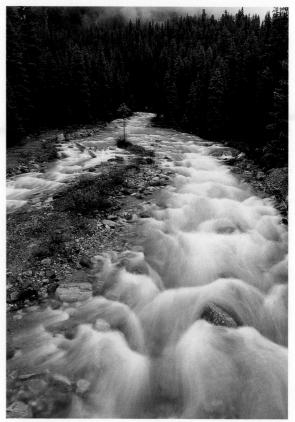

Opposite: One of the many beautiful waterfalls in the Columbia River Gorge near Portland, Oregon. Shot at a speed of 8 seconds to blur the water. The f-stop was set at f 22 for maximum depth-of-field and a polarizer was used to reduce reflections in the water and on the rocks. *Nikon F5, 20–35 f 2.8 lens, polarizer, A2 warming filter, Velvia.*

Right: Mosquito Creek, Banff National Park, Alberta, Canada. Shot at a speed of 4 seconds to blur the water. The f-stop was set at f 22 for maximum depth-of-field and a polarizer was used to reduce reflection. This image was shot from a bridge, looking down for a unique perspective. *Nikon F5, 17–35 f 2.8 lens, polarizer, A2 warming filter, Velvia.*

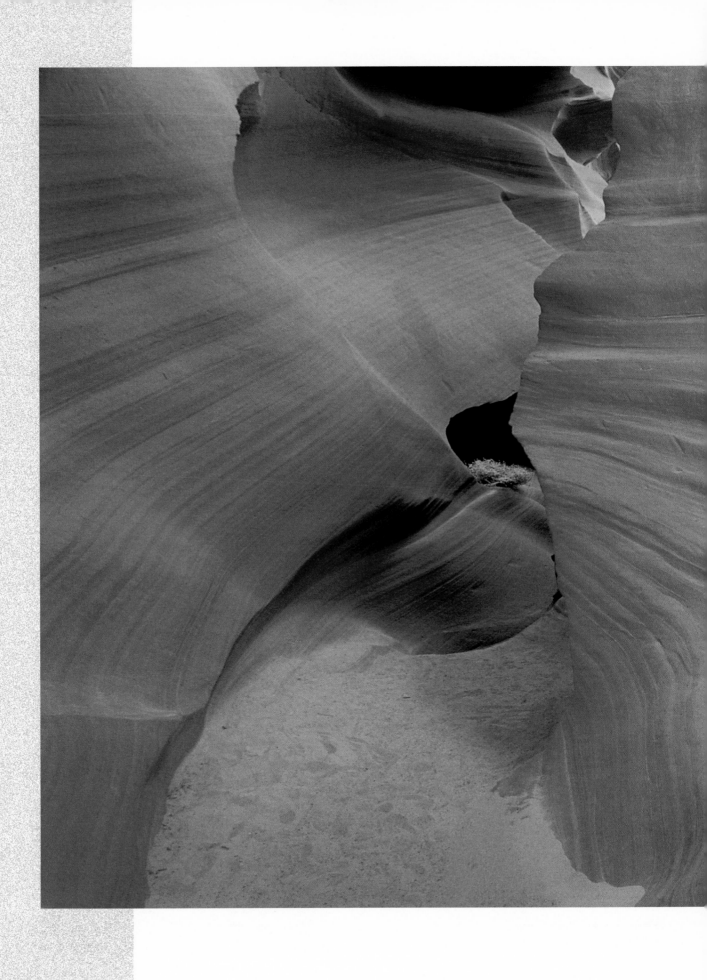

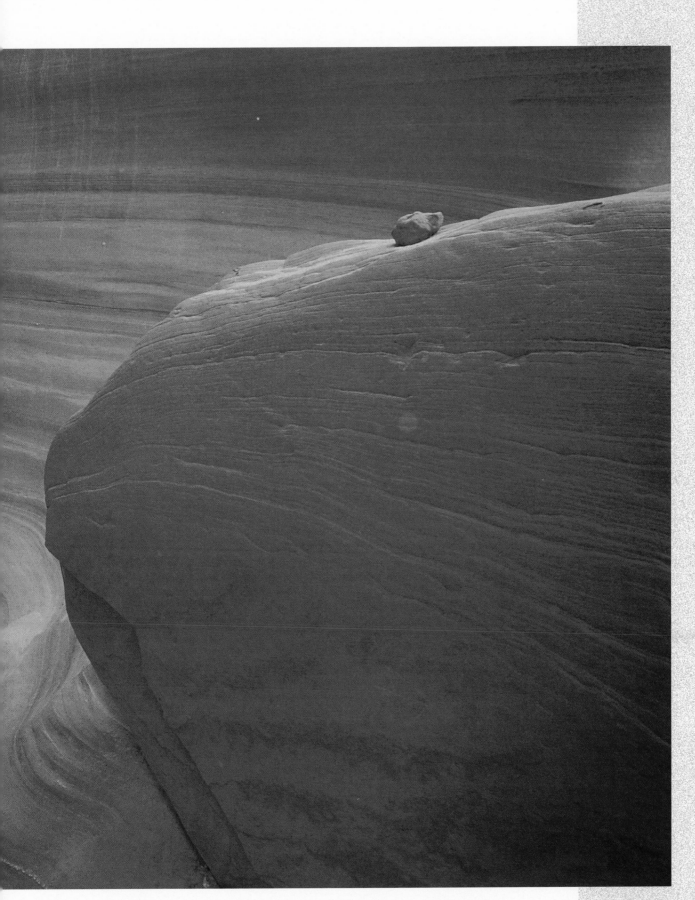

Rock formations cut by millions of years of wind and water in Lower Antelope Canyon, near Page, Arizona. Shot at f 22 for 45 seconds for maximum depth-of-field. *Nikon F100, 17–35 f 2.8 lens, Velvia.*

FOCUSING CONTROL

Today we have wonderful auto-focus cameras that can keep even fast-moving subjects in perfect focus. The important thing to remember about focusing is that what you focus on will become the subject, whether you intended for that to be the subject or not. In other words whatever is sharp in the photograph will become the subject, so focus carefully! Even though auto-focus cameras are very handy and operate much faster than we can, there will still be times that you want to focus manually.

The easiest way to manually focus the lens is to throw the subject well out of focus and then slowly adjust the focus until the subject is very sharp. Most photographers will most often focus just past that spot, then bring it back to the sharpest point, and then stop. If you continue focusing back-and-forth too many times, however, the eye is thrown into "optical accommodation." It gets tired and starts sending a message to the brain that says "That's O.K., that's fine, stop already!" So the best habit is to throw it completely out, then focus until the subject is sharp or just past, and go back and stop. It won't get any sharper, and your eyes will thank you!

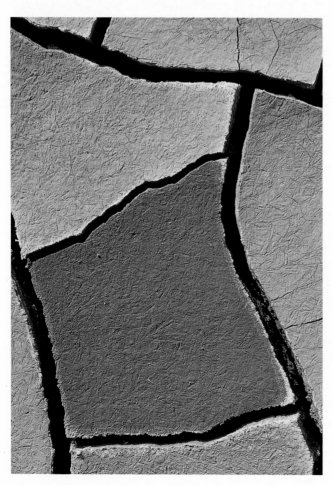

Left: Cracked mud on the floor of a river bed in Paria Wilderness Area in Utah. Shot with a micro lens pointed straight down, keeping the film plane parallel to the ground. Shot at f 22 for maximum depth-of-field and sharpness. *Nikon F100, 200mm micro f 4 lens, polarizer, A2 warming filter, Velvia.*

Opposite: African Lion, scars and all! Shot in Kenya on the Serengeti Plain. Shot near wide-open (f 5.6) to get shallow depth-of-field to emphasize the lion. *Nikon F5, 500mm f 4 AFI lens with TC14-E converter, Kodak Ektachrome SW (pushed one stop).*

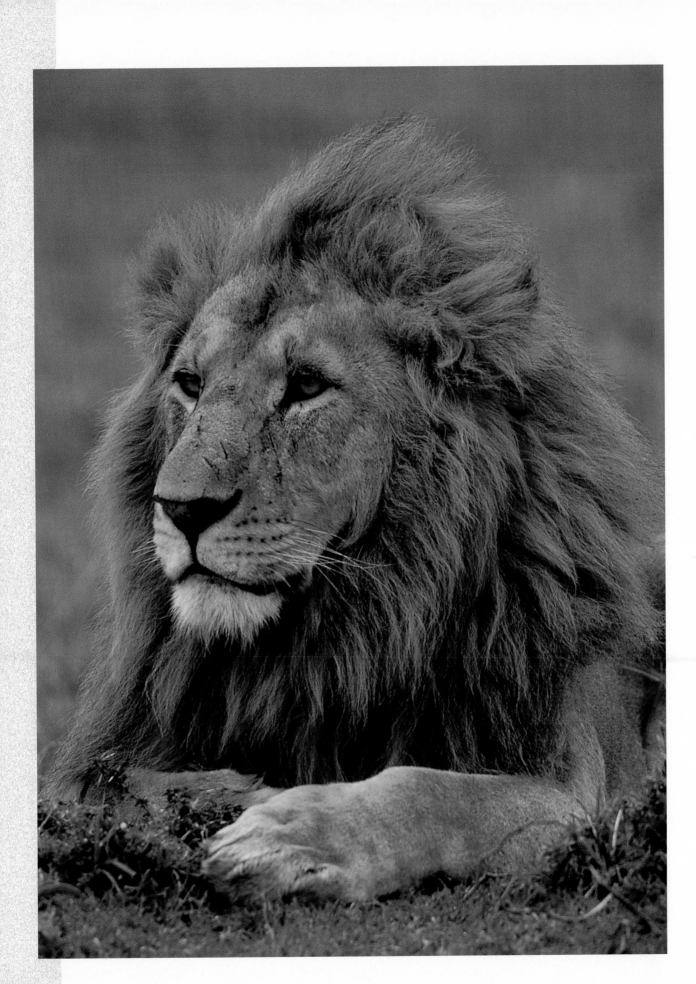

THE RELATIONSHIP BETWEEN SHUTTER AND APERTURE

Now you know that the shutter (by virtue of how long it is open) and the aperture (based on how wide it is opened) determine how much light gets to the film. You're also clear that both the shutter speeds and f-stops (aperture openings) have a doubling and halving relationship.

When you get a suggested exposure setting from your light meter, you can use this doubling and halving relationship to make changes to the f-stop for altered depth-of-field or the shutter speed for different motion rendition and still keep the same exposure. (Chapter 6 discusses light meters and exposure in detail.)

The key is to decide whether depth-of-field or motion rendition is most important, then make changes to the settings to get what you want.

Here's an example: Pretend that you have found a beautiful stream with great spring flowers with a backdrop of dramatic mountains. Your camera meter has suggested an exposure of 1/250 at f 5.6. You decide that you really want the maximum amount of depth-of-field and your lens (a 20–35 zoom) stops down to f 22. If you stop the lens down to f 22, how many f-stops are you changing the aperture?

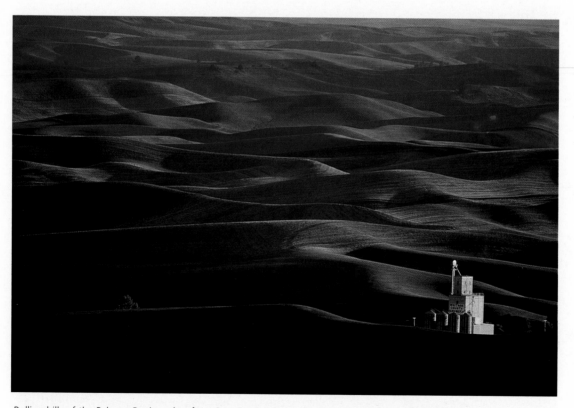

Rolling hills of the Palouse Region, shot from Step Toe Butte, near Colfax, Washington. The lens was stopped down to f 16 to get maximum depth-of-field. *Nikon F5, 400 mm f 3.5 lens, polarizer, Velvia.*

Let's count: from 5.6 to 8 is one, from 8 to 11 is two, from 11 to 16 is three and from 16 to 22 is four. You have stopped down the aperture by four stops.

To gain back the light that was lost from stopping the aperture down you must now adjust the shutter speed by the same number of stops. Since we know you reduced the amount of light by four stops by stopping the aperture down from 5.6 to 22 you now need to increase the amount of light by four stops (think steps) of the shutter control.

So, if the starting point was 1/250, here we go: 1/250 to 1/125 is one, 1/125 to 1/60 is two, 1/60 to 1/30 is three and 1/30 to 1/15 is four. The new settings are 1/15 second at f 22.

If the wind is not blowing to move the flowers, you've got it made. If the wind is blowing, you may want to adjust your settings to stop any blur. By increasing the shutter to a faster speed you can stop the motion of the flowers. Generally speeds of 1/125 second and faster are needed to stop movement.

It is important that you become very familiar with these kinds of calculations—not that you will have to do them often but, when you need to, you really must to be able to work them out quickly.

This is a fundamentally important chapter of your course. If you need to, go back and read this text a time or two again until you feel it is really starting to sink in. The understanding of the aperture and shutter speed is key to doing creative work with your camera.

SELF-ASSIGNMENTS

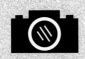

1. Memorize the list of f-stops and shutter speeds and practice going up and down through the scale. This will really help you to get a grasp of their relationship when you need to apply the math in the field.

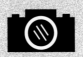

2. Solve these scenarios as quickly as you can: If your meter suggests a setting of 1/60 at f 8, what would be the shutter speed setting at f 4? If your meter suggests a setting of 1/1000 at f 2.8, what would be the aperture setting at 1/60?

3. Make up some of your own photographic situation puzzles and practice working out the details.

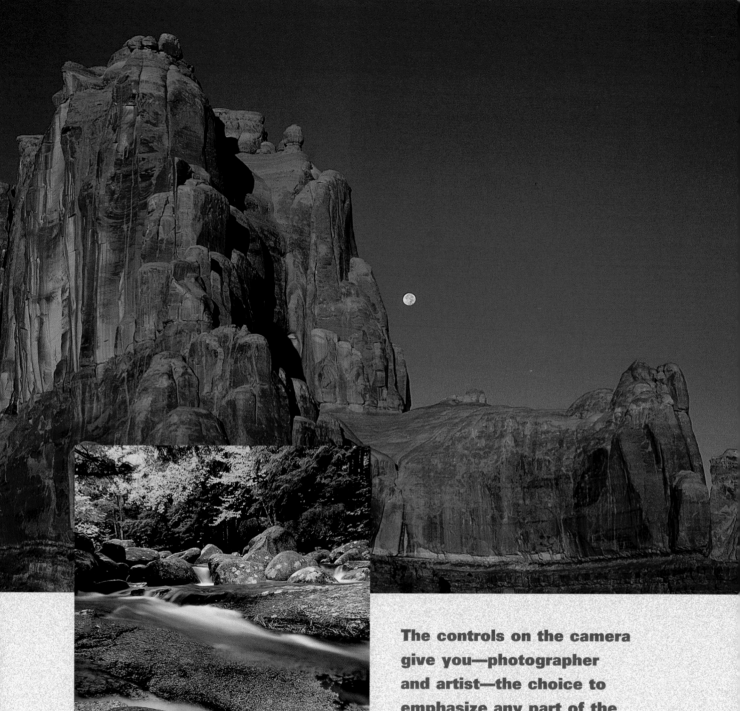

The controls on the camera
give you—photographer
and artist—the choice to
emphasize any part of the
final image you would like.

Using the Creative Controls to be "Creative"

CHAPTER 5

NOW THAT YOU UNDERSTAND how the aperture, shutter, and focusing controls work, it is time to put them together to give you the photographs you really want to make. As a photographer you decide everything: how to make the photograph, what the subject is, what kind of mood you want to set, what statement you intend to make, and so on. You can use the camera's three controls to create the image you want. This chapter explores some actual photographic situations and how to use the major controls to get the desired result in each situation.

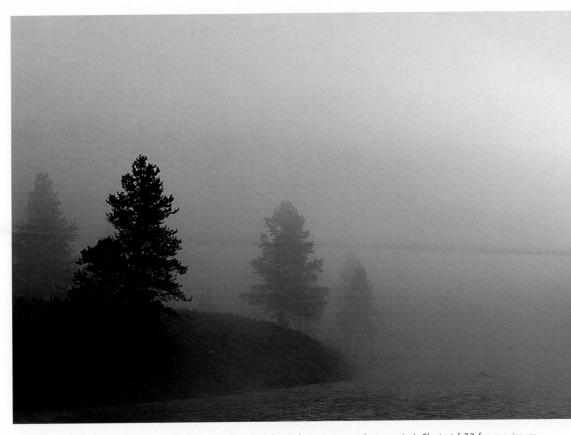

Opposite top: Red Rock formations in Arches National Park, Utah, at moonset (pre-sunrise). Shot at f 22 for maximum depth-of-field. *Nikon F100, 80–200 f 2.8 lens, polarizer, A2 warming filter, Velvia.*

Opposite bottom: Emma's Creek in Vermont. Fall leaves and clear water—what could be better? Shot at a small aperture (f 22) to ensure maximum depth-of-field. *Nikon F100, 17–35 f 2.8 lens, polarizer, A2 warming filter, Velvia.*

Above: Fog and mist on the Madison River in Yellowstone National Park, Wyoming. Shot at f 16 for lots of depth-of-field. *Nikon F100, 80–200 f 2.8 lens, Velvia.*

Remember that running child you wanted to capture on film in the previous chapter—either freezing the action or letting the subject be blurred? Well, sometimes the action is really fast, such as during a sporting event. And chances are, you will want to freeze the action.

In this situation, a very fast shutter speed will be needed. Your camera meter may suggest a setting combination of 1/500 at f 5.6. That should work perfectly. The added challenge in this scenario will be to keep up with the motion so you can capture the action at the decisive moment.

For another example, let's pretend that you are in Grand Teton National Park in late June—a great time to be there, by the way! You discover that the trademark beautiful, bright-yellow flowers, Balsam Root, are in full bloom and the Tetons are still topped with enchanting snowcaps. You want to make an image in which the flowers are only inches from the front of your lens and yet the looming Tetons in the backdrop are sharp and clear. How do you get the shot?

First, take your camera in hand and look at the scene from various heights and angles compared to the flowers. When you see through the lens what you know you want the final image to look like, then set up your tripod to place the camera at that exact spot.

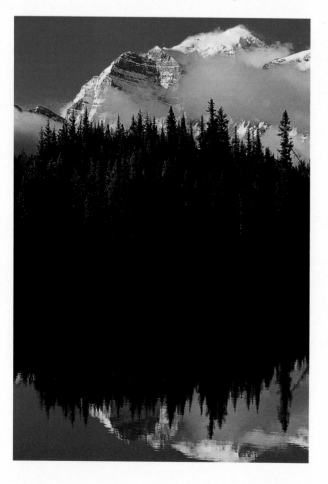

Once you have the framing the way you want it to appear in the image, you will need to decide how much depth-of-field you want. Since you want extended depth-of-field, stop your lens down to the smallest aperture setting your camera offers, perhaps f 32.

Next, you can pick a shutter speed that gives you the correct exposure reading (Chapter 6 discusses exposure in detail). Let's pretend that the camera

Tight landscape portrait of Herbert Lake in Banff National Park, Alberta, Canada. *Nikon F5, 80–200 f 2.8 lens, polarizer, Velvia.*

says you have to shoot at 1/2 second in order to use f 32. As long as the flowers are not moving, usually from the wind, you can make the shot! If the wind is moving the flowers, you can either be very patient and wait for a lull in the wind to shoot, or adjust to freeze the action—or not make the picture.

Of course, there are many different filters that could be used to enhance the overall scene, giving it a completely different look and "feel" (Chapter 9 discusses equipment, such as filters, in detail).

Here's a different scenario: You've found a beautiful Pink Ladyslipper flower on the forest floor in Great Smoky Mountains National Park. You have always wanted to do a photographic portrait of this flower. The light is perfect and the flower is in prime condition. What do you do?

As before, take your camera, probably with a 105mm or 200mm micro lens attached (Chapter 9 discusses equipment, such as lenses, in detail). Stretch out on the ground to see what angle and position you prefer for the shot. Once you have determined the spot for the camera, set up the tripod in that position.

This time you want just the flower to be sharp and in focus. You want the background to be soft and blurred, out of focus. So, open the lens to, say,

f 5.6 and focus on the center of the flower. With the depth-of-field preview button depressed, slowly stop down until the flower is sharp but the background is still blurred. (Not all cameras have a depth-of-field preview button, but it is an important feature to have on your next camera!) Next, determine the correct exposure. We will once again pretend the camera setting turns out to be 1/125 at f 8. If the flower is still you should be able to make the great shot you really wanted. And if it isn't, you know how to compensate!

Flower portrait of Bluets in Cumberland Falls State Park, Kentucky (fifteen miles from my home). Shot near wide-open (f 4) to make everything very soft, except one tiny edge of the flower's petals. *Nikon F3, 105 micro f 2.8 micro lens, Kodak Ektachrome 64.*

Starting to get the idea? In most photographs the first issue to be solved is how much depth-of-field you need to get the shot you want.

The controls on the camera give you—photographer and artist—the choice to emphasize any part of the final image you would like. By using the creative controls (and some other equipment) to your advantage, you can produce images that say exactly what you want them to say.

On the following pages are some photographic illustrations of the use of these principles. Each is accompanied by full details of what controls were used and what effect they produced.

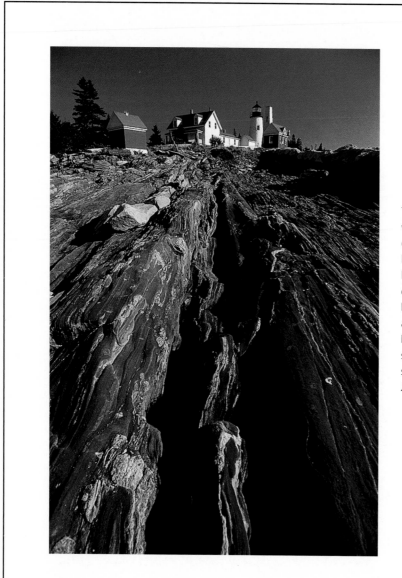

This is a classic case of the decision to work with a small aperture to get maximum depth-of-field. In this photograph I literally lay on the ground with my tripod set very low to shoot the lighthouse with the eroded rock in the foreground leading your eye back to the buildings. Shot with a wide-angle zoom set to f 22 for the most possible depth-of-field. Shutter speed was very slow, but nothing was moving so action stopping ability was not needed. *Nikon F5, 20–35 f 2.8 lens, polarizer, Velvia.*

To obtain very shallow depth-of-field and make the pine stand out from the background I chose a very wide setting of f 4 on my 200mm lens. The combination of shallow depth-of-field and back lighting really makes the pine needles glow! *Nikon F5, 80–200 f 2.8 lens, polarizer, A2 warming filter, Velvia.*

While traveling in Mexico on Contoy Island, I saw a man in a red shirt starting to walk back from our boat to the shore. The color combinations were just two much to pass up! A polarizer really makes the colors pop and a fairly stopped down aperture (f 11) gave enough depth-of-field to make everything sharp. *Nikon FM2, 24mm lens, polarizer, Velvia.*

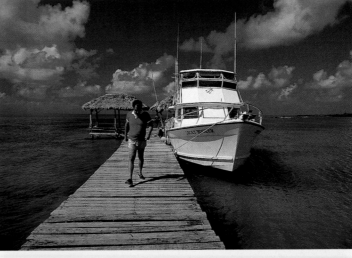

Nothing is much more spectacular than the back-lit Aspen leaves of Colorado in the fall. As in the pine tree shot at the top, I used f 4 to get shallow depth-of-field. Once again the combination of backlighting (always great with Aspen leaves) and shallow depth-of-field creates an image with a real sense of three dimensions. *Nikon F5, 300 mm f 4 lens, Velvia.*

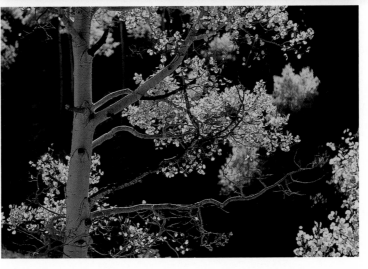

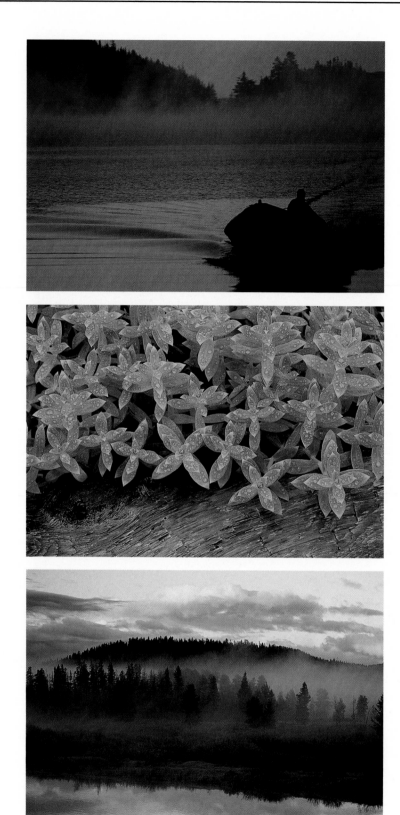

A single boat returning to the dock at sunrise provides a silhouette for the beautiful morning light in Nova Scotia, Canada. Shot with an 80–200 zoom, the lens allowed me to continuously re-zoom to make several compositions as the boat drew closer. Shot with a medium aperture (f 8) for some extended depth-of-field. *Nikon F100, 80–200 f 2.8 lens, Velvia.*

Rich green leaves with dewdrops and a weathered piece of driftwood made for a nice quiet composition in Kenai Fjords, Alaska. Shot at a maximum aperture of f 22 to extend the depth-of-field. *Nikon F100, 105mm micro f 2.8 lens, polarizer, Velvia.*

Early-morning light and fog along the Snake River in Grand Teton National Park, Wyoming. By stopping down to f 11 I was able to get good depth-of-field in a scene where the closest thing to my lens was probably a couple hundred yards away. This allowed a slightly faster shutter speed, preventing the blurring of the moving mist. *Nikon F5, 80–200 f 2.8 lens, Velvia.*

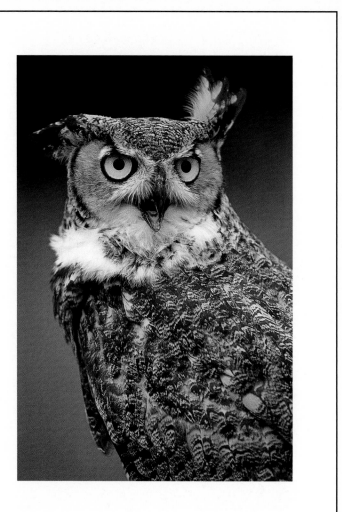

I wanted this to be a portrait of a Great Horned Owl, and nothing else; the background was not important. In order to throw the background completely out-of-focus I used a wide-open aperture of f 3.5. This also allowed a faster shutter speed to stop any movement of the owl. *Nikon F5, 400mm f 3.5 lens, Kodak Ektachrome 100SW.*

SELF-ASSIGNMENTS

 1. Go out in the field to make images in which you pan with a moving subject. The goal is to keep the object in focus while the background blurs.

 2. Make some images in which the main subject is totally isolated from the foreground and background. Remember to use wide apertures (try f 2.8 through f 4) to cause this shallow depth-of-field.

3. Go out on a self-assignment to shoot images in which the main subject and the foreground and background are all clearly in focus. Remember to use a stopped down aperture (try f 11 through f 32) to cause lots of depth-of-field.

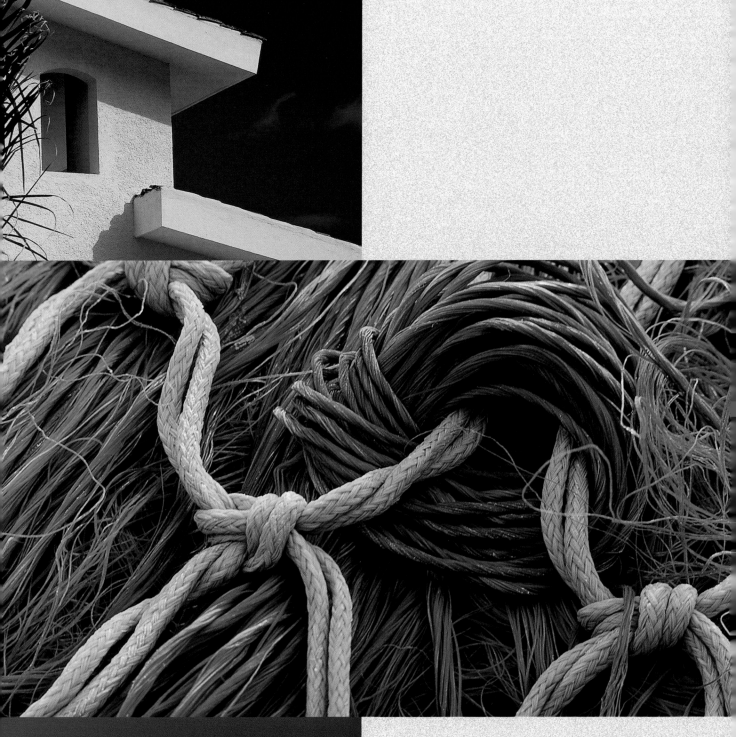

If you can get good exposures with slide film, you will not have any trouble with print film or digital imaging—all the same basic principles apply to each. So learn it once, know it forever!

Exposure — Exposed

CHAPTER

HERE'S A DREAM EXPERIENCE: You find yourself with the perfect subject in great light, with the right background and foreground and with the most wonderful conditions possible. In addition to all that good fortune you make a perfect composition and shoot with exact timing. Here's the nightmare: You *blow the exposure*, and all your efforts are wasted!

More than any other part of photography, exposure has caused countless sleepless nights among the serious photography community. Many photographers believe they just can't understand it; it seems too technical and mysterious. I've got good news: It isn't rocket science! Yes, you need to understand some basic principles, but once you do, it is something you can definitely master.

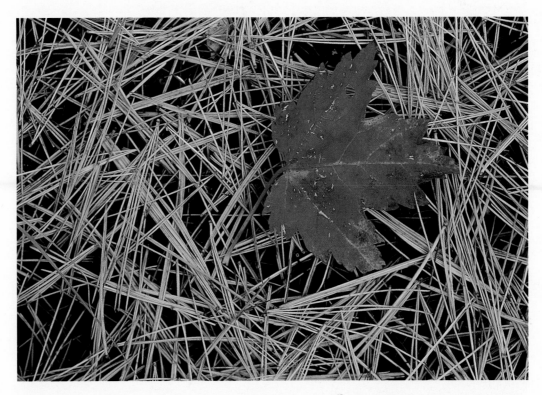

Opposite top: White stucco building and blue skies, Cancun, Mexico. *Nikon FM2, 50–135 f 3.5 lens, polarizer, Velvia.*

Opposite middle: Fisherman's nets, Oregon coast. *Nikon FM2, 105 Micro f 2.8 lens, polarizer, Velvia.*

Opposite bottom: First light on Olympic Mountains, Olympic National Park, Washington. *Nikon FM2, 300mm f 4 lens, polarizer, Velvia.*

Above: Single red maple leaf on pine needles, Acadia National Park, Maine. *Nikon FM2, 200mm micro f 4 lens, polarizer, Velvia.*

I blame the manufacturers of cameras for some of the confusion. From the time I first became a photographer in the late sixties every camera manufacturer was touting how their new SLR (single lens reflex) camera would help you get perfect exposure every time. Unfortunately, that was not quite the case. No camera in the sixties, seventies, or even the eighties could do that without some serious help from the photographer operating the camera. In the nineties new innovations began to change all that, so it wasn't so far from the truth.

THE GRAY CARD

To understand exposure you first need to know how the camera's meter works. In simple terms, here it is:

The exposure meter built into your camera is designed to be pointed at something average in brightness. What does that mean? Consider that all subjects are made up of a range of tones from the darkest, black, to the brightest, white. In any given scene the area that is halfway between the extremes (black and white) is called medium tone or middle tone. If an object you are photographing is not black and not white but somewhere in between, in fact, halfway in between, it is called medium tone.

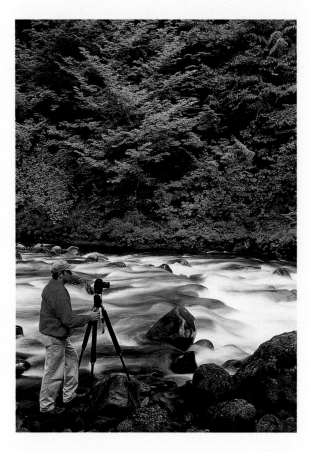

It has been determined that a gray card that reflects 18% of the light that strikes it is medium tone. Yes, I know you're thinking that if it is halfway between black and white it would reflect 50% of the light.

Left: The green leaves in this shot are nearly a perfect medium-tone subject. In fact, to expose for this shot of my son Wesley on the banks of the Sol Duc River in Olympic National Park, Washington, I metered the leaves and then placed them at medium. As it always will, everything else turned out correctly exposed! *Nikon F5, 28–70 f 2.8 lens, polarizer, A2 warming filter, Velvia.*

Opposite: Reflections of the forest and clouds in the Snake River from Schwabachers Landing in the Grand Teton National Park, Wyoming. My meter was set on Matrix and it nailed the exposure perfectly. *Nikon F100, 28–70 f 2.8 lens, polarizer, Velvia.*

But as it turns out, an 18% gray card is actually halfway between black and white. Don't worry, this is the last time you'll hear about that 18%. Forget it, it doesn't matter in our exposure system. (Well, it does matter, but it is not the key to understanding exposure.)

Since you are probably going to be shooting slide film, until you move over to digital, let's learn how to expose slide film properly. By the way, if you can get good exposures with slide film, you will not have any trouble with print film or digital imaging—all the same basic principles apply to each. So learn it once, know it forever! Slide film has a five f-stop range from black with detail to white with detail. Referring to the chart below, let's walk through this together.

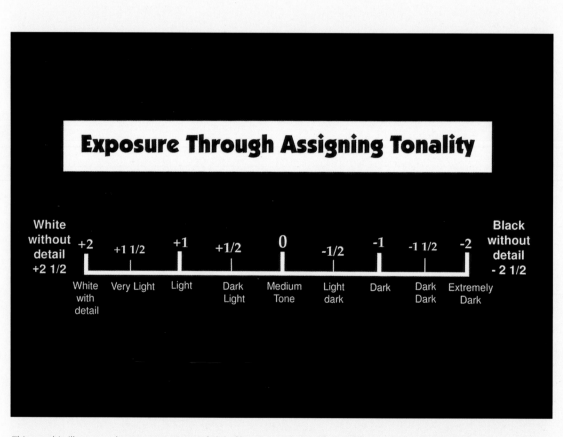

This graphic illustrates the exposure range of slide film. From white with detail (snow, for example) at +2, to black with detail (a Labrador retriever, for example) at –2. This scale covers the five-stop range of slide film. (By the way, digital operates very much the same and negative film actually has more range.) If you use your hand to replicate this scale you will always have a "handy" (sorry about that) reference in the field!

TONALITY

This linear scale has a central point called the "0" point, which represents middle or medium tone. On the extreme left is a point designated +2, and on the extreme right, a point designated –2. You will also notice another point halfway to the left extreme designated +1 and one more halfway to the right extreme labeled –1. Other smaller points exist on both sides of the scale with 1/2-stop designations.

Now what do they all mean!? First of all, your camera probably has a scale something like this one. If yours is not exactly like this, get out your camera's instruction manual to see what your scale looks like. It will give you much of this same information, perhaps under "Manual Exposure Settings." That is, in fact, what you are learning; how to set the camera in manual mode. Here is a brief explanation of the five-stop scale of tonality:

1. The "0" point is the meter's way of saying this is a medium-tone subject, object, or scene.

2. The +2 to the far left indicates White (with detail). For example, snow or a bright sandy beach.

3. The –2 to the far right indicates Black (with detail). For example, a black bear or Labrador retriever.

4. The point designated at +1 is one stop brighter than medium. Actually the palm of your hand is a +1 tonality object. We call +1 Bright; it's not white and it's not medium, it's bright.

5. The point designated at –1 is one stop darker than medium. We call this tone Dark (not black, not medium).

The other smaller points are divisions of brightness in increments of 1/2 f-stop each.

CENTER-WEIGHTED METER

This type of meter works like this: If you point your camera at a scene or object that is medium in tone and you turn your controls to adjust the aperture (f-stops) and shutter speeds until the "0" point is highlighted, you have set your camera for the correct exposure to make the scene or object you've just metered "medium tone." We call this zeroing the meter.

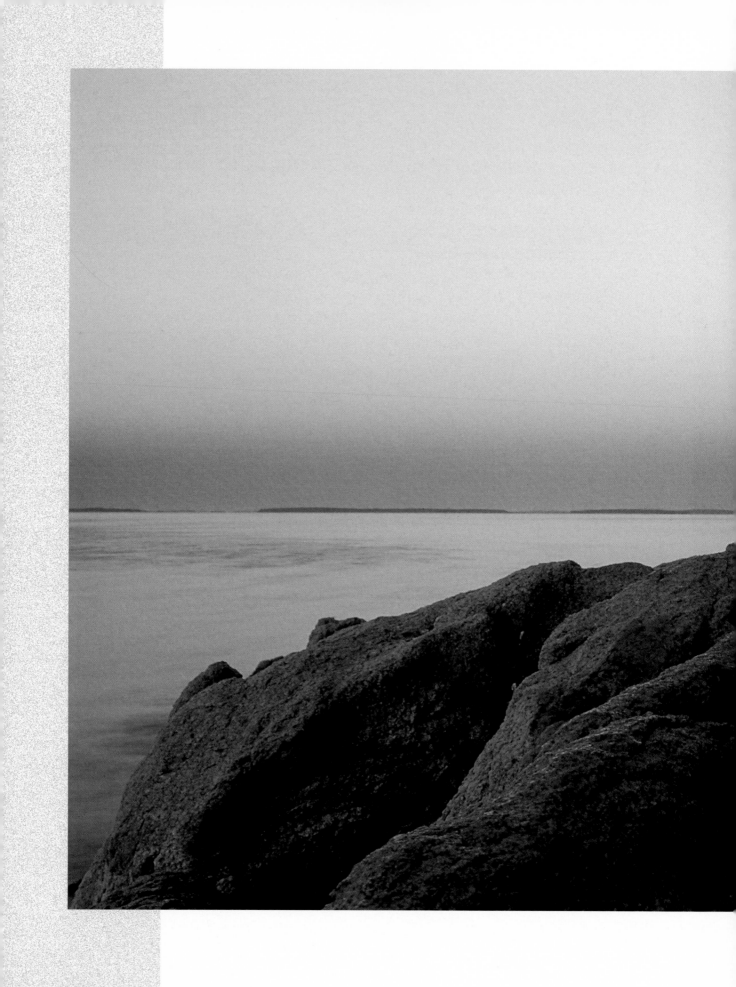

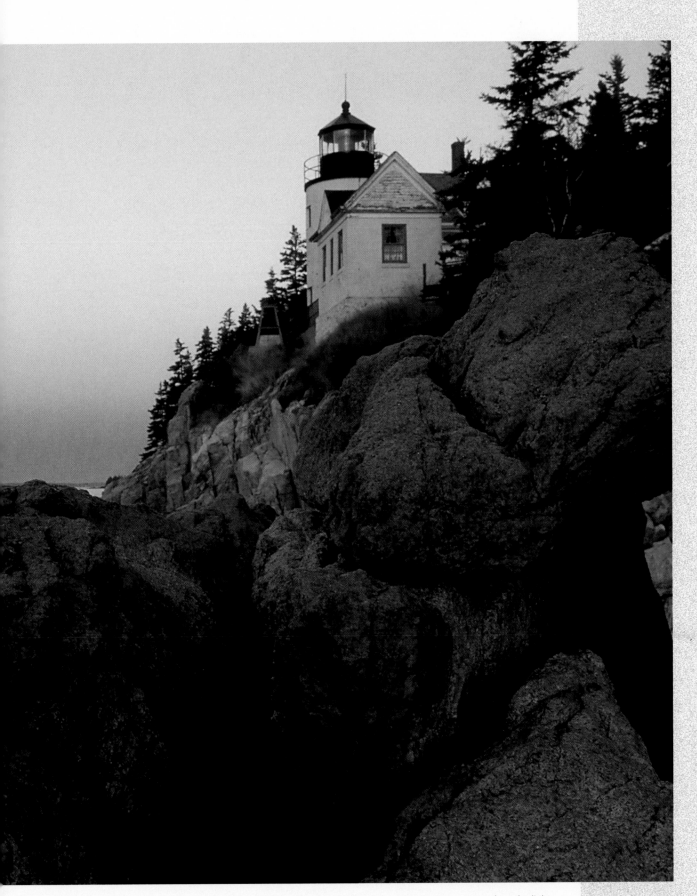

The Bass Harbor lighthouse in Acadia National Park, Maine. Photographed at dawn, the shot was metered on the light sky just above the horizon. The sky was placed at +1 with a spot meter. The important thing in sunrise and sunset shots is to not "blow out" the sky. By metering the sky and making it +1, I've preserved that delicate color that makes the shot work. *Nikon F100, 17–35 f 2.8 lens, polarizer, Velvia.*

If you take a meter reading, zero the meter, and then set the camera guided by your meter, you will make medium-toned subjects actually appear medium tone in the resulting photograph. Why aim for medium tone? If you consider most of the scenes you photograph, you will realize that they are overall medium in tonality.

In the early days of through-the-lens meters the meters were actually averaging meters. They "read" the entire viewfinder and averaged it all together. Because some scenes are slightly lighter or darker overall, this kind of meter was fooled by the scene fairly often. Eventually, the manufacturers realized that a meter that could read a smaller area was more effective, and so the center-weighted meter was developed. It was an averaging meter but it concentrated a much higher percentage of its " weight" in the center of the viewfinder.

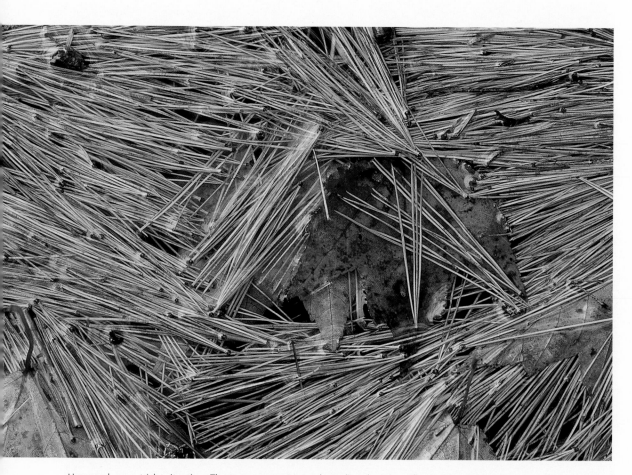

Here we have a tricky situation: The tones are pretty much medium but the reflection from the water is very bright. If I simply meter the scene I would get a misleading meter reading. In this case I took a reading off the palm of my hand, which I know to be a +1 tone, and set the meter for +1. And the shot worked! *Nikon F100, 200mm micro f4 lens, Velvia.*

SPOT METER

The center-weighted meters did a good job. Sometimes, however, the principle subject was much lighter or darker or was surrounded by a large area that was much lighter or darker, and even the center-weighted meter did not work very well. To fill the gap, the spot meter was developed. It takes a reading from a very small area in the viewfinder. The spot meter allows photographers to find the exact area they want to meter, and take a reading from that very limited portion of the frame.

Spot meters take more understanding and care to use than a center-weighted meter, but in the hands of an experienced photographer, they are valuable tools. For the manual readings I have just described, it is the best type for the job.

If you were looking for a medium-tone subject you couldn't find a scene much more medium than this one. Virtually everything here is medium tone. Simply meter and shoot. Any metering pattern will work with this scene. If you spot-read the scene, however, be careful not to get the dark areas between the boards in the meter pattern—they can fool the meter. *Nikon F100, 80–200 f 2.8 lens, polarizer, Velvia.*

MATRIX METER

In the nineties several companies introduced a brand new kind of meter. This very highly advanced meter used the computerized power of new cameras to calculate correct exposure based on a number of important factors. Putting it simply, this type of meter took readings from a number of areas in the frame for brightness, contrast, and color. Next, the meter compared these readings with its very large database of photographic situation information. Then, in a millisecond, the meter automatically set the correct exposure.

Nikon was first to develop such a system, called Matrix Metering. It was followed by Canon with Evaluative Metering, Minolta with Honeycomb Metering, and other manufacturers with their versions of the original matrix-type system. By the late nineties, these metering systems had been further refined and were extremely accurate.

I've experienced great results with this type of meter in my Nikon F5, Nikon D1x, D1H, D100 and F100. The system is nearly perfect. Note I said "nearly." It still can miss the mark in certain situations. For instance, if the overall scene is very light (somewhere between white and light) or very dark (somewhere between dark and black), this meter may overcompensate and give an incorrect exposure reading.

You will soon learn through experience when you can trust a matrix-type meter and when to switch back to a spot meter. For a long time, until I really began to trust the Matrix meter, I made spot readings and compared them to the matrix readings for almost every shot. I soon learned that the matrix got it right the vast majority of the time. When it didn't, I made a mental note of the situation when it failed to do the job. Soon I felt pretty comfortable knowing which meter to use in which situation.

You need to fully understand how to take manual exposure readings with your light meter—whether your camera has a spot meter in addition to its center-weighted meter, or not. Once you can make good use of your manual settings you can and should experiment with using a matrix type of metering system.

HAND-HELD METER

In the early days of nature photography, almost everyone had a hand-held meter, if for no other reason than as a back-up. Today, even though manufacturers make some really nice hand-held versions, most people have come to rely almost entirely on their through-the-lens camera meters. The meter built into your camera body has the advantage of reading through any filters and extension tubes or other devices that could change the reading. The hand-held meter doesn't know any of this and if you don't compensate for these things, you will have an incorrect meter reading. Since I can hardly remember anything, I've given up on trying to use hand-held meters in the field. (Hand-held meters are still often used by studio photographers for studio lighting problems.)

I strongly suggest you learn about the five-stop scale of tonality until you are very comfortable with the information and can apply it from memory. This is the key to making consistently great exposures. If you have a matrix-type meter, learn when to trust it, and enjoy the technology!

SELF-ASSIGNMENTS

1. Here is a great exercise to help you identify medium-tone areas: Go into the field and take a meter reading of your hand and set your camera at +1. The palm of your hand is one stop brighter than medium tone.

With your camera still set for your hand, point your center-weighted meter at subject matter you believe to be medium in tone. If you've guessed correctly, the meter should indicate medium tone. If you're off a bit, it will show how much by its indication. This kind of practice is a great way to get used to identifying medium-toned subjects.

2. If you have a camera with a matrix-type metering system, set it on matrix metering and take a reading of a potential subject. Then check the matrix meter by switching to the spot meter and taking a reading of the palm of your hand in the same light as the subject. If it gives the same reading, you know you can trust the computerized system.

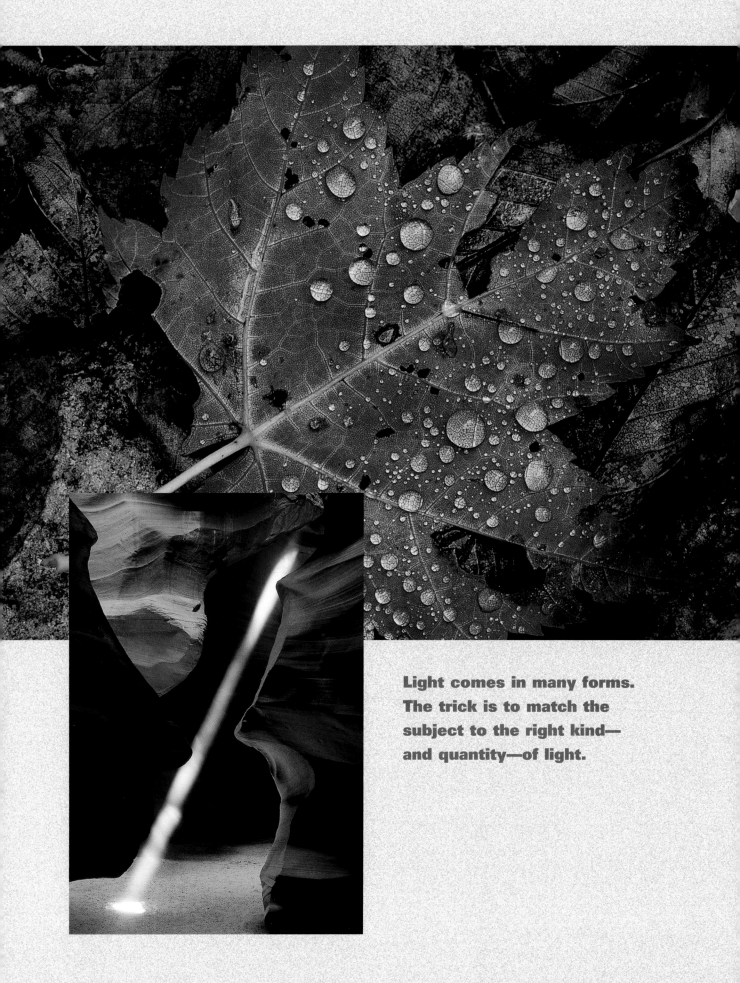

Light comes in many forms. The trick is to match the subject to the right kind— and quantity—of light.

The Importance of Light

7

ONE ELEMENT that we must have to make a photograph is light. In the total absence of light we couldn't make an exposure. It is an understanding of, and more important, a feeling for, light that enables some photographers to get more out of a simple pinhole camera than many of us get out of a $10,000 system!

Light comes in many forms. The trick is to match the subject to the right kind—and quantity—of light. It has often been said by nature photographers that the light of the moment is perfect for something, maybe not what you wanted to photograph, but something.

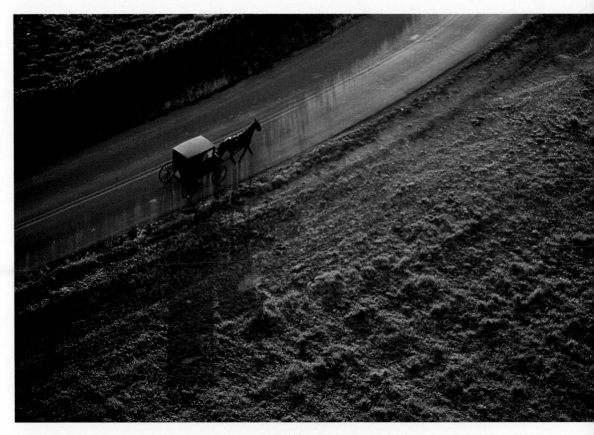

Opposite top: Leaf with raindrops on Grandfather Mountain, North Carolina. *Nikon F3, 105 micro f 2.8 lens, Kodak Kodachrome 25.*

Opposite bottom: Shaft of light in Upper Antelope Canyon, near Page, Arizona. *Nikon F5, 20–35 f 2.8 lens, Velvia.*

Above: Amish farmer going to church by buggy in the Pennsylvania Dutch Country. This is an aerial shot from my ultralight airplane. *Nikon F100, 80–200 f 4.5 lens, Kodak Ektachrome 100 VS (pushed one stop).*

Let me give you an example: If it is raining and overcast it is not very likely that you will get a dramatic sunrise or sunset shot, but it may be a great day to photograph streams or waterfalls. By contrast, on a wonderfully clear morning the light may be spectacular on some mountain peaks or filtering through the grass in a meadow, but it would be far too harsh to capture a deep forest scene.

The point is that each kind of light is best suited to specific types of subject matter or situation. Depending on the quality of the light and the direction of the light, your photographs will take on different moods.

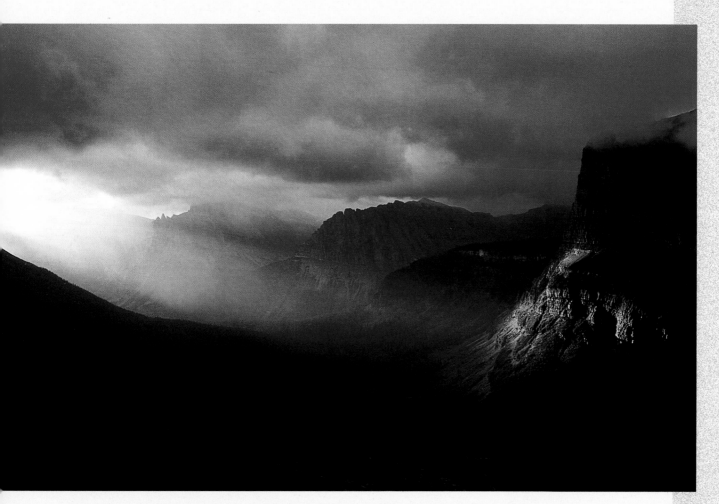

Above: Glacier National Park, Montana, gave me this spectacular light during a thunderstorm. The lesson here is to never think that the weather is too bad to shoot. When you least expect it, the clouds may part and offer up an opportunity of a lifetime. *Nikon F5, 80–200 f 2.8 lens, Velvia.*

Opposite: Upper Horse Tail Falls in the Columbia River Gorge, Washington. To make this kind of photograph you need overcast light. When the sun is subdued it allows for nice, even light on forest subjects. Another plus with overcast lighting is having less light so you can use slower speeds, if you desire. *Nikon F5, 20–35 f 2.8 lens, polarizer, A2 warming filter, Velvia.*

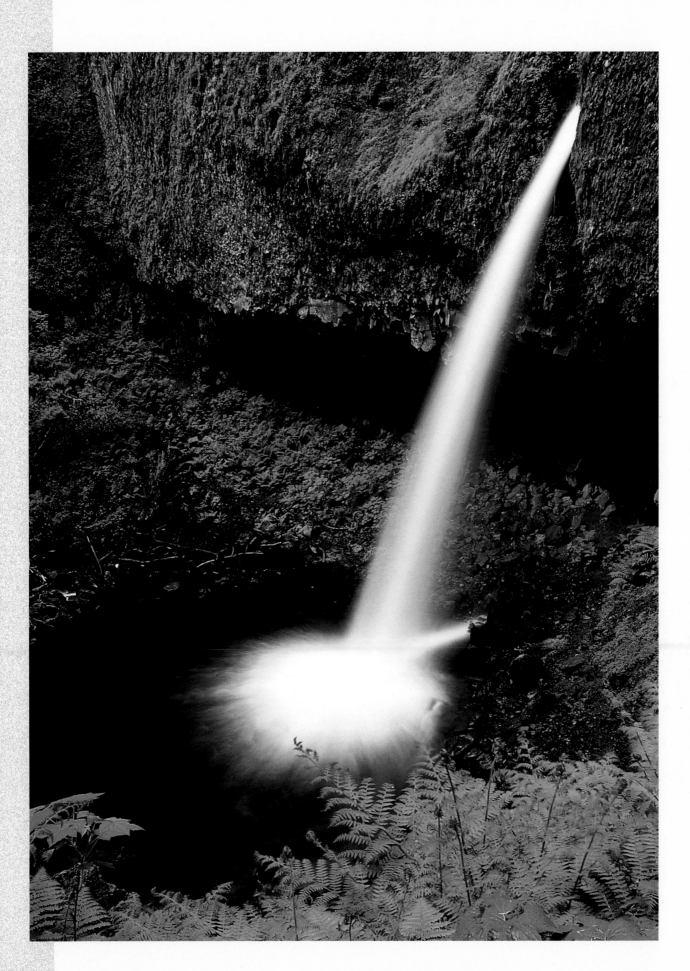

QUALITY

There are two basic kinds of light: specular and diffused. Specular light is bright and harsh, creating strong shadows. Diffused light is broad and soft, creating minimal or no shadows. Of course, the environment will often be a mixture of these two qualities on any given day, providing you with many different combinations of light to take into consideration. Here are simple descriptions of the four main types you will encounter:

• **Heavy Overcast** (very diffused) — Dense clouds or fog, creating no shadows at all. This lighting is difficult to work with because this condition reduces significantly the amount of light available. It can still work for foggy forest scenes, streams and rivers, and close-ups on the forest floor.

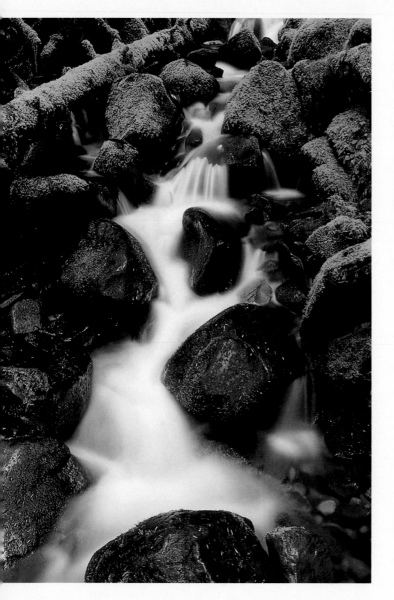

• **Overcast** (diffused) — More ambient light than heavy overcast conditions, creating very faint shadows. Generally, overcast conditions are best for any subject in which you do not want strong directional light. The same types of subject work here as with heavy overcast, you just have more shadow content. This is one of my favorite lighting conditions!

Stream near Sol Duc Falls, Olympic National Park, Washington. Overcast skies gave me the perfect light for this scene. As before, with less light I could use a long exposure (8 seconds) to soften the flow of the water. *Nikon F5, 20–35 f 2.8 lens, polarizer, A2 warming filter, Velvia.*

• **Partly Cloudy to Bright** (somewhat specular) — Good ambient light, creating relatively strong to moderately strong shadows. This is an excellent opportunity for sunrises and sunsets that can throw spectacular color into the clouds. After the sunrise and before the sunset, clouds can often mask the sun and give bright overcast conditions as well. This type of light enhances texture and contour.

• **Clear and Sunny** (specular) — Very direct, bright, harsh light, creating strong, hard-edged shadows. Believe it or not, except for the first rays of the day, these are some of the hardest days to make great images. Once the sun is well off the horizon, bright sunny conditions are often very contrasty and difficult to work in to make nice images.

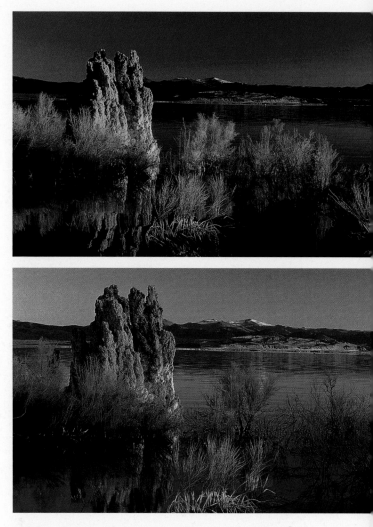

This pair of images illustrates what a difference direct light makes in a scene. The picture on the bottom was taken just seconds before the sun came up on a clear day. The photo on top was taken just seconds after the early sunlight struck these Tuffas at Mono Lake, in the Sierra Nevadas in California. *Nikon F100, 28–70 f 2.8 lens, polarizer, A2 warming filter, Velvia.*

In general, you will find that the best light will usually be the first hour of the day and the last hour of the day, when the light is warm and directional, creating rich color, texture, and contours. The exception would be when your goal for the photograph is to include hard contrasts and sharp shadows.

Light can make the most mundane scene come alive. When a single shaft of light hit the trees on this Colorado Ridge, I knew I had an image. Sometimes the best tool in your arsenal is patience! *Nikon F5, 300mm f 4 lens, Velvia.*

DIRECTION OF LIGHT

Of course, there is always some ambient lighting in the outdoors—you need at least some light to make a photograph at all! But you can position yourself and the camera to take advantage of the direction of that light, dramatically changing the scene you are photographing. The light can come from any of the four directions—front, back, left side or right side—or from a multitude of overlapping directions. Here are the basics:

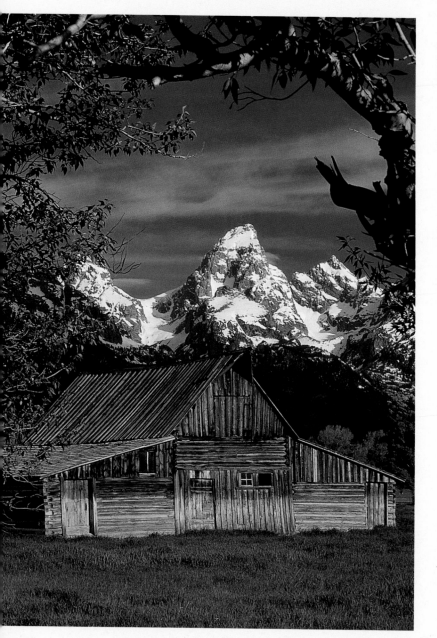

• **Front** — Light that comes from behind the photographer and falls directly onto the subject is often very flat and boring. Because the shadows it creates are hidden behind the subject, they usually are not part of the shot. That's not to say that you can never work in front lighting; it's just more challenging to make interesting than the other directions of light.

Front lighting is often the first light you learn to shoot in. In fact early in my photography career I was encouraged to shoot with the sun over my right shoulder! Actually front light, while usable, is probably the most boring of all directions of lighting. This shot of the infamous barn in the Wyoming Grand Tetons, is O.K., but the best light is early or late. *Nikon F100, 28–70 f 2.8 lens, polarizer, Velvia.*

• **Side** — Side lighting is some of the best light, as it shows contour and texture by creating shadows. Whether from the left or right, this direction of light emphasizes the subject in a unique way, half of it in shadow and often without detail. Much of the work you will do in the field will be with some form of side lighting.

Side lighting is an excellent tool to show texture and give a mood to your images. In this shot of patterns in the sand in Monument Valley, Arizona, the side lighting shows the full pattern of the sand and the shadow of the bush. *Nikon F5, 80–200 f 2.8 lens, polarizer, Velvia.*

• **Back** — When the sun or light source is behind the subject, it can create wonderful rim lighting at the edges of the subject, often called the halo effect. Back lighting can be very effective for a variety of subjects, especially objects that are somewhat translucent. Back lighting can make the subject appear mysterious, by minimizing the details of texture and contour you would otherwise see.

Back lighting is very effective in separating the main subject from the background. When the subject has fine side texture, like the needles on these Saguaro cactuses, they really stand out with the rim lighting created when the light source is behind your subject. *Nikon F4, 80–200 f 2.8 lens, Velvia.*

An example of light at its best is this double rainbow coming into St. Mary's Lake in Montana's Glacier National Park. Moments like this are pure good fortune. Dark skies and a polarizer help maximize the effect. *Nikon F5, 35–70 f 2.8 lens, polarizer, Velvia.*

Many people are under the mistaken impression that photographers mainly look for subjects; we actually look for great light to put our subjects in!

When you look at any photograph, try to determine where the light is coming from and what effect the direction is having on the resulting image. Remembering your feelings and reactions to light will help you to develop a much stronger personal vision of how you want to use light. You learn a lot about photography by analyzing the light in others' work, and then trying to duplicate those effects in your own work.

It has been said that "a forty-five minute difference in time makes a world of difference in results." And that is surely true in outdoor photography.

It is not uncommon for photographers to wait hours in adverse weather, even for seasons to change, in order to have the right quality and direction of light. Good photographers are patient and have the ability to not shoot until the light is right. John Shaw once told me that he felt the single best indication that someone has become a truly good photographer is that he or she knows when *not* to shoot.

A note on white balance: For years, film shooters have just lived with the difference between the film's light balance and the light that was available. Warming and cooling filters and filters for fluorescent lighting were always in the bag of commercial shooters. Now with the new digital cameras we can actually adjust the camera itself to match the light we are working in. We can also alter the white balance to warm or cool an image if that is our desire. Just one more exciting way digital is changing things for the better.

SELF-ASSIGNMENTS

1. Select a few slides or digital images on your computer, and mark each one with its different kind of light, by direction and quality.

Over the next few weeks, shoot new photographs that are examples of each kind of light.

Organize your images into pages or files according to the kind of light used, and then study them. You will see just how different a subject appears in the various qualities and directions of light. If you are able to collect photographs of the same subject, your comparisons will be even more startling and obvious.

2. Re-shoot some of those same subjects under different conditions. When you compare the two batches of images you'll see first hand how impactful light can be.

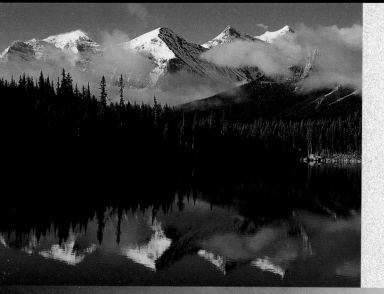

At the core of successful composition is one basic idea: Keep it simple.

Composing for Dynamic Results

CHAPTER

MUCH OF THE ART of photography reveals itself in the composition, or arrangement, of the scene of the shot. Many people believe the purpose of art is to bring order to chaotic material, and thereby to create harmony. The main device for creating harmony in photography is composition. Thus you create artful photography through good composition in your photographs.

In addition to pleasing the senses, composition is what leads the viewer through the myriad elements in your photograph to your idea, your impression, your mood, your feeling, your point of view.

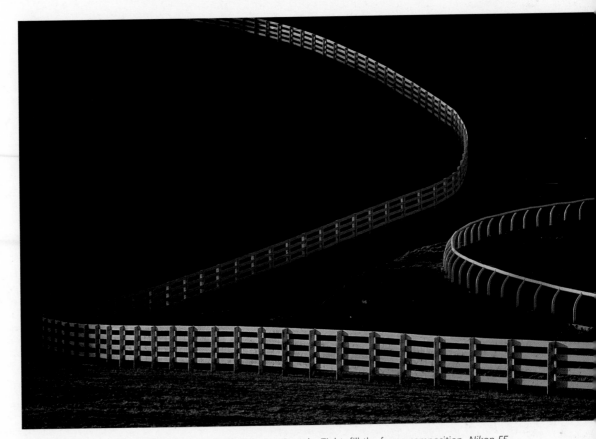

Opposite top: Herbert Lake, Banff National Park, Alberta, Canada. Tight, fill-the-frame composition. *Nikon F5, 80–200 f 2.8 lens, polarizer, Velvia.*

Opposite middle: Julia Pfeiffer State Park beach, Big Sur, California. It's a great example of leading lines. *Nikon F5, 20–35 f 2.8 lens, polarizer, Velvia.*

Opposite bottom: Common Toad in my backyard in Kentucky. *Nikon F3, 200mm micro f 4 lens, Kodak Ektachrome 64.*

Above: Fences in last light, Blue Grass Horse Farm, Lexington, Kentucky. Getting down to eye level with the subject makes these classic S and C curves really spectacular. *Nikon F5, 80–200 f 2.8 lens, Velvia.*

At the core of successful composition is one basic idea: Keep it simple. This means to be sure the graphic elements of a photograph convey one idea and one idea only.

Bruce Barnbaum refers to this as the "unifying thought." When viewers look at your photographs you do not want lots of elements competing for their attention. It should be very clear what your intended subject was.

David Middleton says, "You should be able to state in a short simple sentence what you are photographing." His point is clear: Make sure you know what your subject is, then photograph just that.

In other words, the woman who dresses truly elegantly looks at her jewelry and wonders what she can remove. Understatement is always classic; less is more in photography too! When you keep the compositions simple, you increase the chance that the viewer will be able to find the subject and understand the point you are making in the image.

After simplicity—which is a must—the following principles will help you learn how to bring some order to your photographs.

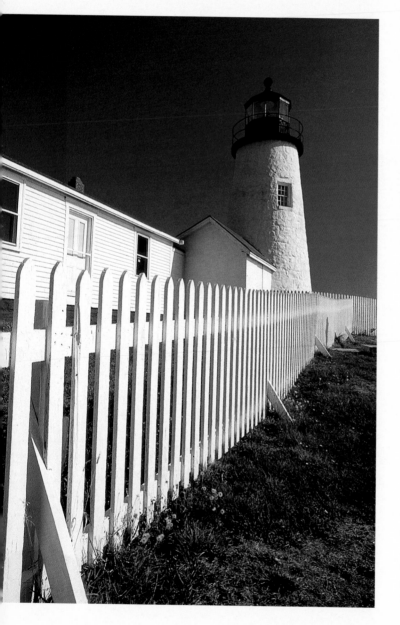

The use of leading lines to take the viewer's eye into the frame and to the subject is one of the most effective ways to create a sense of depth. This lighthouse in Maine takes on added dimension with this technique. *Nikon F3, 24mm f 2.8 lens, Ektachrome 64.*

Where you place the subject within the frame can be a very important decision. Placing the watermelon in the center of the frame, as in the example on the left, leads to a stationary feel. By simply moving the cut watermelon to the right and opening up the frame, you greatly improve the spatial relationships. The result is a much more dynamic image. *Nikon FM2, 105 micro f 2.8 lens, Velvia.*

• **Avoid the Bull's-eye Syndrome.** It is a common mistake of beginners to place the principle subject right in the center of the frame. Though this can work, other compositions usually work better. Placing the subject in the center leads to dull, static compositions that all look alike. It is understandable why people do this, the focusing aids in the viewfinder are—guess where?—dead center.

• **Consider the Rule of Thirds.** This concept goes back to the earliest days of painting, when it was called the Golden Mean. If you divide your frame into thirds both horizontally and vertically, intersections of the lines create points of interest. Placing the subject in the vicinity of one of these points of interest can strengthen your composition. And it applies to both horizontal and vertical compositions.

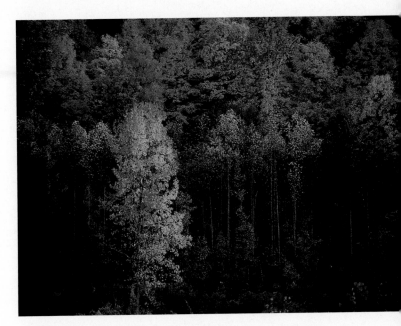

When deciding where to place your subject in the frame, consider the Rule of Thirds. Placing the main subject near one of the points of interest in the frame gives an open feeling to the remaining frame and plays that space against the main subject. *Nikon F4, 50–135 f 3.5 lens, Velvia.*

• **Carefully observe the space surrounding your main subject.** Even if you have a very strong and compelling subject, any unwanted or unneeded objects in the frame can take attention away from the subject. Distractions like tree limbs sticking into the edge of the frame or bright focus spots in the background can be magnets that draw the viewer's attention away from the principle subject or subjects.

• **Watch out for merges and hot spots.** When you are composing a photograph be extra careful to not have elements in the frame that overlap or touch, called merges. For instance if you are looking up through the trees to the sky and several of the tree branches overlap and prevent you from being able to tell where one tree starts and another tree begins this is a merge. Hot spots are simply bright areas in the background or foreground that distract us from concentrating on the main subject. Whenever you look at a photograph your eye goes to the sharpest, brightest, and warmest (warm colors) area in the image. If the brightest area is not the subject it is distracting from what you want the viewer to be paying attention to.

The example on the left illustrates a "merge." Even though we know that the adult and young Masked Boobie in the Galapagos Islands are not grown together at the chest and head, leaving a little blue sky (open space) between them results in the much-improved photograph to the right. *Nikon F5, 300mm f 4 lens, Velvia.*

• **Make your main point of interest stand out from the background.** If you have a light subject, try to shoot it against a dark background. The eye will naturally seek the brightest and sharpest area of the picture, so make that your point of interest. Keep in mind, too, that the foreground can enhance the main subject and should lead the viewer's eye into the photograph, not distract from it.

• **Move in close.** Filling the frame with your subject leads to much more impact. It also helps avoid unwanted background objects—after all, if your subject occupies most of the frame there isn't room for unwanted distractions.

The Blue-footed Booby is filling almost the entire frame. With the subject dominating the frame it leaves little room for anything distracting to intrude. Also, filling the frame with the object leaves little doubt as to what the intended subject is. *Nikon F5, 300mm f 4 lens, Velvia.*

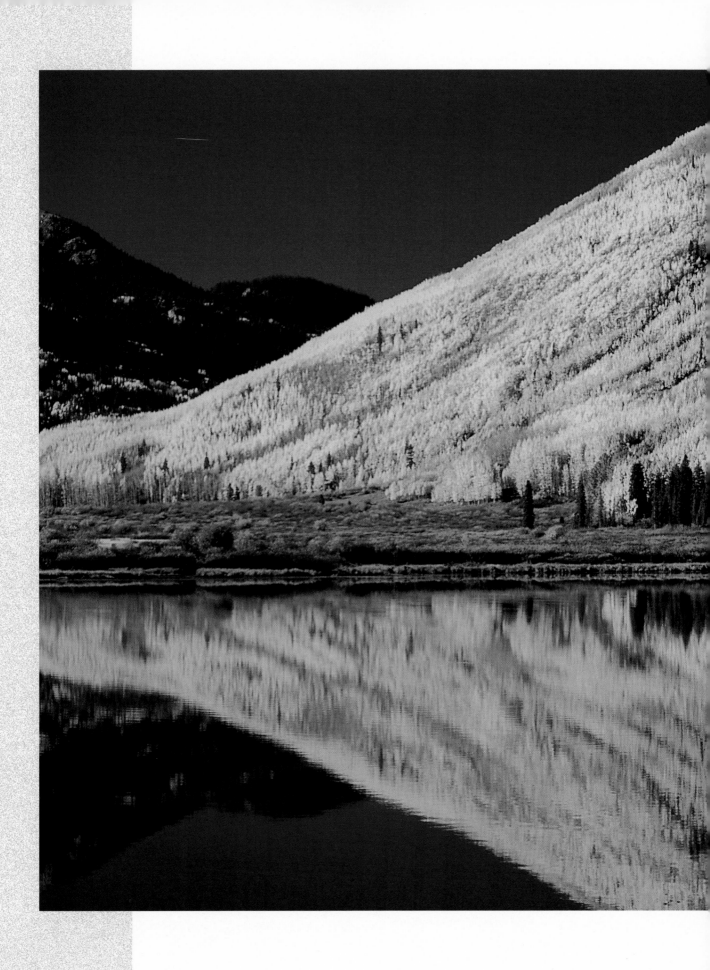

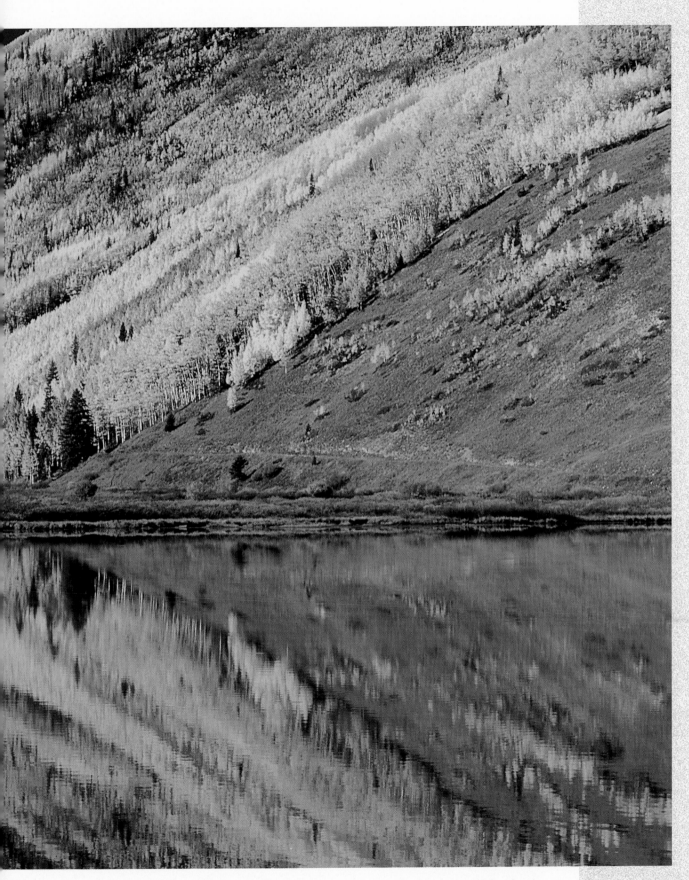

Where to place the horizon line is a decision to be made constantly. Normally, try to keep the horizon high or low, in the upper third or lower third of the frame. The one exception is in perfect reflections. At Mirror Lake in the Colorado Rockies, when the Aspens are in full glory, a split horizon works fine! *Nikon F5, 28–70 f 2.8 lens, polarizer, Velvia.*

• **Be aware of lines and curves within the composition.** Leading lines can greatly enhance the main compositional themes of your photograph. S curves are extremely pleasing, as are classic C curves. Horizontal lines tend to be dignified and show power, while vertical and diagonal lines signal movement and speed. Curves portray serenity, and converging lines can give the feeling of depth.

• **Frame the shot.** The actual borders of your slide or print create a frame, but you can also create frames within frames, or frame a subject with bordering objects. Both are effective in good compositions.

Leading lines and lines of direction not only lead a viewer's eye to the subject, they can be the subject. This farm pattern shot was taken from my ultralight airplane in the Palouse Region of Washington. It is one of my favorite photographs, mostly because of how much fun I was having when it was made. Consider using patterns and lines to your advantage in your images. *Nikon F100, 80–200 f 4.5 lens, Kodak Ektachrome VS (pushed one stop).*

• **Include a size comparison.** Often we make photographs that need something familiar to us to determine perspective. People or animals are great additions to such images for clarifying the subject.

• **Give it "air."** When showing action, always leave room for the subject to move into. For instance, if you are showing a bison running, bird flying, or motorcycle speeding, leave some room in the frame to show that the subject has someplace to go within the frame.

• **Odd is good**. When you have groups of objects or subjects, an odd number of them is easier to compose and usually works best.

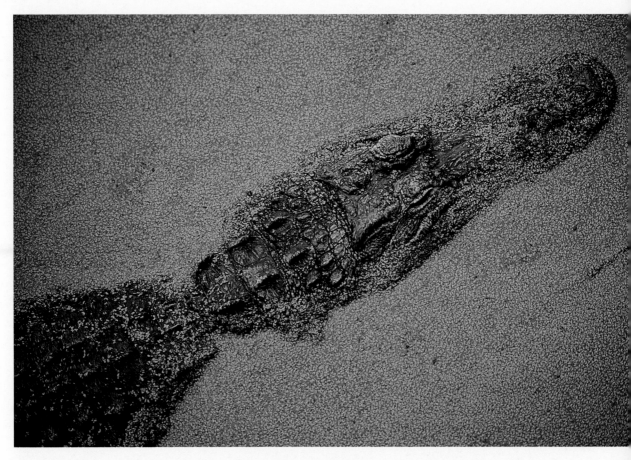

Even a living subject can itself be a line of direction, as evidenced by this alligator in duck weeds. By using the line of direction to bisect the frame you use the main subject as a leading line. When I'm teaching a workshop I jokingly say I shot this alligator standing on another alligator; I was actually standing on a small bridge. *Nikon F5, 28–70 f 2.8 lens, Velvia.*

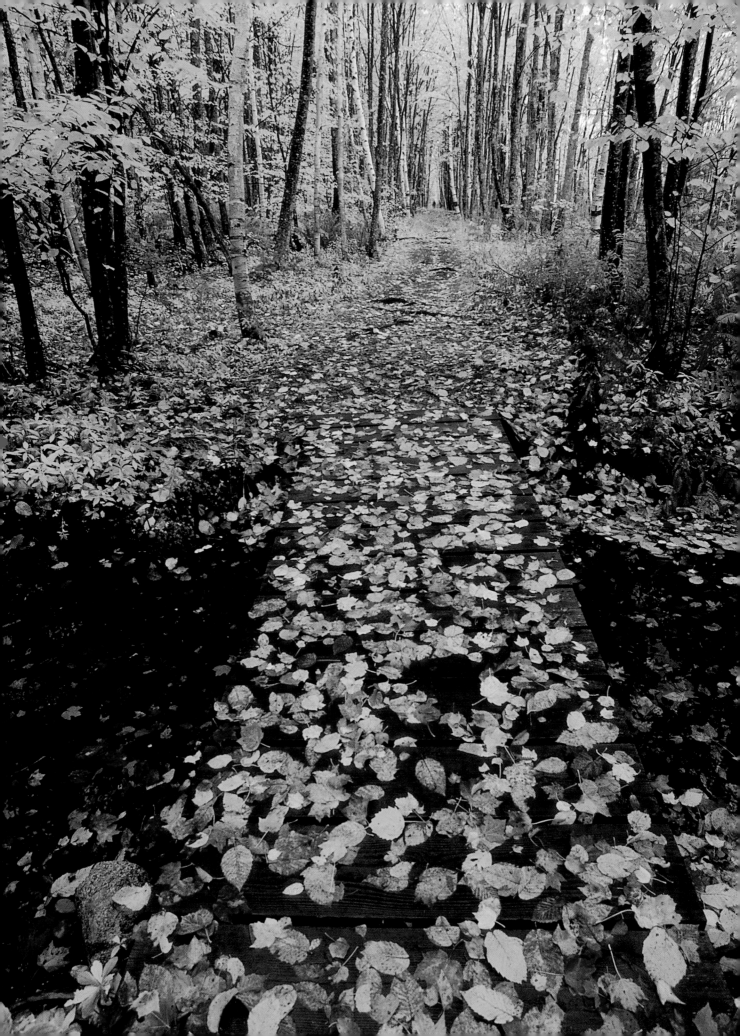

The concept of "the dominant element," emphasized strongly by David Muench's work, is very powerful when you can make one object become the dominant point in a photograph. Since one of the major goals of effective composition is to make the subject very clear, a dominant element helps drive home that point.

Always remember that the eye seeks sharpness, brightness, and warmth. Keeping this principle in mind when you are deciding the composition of a shot will guide you in the most effective placement of subjects, colors, and tones.

In summary, compositional decisions will help you direct the viewers' eyes and attention to what you want them to concentrate on.

SELF-ASSIGNMENTS

1. Go into the field and find a scene you really like. Set up your camera and go through all the steps to make a photograph and fire off a frame or two. Now carefully look in the viewfinder and locate at least five other shot possibilities within the first frame. Change to a zoom in the telephoto range and make new compositions that were a part of the original scene.

2. A close-up test: Tie a ten-foot-long string around the head of a nail. In a location you want to photograph, randomly stick the nail in the ground, then stretch out the string and mark a ten-foot circle. Within the area of the circle, see how many close-up compositions you can find. Don't be shocked if it numbers in the hundreds of interesting photographic opportunities. This exercise will really help you understand just how intricate the close-up world is!

Opposite: Leaf-covered path into garden, Acadia National Park, Maine. *Nikon F5, 20–35 f 2.8 lens, polarizer, A2 warming filter, Velvia.*

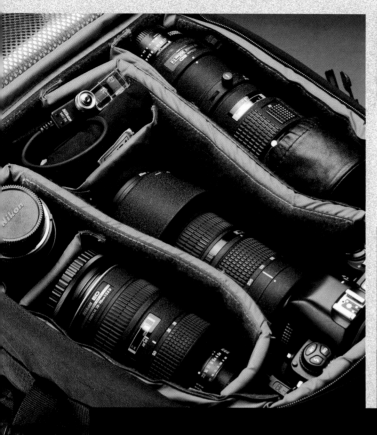

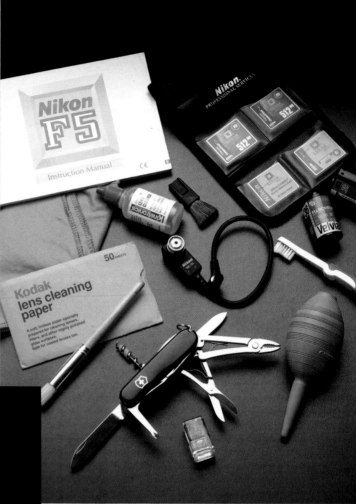

Try to keep your system simple and small; the less you have to carry the more you will enjoy the process of photography.

The Right Equipment

CHAPTER

LET'S FACE IT, half the fun of photography is the equipment! As John Shaw says, "I never met a lens I didn't like." And I can add, "and that I haven't bought!" Equipment collecting and lens fondling can be fun, but don't forget what those lenses, bodies, and accessories are really for—making pictures.

My personal rule for this is that if I'm not using a piece of equipment, I sell it and buy something I really need. Admittedly, I do make a few exceptions to that rule. For instance, I will keep equipment that has sentimental value or specialized functions (rarely used, but sometimes really needed). Also, I sometimes can't pass up a collector's item (old stuff), and some equipment I just lust after. What can I say? We all have our issues.

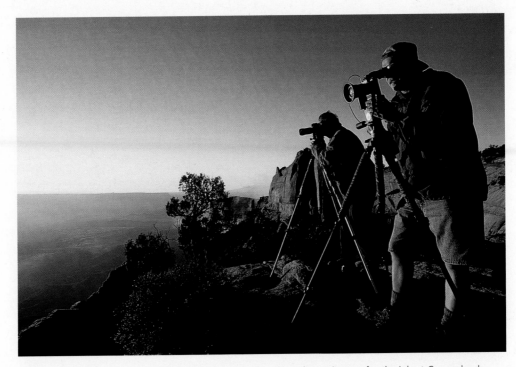

My good photography friend Chico Simich enjoys having the right equipment for the job at Canyonlands National Park, Utah. Take note: Both he and his companion in this shot are using solid tripods. *Nikon F5, 20–35 f 2.8 lens, Velvia.*

The key question is: What do you *really* need in the way of equipment? Let's define some parameters. If you do nature photography, travel photography, general people, and special events and holidays, then you have much the same photographic interests as I do.

LONG LENSES

Lenses are usually identified by their focal length, which is generally measured in millimeters (mm). Lenses of 40mm or less are usually considered "wide-angle" or "short" lenses. Those longer than about 60mm are often called "long" lenses.

Wide-angle lenses take in a wider angle of view and thus show more of the world or the subject, while telephoto lenses magnify the subject by showing a much narrower angle of view. Zoom lenses can be wide-angle, medium-focal lengths (usually 28mm to 70mm), or telephoto zooms (70mm or longer).

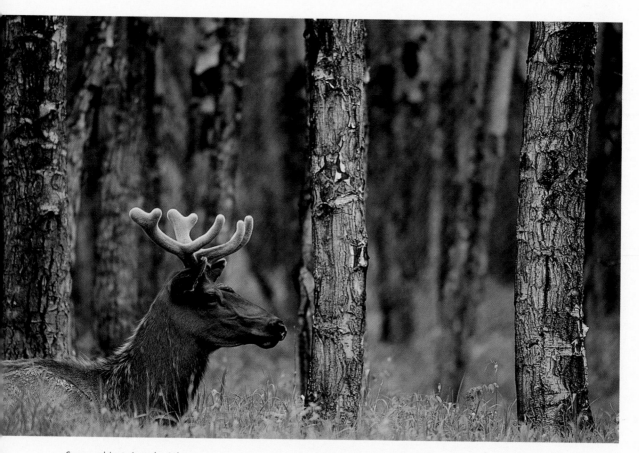

Some subjects just don't let you get too close. This elk was a lot easier to approach optically than physically! Long lenses allow you to make photographs that would otherwise be impossible. *Nikon F5, 400mm f 3.5 lens with a TC14B converter, Fuji Provia.*

In digital photography, most point-and-shoot cameras have zooms that are identified using the same 35mm terms: long and short. (By the way, we get the designation "35mm" because of the width of the film—even though it's actually 24mm high and 36mm wide.)

Most of the digital single-lens-reflex cameras available today actually change the angle of view of your lens to that of a longer focal-length lens. If you take the actual focal length of a lens and then multiply by 1.5, you get the new "effective" focal length. The actual focal length does not change; the lens, however, shows an image in the viewfinder and on the CCD that would be very much like what you would get with a lens that is 1.5 times longer. More on this subject in the next chapter.

When I travel I have a single-camera backpack for 35mm or digital SLR that is always ready to go. It contains most of what I need for almost anything I ever photograph. This bag is a Lowepro Mini-Trekker. I really love it

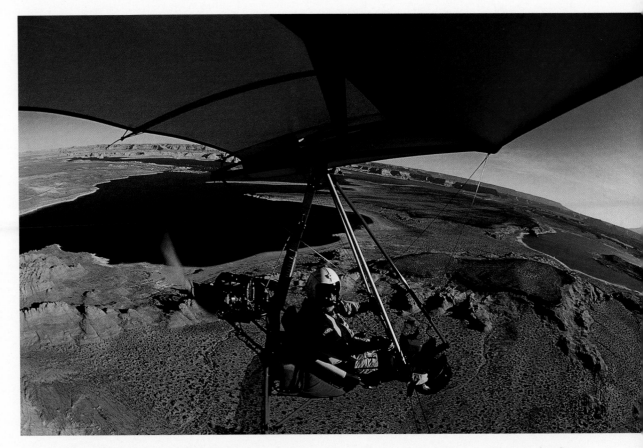

Here's another shot that couldn't have been made without some optical help. An F100 camera is mounted under the wing and is being fired by a Nikon Modulite Remote unit. *Nikon F100, 16mm f 2.8 lens, Kodak Ektachrome 100 VS.*

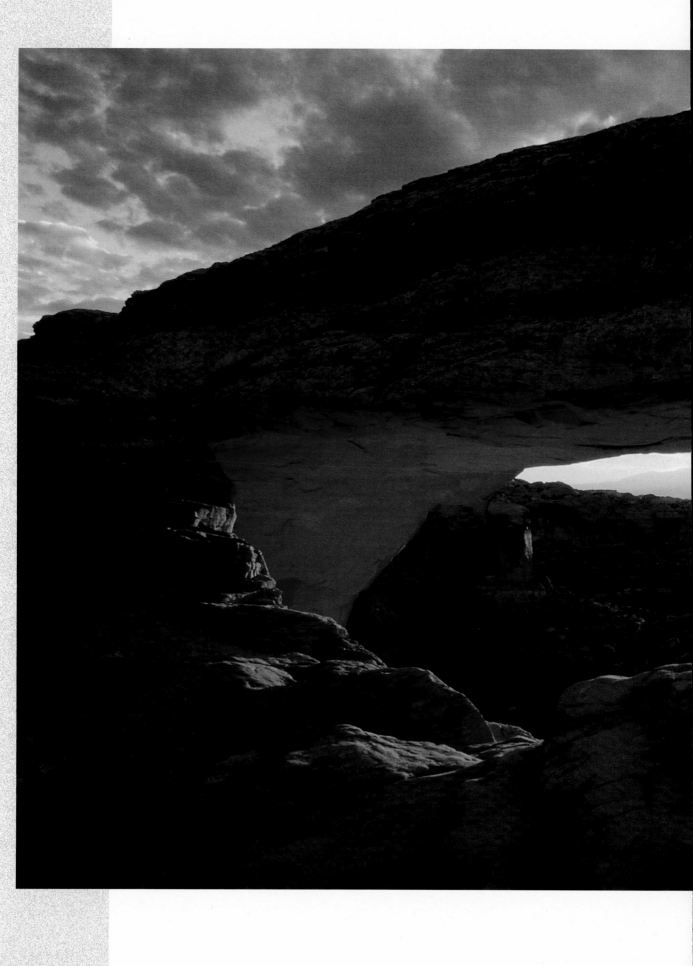

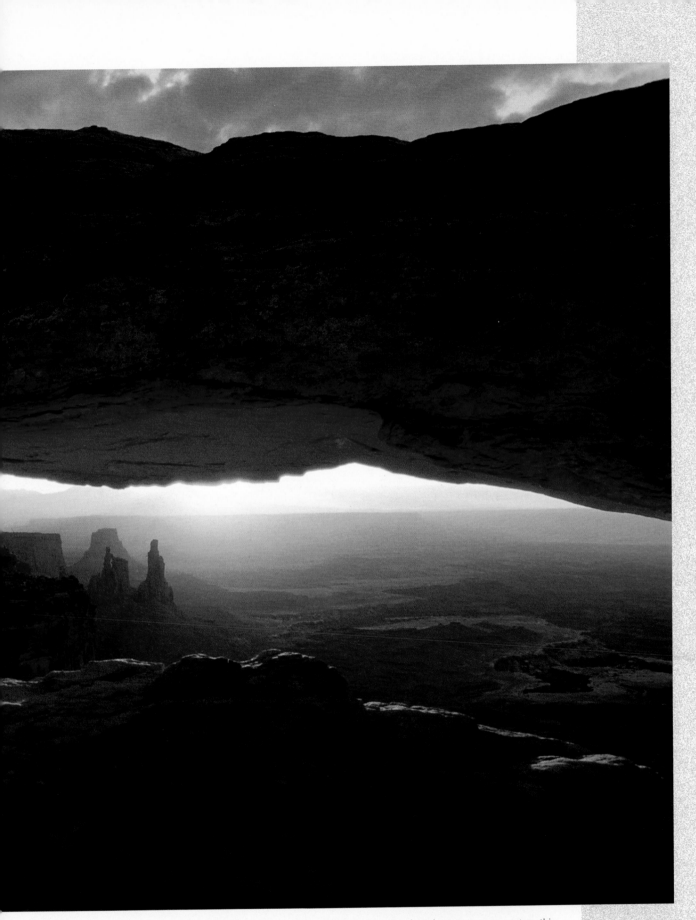

If you find yourself at Mesa Arch in Canyonlands National Park, Utah, at sunrise on a clear day you too can capture this wonderful red glow that appears under the arch. The equipment needs are actually quite modest—the biggest factor is having the light and getting up early enough to be there when the sun pops up. *Nikon F100, 17–35 f 2.8 lens, Velvia.*

because it is big enough to carry what I need and not too heavy, less than twenty-five pounds, when fully loaded.

This bag contains a single camera body, either a Nikon F100 or F5 for film, or a Nikon D1x or D100 for digital capture. Attached to the body is a 70–200 f 2.8 Nikon VR zoom lens. In the compartments of the bag I have my other lenses: 17–35 f 2.8 AFS Nikon zoom, 28–70 f 2.8 AFS Nikon zoom, and 300mm f 4 AFS Nikon telephoto. If I'm shooting digital I will also carry the Nikon 14mm f 2.8 lens.

In addition, I often use a tele-converter, which is a simple device, sometimes called a multiplier, that actually multiplies the focal length of the lens. It fits between the camera body and lens. Tele-converters come in 1.4X and 2X strengths.

I have a 1.4X tele-converter (TC-14E II and a TC-20E II in Nikon's system) to use with the 70–200 and 300mm lenses. Why this combination? I've found that for the subject matter I shoot, this combination of focal lengths (from 14mm to 600mm with the tele-converters) is nearly perfect and gives me no serious gaps.

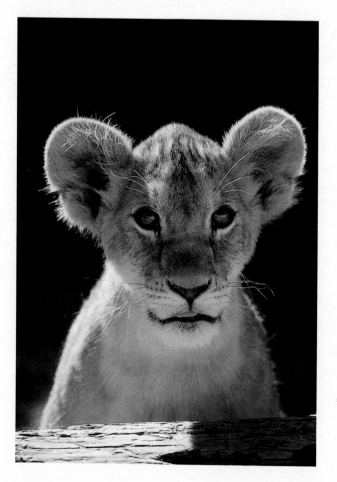

With a long lens, 300mm or longer, you can easily make this portrait in Africa, or at the local zoo. Shooting at eye level allows your viewer to feel even more connected to your subject. *Nikon F3, 300mm f 4 lens, Ektachrome 64.*

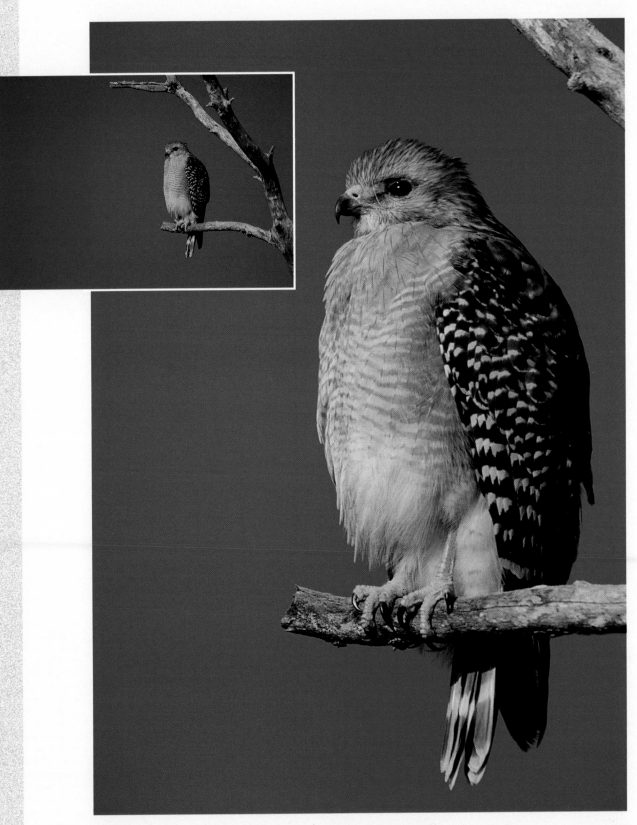

Sometimes you wish you had just a little longer lens than you're carrying. This is a great time to use a tele-converter. In this example the inset shot was made with a 300mm f 2.8 lens. The larger shot was made with the same lens and a TC20E converter, which turns the lens into a 600mm f 5.6. *Nikon F5, 300mm f 2.8 lens, TC20E converter, Fuji Provia.*

CLOSE-UP LENSES

For close-ups, many photographers own a dedicated piece of equipment called a macro or, as Nikon calls it, a micro lens. This lens simply extends within its mount, or shifts lens elements, to focus closer. Dedicated micro lenses are highly corrected to be even sharper in the close-focusing range. Today many photographers are using 200mm micro lenses, especially for nature work. Most manufacturers also offer 55mm to 60mm and 100mm to 105mm lenses as well. All work well but the 55mm to 60mm are less useful in the field, except in digital where the Nikon 60mm f 2.8 micro lens takes on the angle of view of a 90mm lens.

Opposite: This close-up of a rose was made with the Nikon 200mm micro lens. It's one of the sharpest lenses I've ever used. It allows a good working distance and yet is highly corrected for extreme close-up work. You can shoot 1:1 reproduction ratios without any accessories. *Nikon F5, 200mm micro f 4, Velvia.*

Above: The 200mm micro is very useful when photographing skittish creatures like this Common Toad. It wasn't very happy about my being so close and the 200 kept me just far enough way to allow it to stay still. *Nikon F100, 200mm micro f 4 lens, Provia.*

The next popular way to do close-up photography is to use extension tubes. These are simply spacers that fit between your camera body and your lens, thus extending the lens farther from the film plane. Extension tubes allow the lens to focus closer (although, when installed the lens will not focus at infinity). Extension tubes are especially useful with longer telephoto lenses like a 200mm or 300mm.

Another, less expensive, option is a close-up diopter lens. These lenses look much like a filter, and simply screw onto the front end of an existing telephoto or zoom lens. They allow you to make extremely sharp close-ups. Because they are much less expensive and can be added when needed they are a great option chosen by many photographers. Nikon makes diopters in +1.5 and +2 strengths and in two filter sizes 52mm (3T & 4T) and 62mm (5T & 6T).

Above: When Nikon developed its two-element diopters for close-ups it was a great day for all fans of close-up photography! These close-up attachments screw into the end of your lens like a filter but they are, in fact, extremely high quality optical devices. When placed on telephoto lenses of 70mm and longer they can help provide exceptionally sharp results with no loss of light. The 3T and 4T are 52mm in size and the 5T and 6T are 62mm. *Nikon F5, 50–135 f 3.5 zoom lens with a Nikon 3T diopter, Velvia.*

Opposite: The same system was used to capture this dandelion head; a larger opening (f 5.6) was used to soften the edges. *Nikon F3, 50–135 f 3.5 zoom lens, Nikon 3T diopter, Velvia.*

MATCH THE LENS TO YOUR NEED

What about really long telephotos and super-wide lenses? The answer depends on what you are going to use the lens for. If you photograph lots of birds and mammals or sports, you will really benefit from a 500mm or 600mm lens with very good speed and excellent auto-focus abilities. If you shoot interiors of homes or offices, or want very dramatic coverage, you might consider a 14mm or 15mm lens. If you don't do lots of work with these kinds of optics you will find them quite expensive for something that gets used rarely—but then again, they sure are fun! Only you know what you need and what your budget will allow.

One other thing worth considering is how much equipment you want to carry. If you own lots of equipment but always leave some home or in the trunk because you get a backache every time you try to take it with you, then you have too much! You have to consider each piece's value. It's probably better to have less equipment and be able to have it all with you when you need it.

You may be asking why I don't choose some of the less expensive, slower alternatives to these lenses? I do when the budget does not permit purchasing the fast (f 2.8), top-of-the-line lenses, or when I want to carry a lighter, more compact system. Most manufacturers offer slower lenses in the same or almost the same focal-length ranges. I've found these lenses to usually be very sharp and capable. The biggest loss is the brightness of the viewfinder image. I seldom shoot wide open, but with aging eyes I really do appreciate this advantage of the faster lenses.

Each of these lenses does some of the same things. On the bottom, the Nikon 70–300 f 4–5.6 ED zoom is great for travel—extremely sharp, yet very small and compact. Above it, larger and heavier, is Nikon's 300mm f 4 AF lens—very sharp and a constant f 4, so it has better speed. The next larger and heavier lens, 80–400 f 4.5–5.6, is also versatile with even more range, and it's a vibration-reduction lens. At the top, Nikon's 300mm f 2.8 AFS II lens is very fast, has almost instantaneous auto-focus ability, and is extremely crisp even with teleconverters with which it is very well matched. For travel, I like the 70–300; for sports and action, the 300mm f 2.8 AFS II; the 80–400 has VR technology, which is great when you are forced to hand hold; but then the 300mm f 4 is easy to carry and extremely sharp.

Remember, you will often use a polarizer, which will cost you almost two stops of brightness, so faster lenses can pay for themselves over time by reducing eyestrain. I must also admit that I believe the top-of-the-line lenses are often a little sharper and better corrected.

What about lenses made by someone other than the camera manufacturer? My advice would be to stick with the lenses made by your camera manufacturer. They are designed to work with your camera, and usually are more ruggedly built.

Another issue to consider is the exceptional complexity of today's camera bodies. The manufacturer carefully designs lenses to take full advantage of those complex features.

I'm sure some other alternatives exist, but to me the lens is the most important part of the photographic quality chain. Stick with the best you can afford.

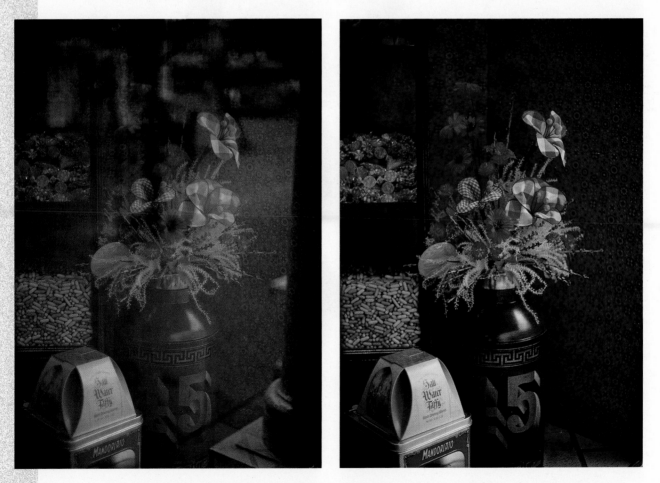

My most-used filter is the polarizer. As you can see in this illustration it does a wonderful job of removing a very distracting reflection in the window of this Walt Disney World shop. Considering that the only alternative here was a rock, a polarizer sure came in handy! *Nikon F3, 35mm f 2 lens, Kodak Ektachrome 64.*

TRIPODS

There are only two kinds of tripods: those that are easy to carry, and good ones! A really solid tripod will not have legs that feel like a fly rod. For the last twenty years I've been using Bogen, Gitzo, and Dutch Hill tripods. I own six of them. A few of my tripods, with heads, cost well over a thousand dollars. I know that seems like a lot of money—and it is—but sharp images are my stock-in-trade.

I actually have tripods dedicated to certain uses. For everyday work, especially when I may have to walk or hike any distance, I use a Gitzo 1348 or Dutch Hill carbon-fiber tripod with a Kirk B1H ball-head. These are very sturdy tripods that are easier to carry. If I am going to be working close to my transportation and will be using very large, long-focal-length lenses

Most outdoor photographers use ball heads. Unfortunately, one big disadvantage to these heads is that they throw off the tripod's balance when you move the camera for vertical shots. Kirk Enterprises came to the rescue when they developed their L bracket, which allows you to simply remove the camera and turn it to the vertical position and then return to shooting from the same solid base as before.

(500mm and longer), I use my Gitzo 410 and a Studio-Ball or Kirk Cobra head. The Studio-Ball is a large-mass ball head for heavier loads and the Cobra is a swing-action head for following wildlife, sports, or any subject that is moving.

If you really want sharp images, don't try to save money on your tripod and head. And don't forget a cable release to smoothly release the shutter on your camera! If your camera has a mirror lock-up control, you can further enhance the sharpness of your images. It would be better to do without one lens in order to own a great tripod-head combination—you will see the difference in your photographs!

Kirk Enterprises also solved another of my problems: How can I use a big lens but be able to follow the action and yet give full support to such a heavy rig? The Cobra provides a solid platform while allowing great mobility for lens and body.

Sometimes you just can't use a tripod. Manufacturers have come to the rescue with vibration-reduction (VR) lenses. These lenses allow you to hand-hold at speeds much lower than you would have ever thought possible and still get sharp results.

In the old days we used to say to take the focal length of your lens and make a fraction out of it by putting a one over it. That fraction was the slowest speed you should attempt to hand-hold that lens. For example, if you were shooting with a 105mm lens the fraction would be 1/105, the closest shutter speed is 1/125 and that would be your slowest attempted speed for hand-holding that lens.

With today's lenses you can often go two or three stops slower and still get sharp images. The question is, can VR lenses yield results as sharp as with a tripod? No, but when you have no choice but to hand-hold the camera they are an answer to a prayer!

FILTERS

I am a big believer in using a minimum number of filters. For each lens in my bag, I always carry a circular polarizer and a warming filter. I also carry a set of split neutral density filters to be used with all lenses.

• The polarizing filter is one of the most valuable filters you can own. It is actually not a filter at all, but a screen in two pieces of glass that shows its effects when one of the screens is turned. The filter screws on the lens like any other filter, but once attached can be operated by rotating its outer ring. As you rotate the filter you will see a dramatic change through the lens. The polarizing screen cuts polarized light and it will deepen the saturation of color in the frame.

A polarizer is most effective at a ninety-degree angle to the sun. A great way to know where a polarizer will work best is to point your forefinger at the sun with your thumb sticking straight up. Rotate your wrist from right to left with the finger still pointing at the sun. Where the thumb points (ninety degrees to the sun) is the exact place the polarizer has the most effect. While the polarizer will darken a blue sky, I find it best for removing reflections from objects and, thus, deepening the color. The best thing about the polarizer is that you can use just the amount you think works best to improve your image.

A polarizer reduces light from your subject, allowing its true, deep color to come through. (Far left, without; near left with a polarizer.) I can't imagine doing color work without this indispensable filter. It sure worked on this storage shack on the coast of Nova Scotia, Canada. *Nikon F100 28–70 f 2.8 AFS lens, polarizer, Velvia.*

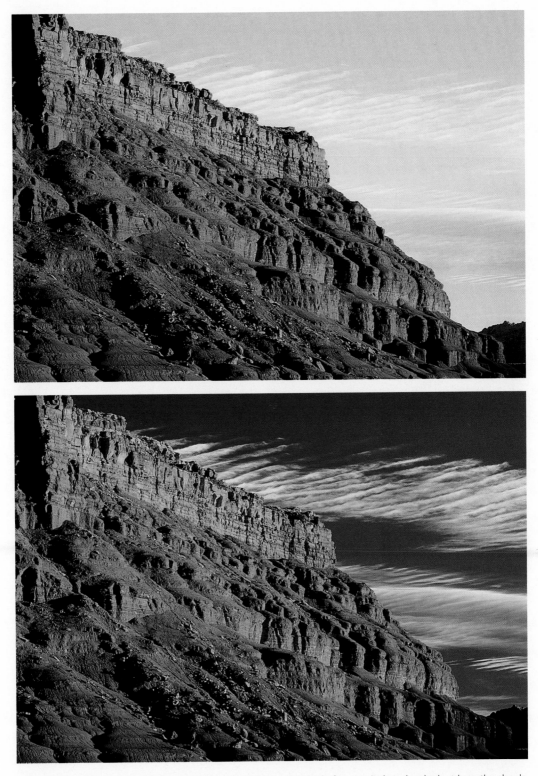

Many people think a polarizer is best used to darken blue skies. And of course it does, but look at how the clouds separate and how much richer the color is with a filter in the bottom shot of this scene from Vermillion Cliff in Arizona.

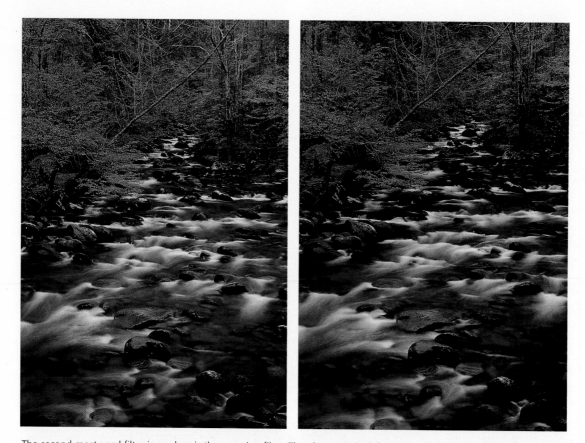

The second-most-used filter in my bag is the warming filter. The photo on the left is without a warming filter; the one on the right is with the A2 filter. With a slightly amber tint, the warming filter reduces the effect of blue light and "warms" your images. Some people love the warm effect, others don't. It is your artistic decision. I use Nikon's A2, which is very much like the more common designation of 81A. 81Bs are warmer still, and 81Cs are even warmer. *Nikon F5, 28–70 f 2.8 lens, no filter (left) and with the A2 (right), Velvia.*

• A warming filter has a slight amber cast. When a warming filter is placed on the lens it gives the entire image a warmer feeling, less cool and blue. Warming filters usually come in 81A, 81B, 81C, and 81EF strengths. The 81A is the mildest and the EF the strongest. Most people find the 81A or 81B to be strong enough. (I use Nikon's A2 which is essentially an 81A. We also call this a skylight filter with guts! Skylight filters do much the same thing but just have less warmth.) I almost always use Nikon filters (polarizers, warming and close-up diopters). I've found them to be of the highest quality available.

I like warmer images and tend to use warming filters a lot. My good friend David Middleton, by contrast, does not use them much at all. It's mostly a matter of personal taste. John Shaw often says he decides to use a filter based on the "Wow Factor." Simply hold a filter in front of your eye and view the scene. If you say "Wow!" you should use it.

• A split neutral density filter is a clear filter that has half of the filter in a neutral gray shade. Often when you find a scene with a sunlit background and a shaded foreground, the contrast range between the two is too great to fit in the film's exposure range. Until the advent of split neutral density filters you just had to walk away. Now you can capture these kinds of scenes with the help of the filter.

To use a split neutral density filter, first take one medium-tone reading in the bright area and one in the shaded or lighter area. If the difference between the two readings is 3 stops, you can use a 3-stop split neutral density filter to even out the scene. Most brands of split neutral filters come in 1-, 2-, and 3-stop strengths with either a hard edge (abrupt change of density) or a graduated edge (gradual change of density). Some companies offer these filters in 1/2-stop strength as well. I've found that with the Matrix Metering I can simply hold the filter in place and meter through the filter to get great results.

The rest of the procedure is simple. After determining which strength of filter you need, hold the filter in front of the lens. While depressing the depth-of-field preview button, align the shaded area over the place in the image where you want the transition to take place. You can get holders to secure the filter in place that simply screw into your lens filter threads, or you can hand-hold the filter. This filter actually helps you make images that the film could not otherwise record.

By the way, you can now do the same and even better corrections digitally, after the fact with Photoshop, which is one great advantage to digital capture. You see how your filters work at the moment of image capture.

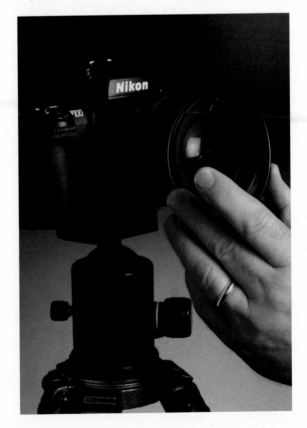

Filters are truly simple to use—they just screw into the threads on the end of your lens. Be sure to know what size filters your lens can accommodate before buying. One nice feature of my lenses are that all of my three prime lenses use the same-size filter (77mm).

FILM

The most important piece of equipment is your film or memory card. Today we have many great films to choose from and Fuji and Kodak are always bringing us even better films. For many years Fujichrome Velvia has been the film of choice in the outdoor, nature, and travel area. A few years ago Kodak introduced Ektachrome 100VS, which is an excellent film and has done well in the market. It is not, however, as fine grained as Fuji's Provia 100F. In the nature and travel markets, Fuji has pretty much reigned supreme. Color print film is also available from Fuji and Kodak. My two standard films are Velvia and Provia 100F.

Of course black-and-white negative film is also available and a number of photographers still love to work in the black-and-white darkroom.

One of the great advantages to digital is that once you capture an image, you can view it either as a color image or as a black-and-white image.

Film is sold in different speed ranges marked as ISO (which stands for International Standard Organization). A film with an ISO of 50 is half the speed of a film with a speed of 100 ISO. Obviously a film with a speed of 200 ISO is twice as fast as a 100 ISO speed film.

Generally speaking, slower films offer higher quality (more sharpness and finer grain) while faster films offer more ability to capture action. Faster films are getting better all the time. Remember, however, that in general, the slower the film the higher the quality.

The rule has always been to shoot the slowest film you can for the maximum quality of the final image. As a general rule most people consider ISO 50 and lower to be slow. Around ISO 100 is medium speed, and films of ISO 400 and greater are fast films.

The same quality concerns hold true in the digital-equivalent ISO's—lower numbers yield higher quality results.

WHAT SHOULD BE IN YOUR BAG

Over the years, I have come up with a list of "must haves" for general nature, travel, and people photography. A complete system should include the following:

• A camera body—two is even better, with one serving as a backup.

• A wide-angle lens or wide-angle zoom lens. Either a 17–35 or a 20–35 is great, and both cover lots of focal length in a single lens. If you buy just one single-focal-length wide-angle lens, try a 28mm for all-around use.

• A mid-range zoom for general work. A 35–70, 28–70, or 28–105 are all good options. A 50mm here would serve as your single-focal-length lens.

• A moderate telephoto zoom in the 70–200 or 80–200 range is great. Other options here are the 70–300 and 100–300 lenses, which are very nice for travel, usually being a little slower and thus smaller and more compact. A 105mm and 180mm or 200mm can work as two single-focal-length lenses in this category.

• If you don't purchase a 70–300, then a 300mm is a great way to reach out and pull in distant subjects or effectively crop a scene. Remember, 300mm f 2.8 lenses are really great but much heavier than the f 4 versions.

• A tele-converter can really "stretch your reach" when used with a high-quality lens. It is important to note, however, that converters and lenses should be carefully matched, and the quality of the prime lens will determine the quality you will get with a converter. Also, most zoom lenses do not work well with converters, but a few are designed to do so and are very convenient. Your dealer or manufacturer can tell you which ones work and which ones don't work with your system.

What I carry has a lot to do with how much walking I will be doing. If I'm traveling and need to carry everything all the time I will use a light system. Shown on the left is my travel lens system: a 17–35 f 2.8 zoom, 28–70 f 2.8 zoom, and 70–300 f 4.5-5.6 zoom, shown with a Nikon D100 digital SLR. If I won't have to walk much, I replace the 70–300 zoom with the 80–200 f 2.8 lens and the prime 300 f 4 shown on the right.

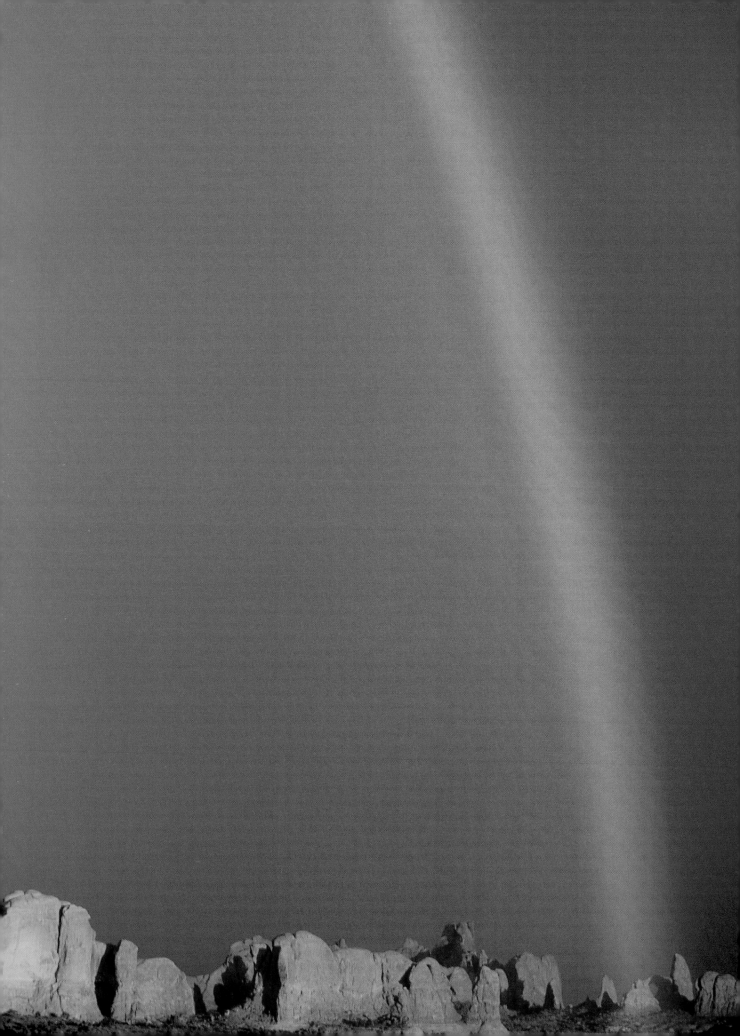

BUILD YOURSELF A GREAT SYSTEM

Here are some general tips on how to be sure you end up with the best system for the kinds of shooting you do.

• Buy the best lenses you can afford. Quality gear is a very long term investment. You get what you pay for, so it is better to get high-quality equipment the first time and not spend years replacing inferior-quality lenses.

• If you can, buy the best or next-to-best camera bodies from the same manufacturer. For instance, I shoot Nikon in 35mm and currently use the F5 and F100 camera bodies and Nikon D1x and D100s. All are designed to take the same lenses and operate the same. The build quality is almost identical (except for the D100 which is built for slightly lighter duty), so I have a great deal of confidence in all these bodies.

• Try to keep your system simple and small; the less you have to carry the more you will enjoy the process of photography.

• Buy a camera bag or backpack that meets your current and future needs. For nearly ten years I've used Lowepro packs, and Lightware or Pelican cases for all my photography transporting and shipping. These three brands have proven to be tough under fire. I don't worry about my gear when I know it is so well protected. When you find a bag that works for you, stick with it.

SELF-ASSIGNMENTS

1. Shoot for one day with just one lens. It will really give you an idea of just how many uses you can find for that optic. After completing that assignment, use a different lens. You will soon learn that your lenses can really help you shape the perspective of the images.

2. Shoot during an outing with and without filters. When you get back to the computer or light table, look carefully at the results to see just how much the filter affects the resulting images.

3. Go out and shoot the same subjects in the same light with different films. When you get your slides back do some direct comparing on the light table. You will see how each film has its own special way of "seeing" the world. You will know which you like best.

Opposite: Turrett Arch in Arches National Park, Utah. *Nikon F5, 80–200 f 2.8 lens, polarizer, Velvia.*

The bottom line is that digital has arrived. And as it matures, as film has been for some time, it will create new and exciting opportunities for you to be a better photographer than ever before.

Film or Digital? Or Both?

CHAPTER

10

We have just begun to see the potential for digital photography. By the time this book is published, it will have changed even more.

Digital photography is like a freight train coming down the track. You only have three choices: (1) get onboard, (2) step off the tracks and let the train go by (and be left behind), or (3) get run over! It can't be stopped. As I teach seminars and workshops across America, digital photography is a significant part of the program. My advice to you is: Start to learn about digital now. Of course, this does not mean you can't shoot both film and digital!

The good news is that photography will not change. Both film and digital offer great ways to capture the image—and each offers distinct advantages.

O.K., I know your first question: Will film be replaced by digital someday? Most experts feel that film and digital will co-exist for some time to come, but digital is certainly gaining in popularity. In the pro ranks—photojournalists, sports photographers,

Opposite top: Cuban cigar maker and his product. *Nikon D100, 24–85 AFS G lens, Nikon RAW-NEF file (Nikon Electronic File).*

Opposite middle: Glass beads in a statue in San Diego, California. *Nikon D100, 60mm f 2.8 micro lens, Nikon RAW-NEF file.*

Opposite bottom: Sunset and sailboat off coast of Key West, Florida. *Nikon D-100, 70–300 f 4.5–5.6 ED zoom lens, Nikon RAW-NEF file.*

Right: Vietnam War Memorial Wall, Washington, D.C. I shot this image as part of a portfolio to produce a slide show to accompany the song "God Bless The USA" sung by Lee Greenwood for a television special. *Nikon F4, 35–70 f 2.8 lens, Velvia.*

medical and forensic users—photographers are moving heavily into digital. In the nature and travel markets most photographers are still mostly working with film, but many are adding digital to their bag of tricks.

It's likely that the non-serious picture makers, who make up over ninety-five percent of the photo marketplace, will be the first to go digital. Many consumers have computers, and a large percentage of the population communicates by e-mail. It only makes sense that people will enjoy making photographs and then seeing them on the computer and sending them to relatives and friends via email.

More and more photo labs are making prints from re-useable memory cards, and soon all will. Most computer operating systems include simple ways to download your images and then store them, manipulate them, and send them via email or print them.

Above: White dormer, roof, and sky in Key West, Florida. *Nikon D100, 24–85 AFS G lens, polarizer, Nikon RAW-NEF file.*

Opposite: Opening to Costa Maya, Mexico, cruise ship port. *Nikon D100, 24–85 AFS G lens, polarizer, Nikon RAW-NEF file.*

COST OF A SYSTEM

The cost of digital is really coming down. Well, really good digital cameras still cost more than equivalent film-based cameras, but think about this: About six years ago I was invited to Kodak to see the revolutionary new digital SLR. It was a 1-megapixel camera that sold for $30,000. Today you can buy Nikon's D100, a 6-megapixel SLR that is far more capable for under $2,000.

As the price of digital equipment is coming down, the quality is going up, way up. The big plus is that, over time, your savings on film and processing costs will really add up.

If you're very serious about getting into digital photography, at a level approaching what you've been doing with film, here's a short list of what you're going to need for the kind of work you will want to do.

• A serious computer running at 1 Ghz (or more), at least 512 gigs of RAM, 40 gig hard drive (or more), 16MB (or more) video card, Firewire and USB ports, and a 19" monitor that can be calibrated.

• Lots of storage—at the very least a CD burner, or maybe a DVD burner.

• Photoshop 7.0 or Photoshop Elements 2.0. And if you shoot Nikon: Nikon View 5 and Nikon Capture 3.5.

• A quality inkjet printer—virtually everyone I know is using Epson printers. The favorites are 1280, 2200, 7500, and 7600.

• A high-quality, 4000 dpi film scanner. Once again, I and most of my friends are using the Nikon Coolscan 4000 or 8000.

• And, of course, a high-quality 4- to 6-megapixel digital camera.

Yes, that's a big investment, but let's see what you are actually buying: an image-processing lab, a digital darkroom with the ability to make substantial improvements to your images, the ability to make extremely high quality archival prints up to 13"x19" or even larger, personal control of the quality of your images and prints, images that can be quickly and easily sent via e-mail. And all of it fits onto a large desktop!

Opposite: Rack of hats in a cigar shop, San Diego, California.
Nikon D100, 24–85 AFS G lens, Nikon RAW-NEF file.

Windows and palm tree in Costa Maya, Mexico. *Nikon D-100, 70–300 f 4.5–5.6 ED zoom lens, polarizer, Nikon RAW-NEF file.*

WHY SHOOT FILM?

For many applications, film is still the best way to capture the image. If you are making very large prints (larger than 20" x 24"), it may still be easier to work with high-quality transparency film. If you need to do high-quality presentations to groups of people, slides still look better on the screen. However, LCD projectors are getting better and are a lot lighter to pack and easier to set up.

I wasn't convinced of the value of digital until an experience I had a about a year ago. One of the participants in my workshop had a Nikon D1 digital SLR. In lots of different locations he was asking me to come over and see if I thought he had captured the scene well—seconds after he had shot it! I knew then that when some of the problems of digital get resolved this will be a really valuable technology. What problems?

Red beans in open market. Queens Park Market, Belize. *Nikon D-100, 70–300 f 4.5–5.6 ED zoom lens, 5T close-up diopter, Nikon RAW-NEF file.*

Here are some of the reasons many serious film shooters have not made the switch totally to digital yet:

• Digital SLRs still can't give you as much detail as film. A digital camera would need to capture at least 10 to 25 megapixels (depending on which expert you ask) to hold as much detail as a 35mm Fujichrome Velvia slide (the current standard for quality).

• Some digital cameras use up batteries faster than film cameras. If you plan to do much field work, you need a serious plan for charging batteries and having back-up cells pre-charged. Some cameras allow the use of standard alkaline AA cells but, in many cases, they don't last as long as in film cameras, since digital cameras require more power to operate.

• Long exposures do not always turn out well. Current digital cameras produce noise (areas of lost data) when the shutter speeds are longer than twenty to thirty seconds. Some cameras do better than others but no digital cameras can compete with film, at least at this point in digital evolution. Noise reduction is getting better but digital still can't match film for very long exposures.

Mexican security guard against a unique combination of colors! Costa Maya, Mexico. *Nikon D-100, 70–300 f 4.5–5.6 ED zoom lens, polarizer, Nikon RAW-NEF file.*

Above: Red brick facade in Key West, Florida. *Nikon D-100, 70–300 f 4.5–5.6 ED zoom lens, polarizer, Nikon RAW-NEF file.*

Opposite: Flag billowing from porch, Key West, Florida. *Nikon D-100, 70–300 f 4.5–5.6 ED zoom lens, polarizer, Nikon RAW-NEF file.*

• Some editors and publishers still prefer film. One reason is because digital files take time to open and view. Another is that they are just used to being able to view and compare lots of film at once. For these reasons, many publishers are not fully ready to take advantage of the digital revolution. This is changing, however, and it will be less and less of a factor in the future.

• Fine-art prints and very large prints (over 20" x 24") are still best made from film. A few people are using digitally captured images, but the file sizes from digital cameras simply won't support the high quality and large size without considerable interpolation.

• Large digital files take lots of disc space, and even though hard drives and DVD burners are coming down in price, the storage issue is still a factor for digital photography.

Brightly colored umbrellas in courtyard in Costa Maya, Mexico. *Nikon D-100, 70–300 f 4.5–5.6 ED zoom lens, polarizer, Nikon RAW-NEF file.*

WHY SHOOT DIGITAL?

There are a ton of reasons to try digital. One is just because you might want to. Here are a few others:

• **No film and processing costs!** This is a very big factor in favor of digital imaging. Once you have made the initial cash layout for gear and memory media, the savings are considerable.

• **Better white balance control.** Digital capture can easily be adjusted for different kinds of light. Getting the white balance right with film is a big challenge. Often, the print maker automatically does it for you, but not always as perfectly as you would wish. With digital, you can adjust the white balance control, or even bracket it so you have several choices.

• **Immediate feedback.** One of the biggest advantages to digital is that you see right away if you got the shot, if the exposure was right, and what your composition looks like. This is a huge plus, especially if you will not get a second chance to capture the image, which happens pretty often.

Not using digital might be compared to learning to bowl with a curtain over the pins! You throw the ball, it goes through the curtain, and you hear a crash but you don't find out until several days later how many pins were knocked down. This is much the way you learn photography with film-based cameras—the results come back days and sometimes weeks after the shooting session. No more waiting with digital.

• **Ease of use.** Actually, digital cameras operate much the same as film cameras, but the immediate feedback makes the learning process much faster. For that reason they certainly seem easier to use!

• **Simple to share.** One of the greatest joys of photography is sharing your work with others. Digital files can be distributed quickly and easily with very little expense to many people via the Internet.

• **Enhanced learning.** With digital's immediate feedback, you are more likely to try new things knowing you can see the image immediately and erase it if you don't like it. Anything you try with film costs you money; with digital you simply throw it away and re-use that space on the memory card.

• **Try it before you use film.** For many years commercial photographers have used Polaroid cameras to test a shot (called a "back") before committing it to film. With digital you can do the same thing.

Opposite: Flag embroidered with eagle symbol. Corbin, Kentucky. *Nikon D-100, 70–300 f 4.5–5.6 ED zoom lens, polarizer, Nikon RAW-NEF file.*

First light on the Grand Tetons in Wyoming. Shot for my book project *America From 500 Feet!* from a Cessna 172 at an altitude of 11,000 feet. The windchill factor with the plane's window open was 68 degrees below zero! *Nikon F100, 28-70 f 2.8 lens, Kodak Ektachrome 100 VS.*

DIGITAL VIDEO

A few years ago I bought a Hi-8 video camera to do some underwater work. The quality was acceptable, but it was either going to cost another $30,000 to get the proper editing equipment or pay a very high price per hour to out-source all the editing. So that camera went on the shelf with all the other seemed-like-a-good-idea-at-the-time gear.

Then I starting reading about the digital revolution in video. Now you can buy a mini DV video camera with quality rivaling that of broadcast cameras of a few years ago—for well under $1,000.

As my son Wesley and I were just starting our previous book project (*America From 500 Feet!* NorthWord Press 2001), I realized we would need to record our adventures with video cameras for use in future workshop programs, speaking engagements, and television productions. Fortunately, Sony became a sponsor for that project and provided us with the revolutionary PC-100 MiniDV Camcorder.

Rolling green fields of winter wheat in the Palouse Region of Washington State. Shot from my ultralight airplane for *America From 500 Feet! Nikon F100, 89–200 f 4.5 lens, Kodak Ektachrome 100VS.*

This was the first megapixel mini DV camcorder with extremely high quality video and sound. The real kicker is that with mini DV tape you can do full-blown editing, with transitions, special effects, and titles right on your home computer, or even on a laptop. Not only do these video cameras work great for home activities and vacations, but you can do serious nature and travel video as well. With the wealth of great editing programs on the market today, you can learn to do first-class productions in no time.

I am currently using two Sony DCR PC-100s, a Sony VX2000, and the new Sony TR950. In my office I have a Mac G4 and I travel with a G4 Titanium for field editing and writing. My editing programs are Apple's iMovie2 and the full-fledged Final Cut Pro 3. Of course, many programs are available for PCs as well. I highly recommend that you give a mini DV camcorder a whirl. You may be surprised how much you enjoy producing video, and how much it will improve your still-shooting skills as well.

The bottom line is that digital has arrived. And as it matures, as film has been for some time, it will create new and exciting opportunities for you to be a better photographer than ever before. This change will be good for our craft. Photography, at its core, will still be the same!

Single rock spire in Utah's Arches National Park in the Devils Garden Trail area. *Nikon F100, 28–70 f 2.8 lens, polarizer, Velvia.*

Great light is no less
important in photographing
people than in shooting
the grand scenic.

People and Travel

CHAPTER 11

WHILE MOST OF MY PHOTOGRAPHY over the last decade has been in the natural history field, I have shot and still do shoot plenty of travel and people pictures. The thrill of photographing as you travel is the fun of bringing home to share with others the wonderful things you see and experience. Not only can you share them, you can remember fondly those great travel moments yourself.

Of course, taking photos of family members and friends is one of the greatest uses of your camera gear. When my grown children come home to visit Sherelene and I, one of their favorite pastimes is looking at tray after tray of slides we took while they were growing up. Yes, my wife is an excellent photographer in her own right!

Opposite top: Pleasure boats reflecting the calm water on the Maine coast. *Nikon F100, 300 mm f 4 lens, polarizer, Velvia.*

Opposite bottom: The Saint Jean Cathedral on the Sone River in Lyon, France. *Nikon F100, 28–70 f 2.8 lens, Velvia.*

Above: My daughter Catherine sitting in a log cabin window in Cades Cove of the Great Smoky Mountains in Tennessee. She must have loved those trips; many years later she was married in the Primitive Baptist Church only a mile from this setting. *Nikon FM, 105 mm f 2.5 lens, Kodak Ektachrome 64.*

Here are some suggestions that will help you to make the most of your travel and people photography efforts:

PHOTOGRAPHING PEOPLE

• **Keep them busy!** People will look more natural and relaxed if you can capture them when they are busy in some activity. Most people are uncomfortable being photographed, so try to let them get the camera off their mind before you start shooting. Children at play are great subjects and people working or doing what comes naturally make the best images.

• **Catch them in candid moments.** If you don't make a big production out of getting pictures of your friends, family members, and for that matter, complete strangers, you can get truly remarkable images. People become involved in a variety of interesting activities; catch them when they are unaware that you are photographing them.

Keeping a coal miner busy is not very difficult. These folks work very hard in rather tough conditions. Here's a tip for photographing people: Allow a few minutes for them to stop thinking about your presence, then you can get truly good images. *Nikon F3, 35–70 f 3.5 lens, two flash units, Fuji 100.*

• **Develop a relationship before you start shooting.** You may need to make photographs of people you don't know. It is always best to spend a few minutes visiting and explaining why you would like to make a photograph of them. Famous travel photographer Bob Krist calls it "making small talk." Most people will appreciate your interest in them and their activities. The bonus is you'll make some great new acquaintances along the way.

• **Be sensitive to cultural taboos.** In some cultures it is rude to make a photograph and you may be asked not to do so. In those situation, discretion is the better part of valor; just walk away and know you can't always photograph everything you would like. It's better to not offend a person and lose the shot. I once was refused a shot of a booth at an open-air market in France. As I politely left, another booth owner observed my behavior and invited me to photograph his flower stand. It produced great images. Sometimes just being polite pays off.

One place that you don't have to worry too much about being noticed is in the surgery suite. These people are fully concentrating on the work at hand. Because of the strong lighting needed for surgery, the reflected light was perfect for this image. *Nikon F4, 85mm f 1.8 lens, Fuji 100.*

- **Shoot really tight.** The corollary to backing off and showing a person in the environment is to close in for the details. Tight portraits and tightly cropped group shots can add impact and eliminate distractions.

- **Vary your approach compositionally.** Not every image of a person has to be a closely cropped portrait. People in nature, participating in sports, making crafts, and many more ideas will give a good variety to your work. You don't even have to show the person's face. I love to photograph people's hands at work. Think of different ways to use people in your photographs.

- **Use people to give a size perspective.** How tall is the tree? How big is the waterfall? Very often without something to compare your subjects to, you really can't tell what the scale is. By placing people in your photographs you immediately can see a comparative size perspective. And since we are all human beings, we are naturally interested in other people. Adding people to your photographs truly adds human interest!

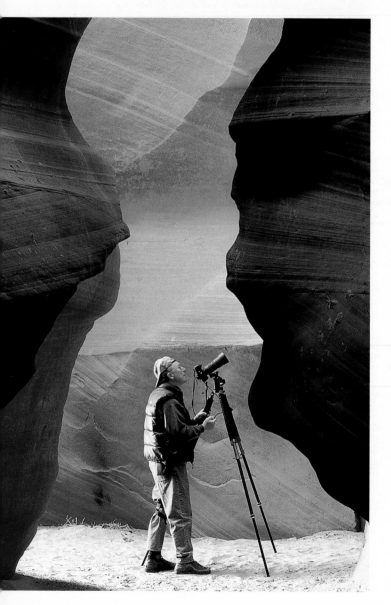

- **Remember, light matters.** Great light is no less important in photographing people than in shooting the grand scenic. Look for people in the most complimentary light possible. Never pass up a chance to photograph by window light or on overcast days. Light can be your best friend when you want to really capture great images of people.

Left: Photographer Neil Silverman worked on capturing the texture of Upper Antelope Canyon near Page, Arizona, while I captured him. People busy at work make nice, natural subjects. *Nikon F5, 28–70 f 2.8 lens, Velvia.*

Opposite: The statue in the Lincoln Memorial is striking all by itself, but when this woman came in and became lost in contemplation, it made for a very compelling image opportunity. *Nikon F3, 35mm f 2 lens, Kodachrome 64.*

IMPROVING YOUR TRAVEL PHOTOGRAPHY

A couple of years ago I had the great pleasure of working with travel photographer Bob Krist on some one-day seminars. I truly enjoyed working with this master travel photographer, and very funny guy!

I have listed Bob's wonderful book, *Spirit of Place* (Amphoto 2000) in our resource section, but I wanted to mention it specifically because it's a great book. Much of what I'm sharing here is from what I've learned from Bob.

• **Study, research, and plan.** Unless you are extremely familiar with your travel destination learn all you can before you arrive. Good planning will allow you to make the most of your time at your destination. Where are the best locations to photograph the city skyline? Are there any festivals or street fairs planned while you will be visiting? What about parks and locations where people may be gathering? Where are the safe areas to travel with camera gear? All these and many other questions answered in advance will increase your chances of photographic success immensely.

Opposite: The popcorn wagon in Florida's Walt Disney World was the perfect foreground object for the Town Hall at Main Street USA. I find it to be a very difficult place to make good images—not because of a lack of subjects, but rather sensory overload. There is really too much to shoot! This is when careful planning and patience really pay off. *Nikon F3, 24mm f 2.8 lens, Kodachrome 64.*

Above: The one-room schoolhouse at Kentucky's Hensley Settlement in Cumberland Gap National Historical Park. *Nikon F3, 18mm f 4 lens, Fuji 100.*

Lavender fields in Provence, France. Having a capable guide will often get you to the right spot at the perfect time. In this case internationally known photographer Bryan Peterson was my guide and he put me in the right place at the right time! *Nikon F100, 17-35 f 3.5 lens, Velvia.*

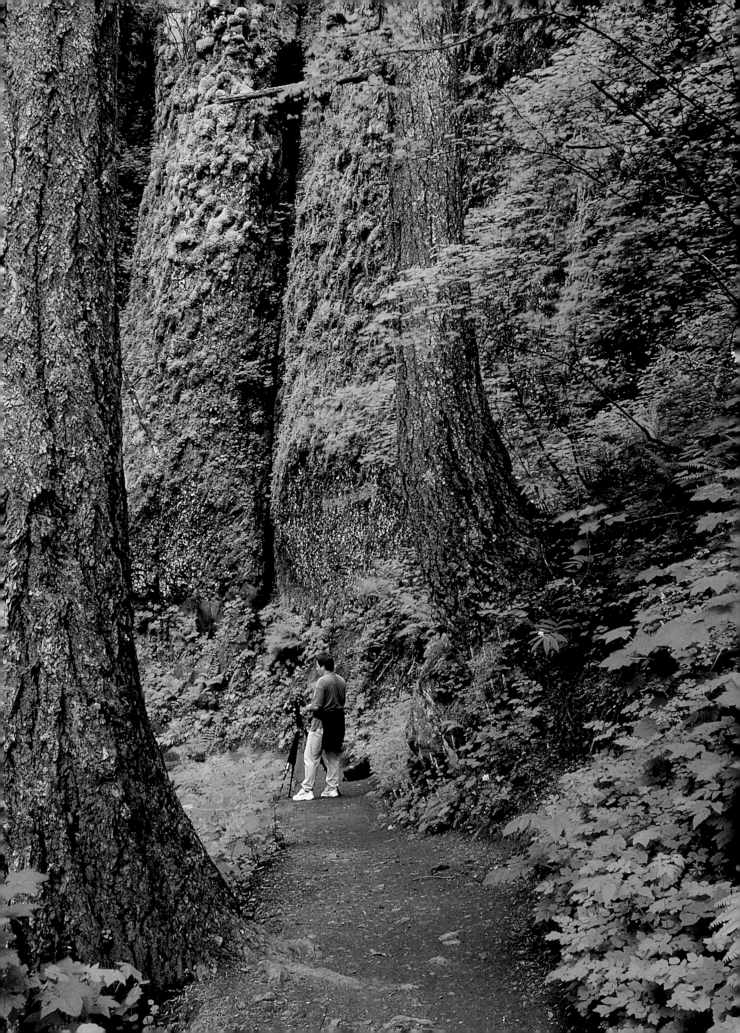

• **Decide how much gear to carry.** It's not a matter of how much you can carry, but how much you can carry and still be comfortable working. It has been my experience that the less you have to think about your equipment, the better your photographs will be. Come up with a travel package that works best for you.

Here is a a typical kit I might take on a trip when I don't want to be bothered with a lot of gear: Nikon F100 (film) or D100 (digital) and 17–35 f 2.8, 28–70 f 3.5, and 70–300 f 4 ED lenses. If I really want to travel light I might just take my Coolpix 5700; it has a 35mm-equivalent 35–280 zoom.

• **Don't bite off more than you can chew.** I'm as guilty of this as anyone. Say you are going out West and you decide if you really work at it you can drive 1,500 miles and cover eight national parks in ten days. Be realistic about how much ground you can cover when traveling. It is much better to fully explore and enjoy three places in a week than to kill yourself trying to do a different location every day. Remember, you may have to wait for the light and conditions you need. If you cut your plans too short you just might miss the best situation!

• **Take your flash.** Today's cameras offer very sophisticated flash systems that can do balanced fill-flash. With balanced fill-flash the camera's meter helps you expose for the scene while the flash also reads the scene and adds just enough light to lift the shadows. If your camera or flash gives you the option, try setting the flash compensation on –1 and see if you don't love the results!

• **Work with patterns, textures, and reflections.** As you travel and try to capture what you're experiencing keep a sharp eye out for unique patterns and textures of the region. In the story-telling process these close-in snippets are great to fill in the mood of your coverage. Silhouettes and reflections are also great ways to add variety to your coverage of a location. I've actually found patterns to be one of my favorite subjects over the years.

Most importantly, remember you're traveling for pleasure; don't let your zeal for photography make the journey less of a joy!

Opposite: Well-known photographer and instructor Cliff Zenor is dwarfed by the old-growth forests in the Columbia River Gorge, near Portland, Oregon. *Nikon F5, 28-70 f 2.8 lens, Velvia.*

One of the best ways to get
started in selling prints is
to make photographs of the
many interesting, historic,
and beautiful things near
where you live.

What to Do with All My Great Photographs?

CHAPTER

12

SO NOW YOU HAVE BURNED TONS of film and you have a lot of nice images. Unless *National Geographic* is ringing the phone off your wall, you're probably wondering what you are going to do with all of them. Believe it or not, this is a pretty common question in my office and at photo workshops around the country. Actually there are quite a few good uses for the fruits of your hard work. Here are some of my favorite ideas:

SHARE WITH OTHERS

Organizations, elder hostels, nursing homes, school groups, and civic clubs are all starved for good programs. Your images set to music will not only entertain these folks, they will encourage them think about protecting and preserving our wonderful wild lands. A bonus is that since groups such as these seldom see a wide variety of photography, they just may think you are the next Ansel Adams! It really is a great thing to be able to use images to help others appreciate and enjoy nature. Many people have never seen the kinds of beauty that you regularly have the chance to photograph.

Opposite top: Shadow of saw blade on rustic barn in southeastern Washington farm country. *Nikon F100, 80–200 f 2.8 lens, polarizer, A2 warming filter, Velvia.*

Opposite middle: Keyboard with rose and pedals. Studio setup shot for a recording company. *Nikon F4, 105mm micro f 2.8 lens, Velvia.*

Opposite bottom: Paint peeling from an old screen door on an abandoned house with fall leaf. *Nikon F100, 80–200 f 2.8 lens, polarizer, A2 warming filter, Velvia.*

Left: One of the best things to do with your great pictures is to decorate your own home. What could be more personal than your work hanging where you can enjoy it best? This 42" x 72" print hangs in my dinning room in Kentucky. *Pentax 645 II, 35mm lens, Velvia.*

One of the great joys of shooting for enlargements for your home and to sell is discovering all the magical places you can record on film or digital. This is the beach and falls at Julia Pfeiffer State Park, on the Big Sur coast of California. *Nikon F5, 28–70 f 2.8 lens, polarizer, Velvia.*

I have a photographer friend who lives in New York. In his spare time he has done a great deal of work for the wildlife refuges in his region. His slide shows and stock photography have helped various organizations more effectively promote their conservation message. I have another friend, a pastor, who shows his great slides at nursing homes and retirement homes throughout our area. I've never seen an audience that did not receive a rich blessing from his efforts!

DECORATE YOUR WALLS

Quality art, such as the prints you have produced, is expensive to purchase. And what could be more rewarding than for you to have all the compliments—both for your decorating skills and for the pieces themselves.

The enlargement quality possible today far exceeds that of just a few years ago. Photography has truly entered the world of art with the advent of new archival print processes. Inkjet printers today, such as those from Epson, allow you to make beautiful prints right at home where you can control the printmaking process yourself. Some inkjet prints not only equal the quality of lab prints, they also are just as archival (fade resistant).

Not only can your prints decorate your home or office, they make wonderful gifts for friends and family members.

I've decorated my home with some of my favorite images. This walkway wall is my own personal gallery. If you pick images to display that are meaningful to you, every time you glance at them the great memories will come back. *Pentax 645 II, 35mm lens, Velvia.*

MAKE NOTE AND GREETING CARDS

Many photographers use their own work for note cards and holiday greeting cards. It is not only fun to see your work beautifully reproduced but it is also good marketing of your talents to people who might want to take advantage of your services for themselves.

Inkjet cards look great and you can produce just the number you need. If you need larger quantities, some commercial print shops specialize in making high-quality cards for photographers.

Photos and cards by John Snell.

TEACH A CLASS

When I first fell in love with photography I lived in a small town in the Appalachian Mountains. I was one of the few serious photographers in our town. It wasn't long before people were asking if I would teach classes. I started with a beginner's class and found that I enjoyed it so much that it led, eventually, to the career I enjoy today. It is really fun seeing other people get turned on to photography!

If you are conscientious—and you shouldn't teach if you're not—you will work extra hard to make sure you thoroughly understand the material you are teaching. That extra work will help you to be a much better photographer.

EXHIBIT AND SELL

Many modest-sized galleries often exhibit prints of local photographers. Area arts and craft shows are good places to show your work. And depending on your interest, these opportunities can lead to selling your prints.

One of the best ways to get started in selling prints is to make photographs of the many interesting, historic, and beautiful things near where you live. Until you become the best photographer in America, you can make it your goal to be the best photographer in your city, county, or state. Many very successful photographers have made a very comfortable living specializing in what is close to them. After all, no one knows your area like you do. You can often obtain special access and opportunities others could not. If you have an advantage over the competition, take advantage of it! It is also a lot of fun to learn more about the place in which you live.

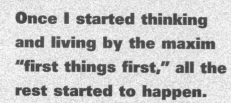

Once I started thinking and living by the maxim "first things first," all the rest started to happen.

Final Thoughts

CHAPTER

13

PERSPECTIVE IS A GREAT WORD, and it has many shades of meaning. The dictionary says perspective is the view of anything from a particular location.

Obviously, in photography, the subject can look very different if viewed from different perspectives. Interestingly, life is much the same. Let me end our time together with a story about how a person's perspective evolves and changes.

When this book is published, it will be almost exactly the twenty-third anniversary of an important event in my life. Twenty-three years ago I was lying in a hospital bed preparing to hear some news from Murph Greene, my doctor, surgeon, and friend. Dr. Greene had removed a tumor from my lower stomach about the size of a man's fist. He told me that he was almost certain that the tumor he had removed was cancerous. He feared it was multi-strained, which has only a three- to five-percent survival rate.

I was devastated. At thirty-five years of age I had three young children and a wonderful wife and family. Yet I felt that few of the dreams I had for my lifetime had come true yet.

Opposite top: The Grand Tetons from Oxbow Bend on the Snake River in Wyoming, at sunrise. *Nikon F5, 28–70 f 2.8 lens, Velvia.*

Opposite bottom: My son Wesley photographing from atop a conical rock formation in Coyote Buttes South, near Page, Arizona. *Nikon F5, 28–70 f 2.8 lens, Velvia.*

Left: Young boy sitting at a table in cabin window. This is one of my favorite photographs because of its strong sense of peace. It was actually made by my wife Sherelene, an excellent photographer in her own right. *Nikon FM, 70–150 f 3.5 Series E lens, Kodak Ektachome 64.*

I went through all the emotions that anyone would. First, I'm a Christian, so I blamed God. How could this be happening to me? I had tried to be the best person I could and there were some truly evil people in the world—why me Lord? It didn't take very long to figure out that blaming God was not such a good idea in a situation like this, so I went through a day of feeling sorry for myself. That soon wore thin as well.

Finally, on the evening before my doctor was to return with the full pathology report, I simply broke down and wept. I asked God to give me the strength to face the future for the sake of my family and to give me the peace that could only come from him. I also added that if he made deals—and I was pretty sure he didn't, and even more sure that if he did, I was not eligible for one—that he let me live just long enough to see my children grown and on their own.

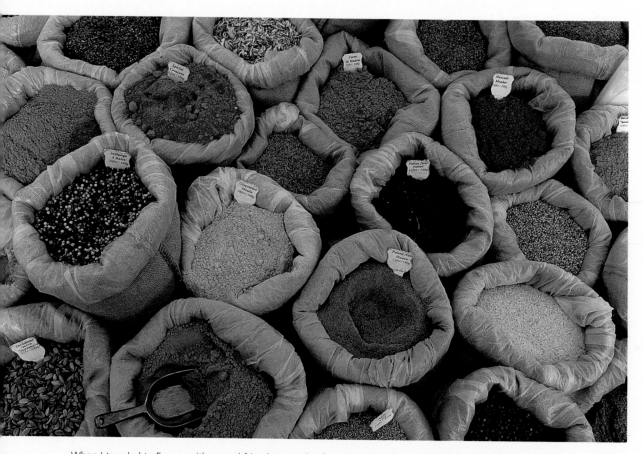

When I traveled to France with several friends a couple of years ago I had only one shot in my mind that I really wanted to make. I had seen a very similar shot to this one in a brochure and I was obsessed with shooting these spices in an open air market. Thankfully at the very end of the trip in Paris I found them. This shot now hangs in our kitchen, 40" x 60"! *Nikon F100, 28–70 f 2.8 lens, Velvia.*

The next morning, after a wonderfully peaceful night of sleep, I might add, Murph returned with the pathology report. He had a big smile on his face, which kind of irked me. I wondered what he was so happy about. He started with the old line, "I have some good news and some bad news." I told him to go ahead and give me the bad news so we could get it over with. He complied. "Bill," he said, "the bad news is that the tumor we removed was cancerous." My heart fell to my knees. He went on, "The good news is that the cancer is not multi-strained as I had feared. It is seminoma, the most treatable form of cancer. You should have about a ninety-five-percent chance of survival!"

This is where perspective comes in. If you had asked me a week before my surgery what my priorities were, I would have told you: Number one is my relationship with God; number two, my wife and children; number three, my friends and family; and lastly, my profession.

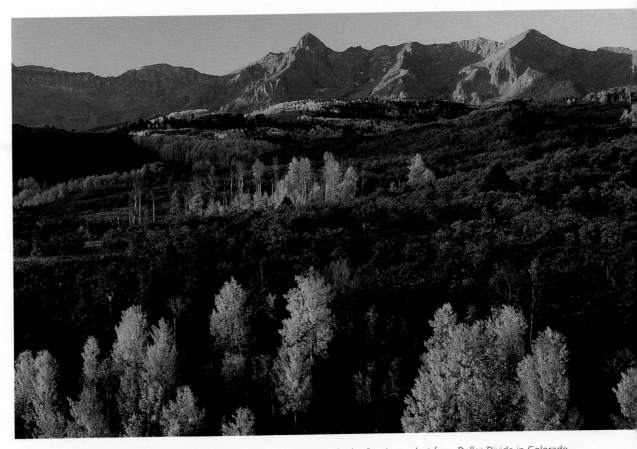

One of my favorite locations is the Rockies in fall—this scene in the San Juans shot from Dallas Divide in Colorado is a breathtaking view. This was late in the fall with some of the leaves already down, and no snow yet on the mountains. Sunrise at the Divide and then breakfast at the True Grit Cafe in Ridgeway—what could be better? *Nikon F100, 28–70 f 2.8 lens, Velvia.*

But I would have been lying to you. I wouldn't have meant to lie to you; in fact, I wouldn't have even known that I was lying. I would have been trying to tell you what I thought was true in my life. Most people know what their priorities *should* be and, in fact, think that those *are* their priorities. If you want to know what a person's true priorities are, don't ask; watch. By observing what people think is important, what makes them happy, what upsets them, how they spend their time, and how they react to stress, you will soon see what they truly value.

I did honor God and love my wife and children, family and friends, but to be honest, I loved myself a lot! I was very driven to become a "famous photographer." Interestingly enough, when I did get some notoriety later in my career, I found that there was less joy in being "better known" than I had thought there would be.

During the days I thought I was facing almost certain death, I started to see things a lot more clearly. I realized that I wanted to be a great husband and father a lot more than a great photographer. Don't misunderstand me, to this very day I'm driven to be the best craftsman and artist that I can possibly be. It just isn't the number-one goal of my life.

A funny thing happened after I got that huge attitude adjustment: Once I started thinking and living by the maxim "first things first," all the rest started to happen. It seemed that when I stopped trying so hard to have the success I once wanted so badly, it came so much more effortlessly.

If I could go back to the day I learned I had cancer and erase the entire event from my life, I would not. As much pain as it carried, the lesson learned was too valuable to ever give up!

Some day I will check into the great darkroom in the sky. When I do, I hope that something more can be said of my life than that I made some really great photographs. I hope that at least one friend says I was a great friend. I hope that my wife can say I was a wonderful husband, and that my children will remember me as a good and loving father, and a good mentor and example for my grandchildren. If anyone remembers the images, that would be just fine.

As Dickie Fox said at the end of the film *Jerry Maguire*, "Hey, I don't have all the answers. To be honest, I've failed as much as I've succeeded in life. But I love my wife and I love my life, and I wish you my kind of success...."

Your perspective on how photography fits in your life may change, but I hope that you have enjoyed our journey together. And I hope that you are now well on your way to becoming the photographer you always dreamed you could be!

The Last Dedication

BOOKS ARE SUPPOSED to have one dedication. In fact, I have one in the very front of this book. But since this is *my* book, and since a dedication is a chance to thank those most responsible for allowing you to have the chance to do a book in the first place, this book must end this way!

The photograph is of my daughter Catherine and I together at Arches National Park in Utah. It was made of us by my friend Carl Skoog. It is one of my most prized images. Isn't it amazing how much a beautiful young face improves the looks of an old wrinkled one! Without all of Catherine's hard work through the years, helping me build and run the Great American Photography Weekends company, I would never have had the opportunity over the last ten years to make many of the images in this book, and most of the 35,000 slides in my files.

Thank you, Catherine, for years of covering for me, taking my messages, running our business, being a real friend to me and our customers, for giving Sherelene and I two incredible gifts in Cassidy and Cade, and most of all, being the best daughter a father could ever hope for.

This book is dedicated to you.

Appendix

THE LISTS OF TEN
As I began working on this book, I kept a list of topics to include in the text. In the end, the ideas seemed to gather in groups of ten. Since I never found a way to add some of them to the text, I thought you might enjoy reviewing them here.

Ten myths of photography
1. You have to be born with artistic abilities to shoot artistic work.
2. You must own very expensive equipment to make great photographs.
3. Quality glass is not worth the money.
4. All lenses should have a skylight filter attached.
5. Polarizers only work on sunny days.
6. Ansel Adams never manipulated his images.
7. Someone, somewhere, makes a better film than Velvia.
8. Lenses made in Germany are superior to any made in Japan.
9. Any truly gifted photographer is born holding a camera.
10. Photoshop will make us all great photographers.

Ten people (well, eleven) you should take a class with
1. John Shaw
2. David Middleton
3. Freeman Patterson
4. Jack Dykinga
5. Rod Planck
6. Pat O'Hara
7. Bill Fortney
8. Bob Krist
9. Rob Sheppherd
10. David & Marc Muench

Ten (or so) items to always carry in your camera bag
1. A cable release (and a spare).
2. A micro-fiber cleaning cloth.
3. A Swiss Army® knife.
4. Spare batteries.
5. Lens cleaning paper & fluid.
6. A good marking pen.
7. An old toothbrush for cleaning grit out of camera crevices.
8. A baby ear syringe for blowing off lens surfaces.
9. A bubble level (and a spare).
10. Eye drops and extra-strength pain reliever.

Ten steps to take before you push the shutter release

1. Walk around with your camera and compare placement options before you set up your tripod. Then set it up at the best spot.
2. When you find a good scene, consider what the best lens will be for the scene.
3. Ask yourself the question, What is my subject?
4. Answer the question in one short sentence or phrase. If you can't, find a different shot.
5. Determine whether depth-of-field or motion rendition is most important. Then make your exposure, aperture opening, and shutter speed selections based on that.
6. Decide if filters might improve the shot and add the ones you feel will work best.
7. Compose carefully, making sure the main subject is clearly defined.
8. Look all around the frame for distractions, merges, or hot spots. If you find any, compose to eliminate them.
9. Use a cable release.
10. Wait for the decisive moment and then push the shutter release.

Ten ways to improve your photography

1. Subscribe to magazines such as *National Geographic, Outdoor Photographer,* and *Nature's Best*—and pore over every issue, cover to cover.
2. Take an art appreciation class.
3. Take a design class.
4. Go to the bookstore and study the work of professional photographers such as David Muench, Jim Brandenburg, Jack Dykinga, Pat O'Hara, Freeman Patterson, and Christopher Burkett.
5. Go out and sit on the ground without a camera, and don't get up until you can find twenty-five wondrous things. It won't take as long as you might think!
6. Simplify your camera gear to a maximum of four lenses.
7. Slow down and practice your photography very carefully.
8. Study what is in the viewfinder thoroughly before you push the shutter release.
9. Get a tripod that is slightly heavier than you want to carry— and use it all the time.
10. Find a photo buddy who will tell you the truth about your work and progress.

Ten questions to ask yourself when critiquing your own work
1. Is the subject well defined?
2. Is the exposure effective?
3. Are there any distractions in the frame?
4. Is the image sharp? (If you intended it to be sharp.)
5. Is the composition simple and clear?
6. Are lines used effectively to lead your eye to the subject?
7. Are lines used effectively to give an illusion of depth?
8. Did the image need a polarizer? Did you use one?
9. Did the image need any other filters? Did you use them?
10. What do you feel when you look at this image?

Ten Things that I've never regretted buying
1. My first Nikkor 105mm f 2.5 lens.
2. My Nikon camera bodies (F5-F100-D1x & D100).
3. Boat loads of Velvia film.
4. A Lowepro Mini-Trekker. (It has saved my back!)
5. Nikon 17–35 f 2.8, 28–70 f 2.8, and 80–200 f 2.8 lenses, my constant companions.
6. My Apple G4 Titanium Powerbook, for field digital work.
7. Nikon Polarizers and Lexar Cards.
8. Lee graduated neutral density filters and the same function in Photoshop.
9. John Shaw's first book, *The Nature Photographer's Complete Guide to Professional Field Techniques*.
10. My "Alaska Bob Mad Bomber Hat" and "Billy Bob Teeth."

PHOTOGRAPHIC RESOURCES
Over the years I've used a lot of products and services; here are my favorites:

Arca Swiss Plates
Kirk Enterprises
138 Millbrook Rd.
Angola, IN 46703
800-626-5074
Contact: Jeff Kirk
www.kirkphoto.com

Archival Supplies
Light Impressions
800-828-6216
www.lightimpressionsdirect.com

AV Dissolve Controls
Arion Corp.
Contact: Jean Carlburg
800-328-0595
www.arion-usa.com

Ballheads
Kirk Enterprises
www.kirkphoto.com

Graf Studiboball (larger lenses)
www.rtsphoto.com

Bubble Levels
Culman
www.rtsphoto.com

Camera Bags
Lowepro
www.lowepro.com

All Lightware Cases
www.lightwareinc.com

Enlargements
The Digital Imaging Center
660 Merrimon Ave.
Asheville, NC 28804
Contact: John Smith
828-258-9321

Film Processing
A & I Color
933 North Highland Ave.
Hollywood, CA 90038
800-883-9088
Contact: Jennifer Conradt
www.AandI.com

Goodies Catalog
L.L. Rue Enterprises
7410 N. Williamette Blvd.
Blairstown, NJ 07825
800-734-2568
Contact: Len Rue, Jr.
www.rue.com

Lens Cleaning Supplies
Kinetronics
4363 Independence Ct.
Sarasota, FL 34234
800-624-3204
www.kinetronics.com

Light Table
B & H Photo
www.bhphotovideo.com
800-947-7785

Location Scouting Information
Photograph America Newsletter

1333 Monte Maria Ave.
Novato, CA 94947
415-898-3736
Contact: Robert Hitchman
www.photographamerica.com

Maps
DeLorme Atlas & Gazetteer Maps
Yarmouth, ME 04096
800-452-5931
www.delorme.com

Slide Dupes
Chromatics Transparency Services
888-254-0063
Contact: Mike Borum or Kevin Free
www.chromatics.com

Slide Pages
Print File
407-886-3100
www.printfile.com

Tripods
www.bogenphoto.com
www.gitzo.com
www.dutchhill.com (425-334-1794)

Video Tapes
www.blackrabitt.com

RECOMMENDED READING

Any of these books will make a nice addition to your photography library:

Tom Blagden, Jr.
Lowcountry, Legacy Publications 1988

Gary Braasch
Photographing Patterns in Nature, Amphoto 1990

Jim Brandenburg
Chased by the Light, NorthWord Press 1998

Christopher Burkett
Intimations of Paradise, West Wind Arts 1999

Anthony Cook
Fall Colors Across America, Graphic Arts Center Publishing 2001

Kathleen Norris Cook
Spirit of The San Juans, Western Reflections, Inc. 1998

Ken Duncan
America Wide, Ken Duncan Panographs 2001

Jack Dykinga
Any of his landscape books!

Ric Ergenbright
The Art of God, Tyndale House Publishing, Inc. 1999

Bill & Wesley Fortney
America From 500 Feet, NorthWord Press 2001

Tom Fox
The Wonder of It All, Broadman & Holman Publishers 2001

Bob Krist
Spirit of Place, Amphoto 2000

George Lepp
Beyond the Basics, Lepp & Associates 1993
Beyond the Basics II, Lepp & Associates 1997

Thomas D. Mangelsen
Polar Dance, Images of Nature 1996

Joe McDonald
The Complete Guide to Wildlife Photography, Amphoto 1992
Designing Wildlife Photographs, Amphoto 1994
Photographing on Safari, Amphoto 1996

David Middleton
Ancient Forests, Chronicle Books 1992
Prayers though the Seasons, Radiant River Press 2001

Arthur Morris
The Art of Bird Photography, Amphoto 1998

David Muench
Nature's America, Brown Trout 2003
Plateau Light, Graphic Arts Center Publishing 1999
Vast and Intimate, Arizona Highways 2002
Wind Stone, Graphic Arts Center Publishing 2003

David & Marc Muench
California, Graphic Arts Center Publishing 1999
Primal Forces, Graphic Arts Center Publishing 2000

Pat O'Hara
Wilderness Scenario, American and World Geographic Publishing 1991

Freeman Patterson
Photography & the Art of Seeing, Key Porter Books 1985
Photography for the Joy of It, Key Porter Books 1986
Photography of Natural Things, Key Porter Books 1982

Bryan Peterson
Focus on People, Amphoto 1990
Learning to See Creatively, Amphoto 1988
Understanding Exposure, Amphoto 1989

Rod Planck
Nature's Places, Hawk-Owl Publishing 1992

Galen Rowell
Mountain Light, Sierra Club Books 1986

John Shaw
The Business of Nature Photography, Amphoto 1997
Closeups in Nature, Amphoto 1987
Focus on Nature, Amphoto 1991
Landscape Photography, Amphoto 1995
Nature Photography Field Guide, Amphoto 2000

Bill Smith
Designing a Photograph, Amphoto 1990

Dr. Chuck Summers
A Year in the Big South Fork NRRA, Contemplative Images 1999
A Year in the Cumberland Gap NHP, Contemplative Images 2002

Linda Waidhofer
Stone & Silence, Western Eye Press 1997

Art Wolfe
The Art of Photographing Nature, Crown 1993
Light on the Land, Beyond Words Publishing 1991

Acknowledgments

THIS IS THE BOOK I've always wanted to write, and a number of people have helped make it possible with their support and shared knowledge through the years, including Richard LoPinto, Jerry Grossman, Diane Bachman, Anna Marie Baker, Sharon Lebowitz, Steve Heiner, Michael Corrado, Ellen Coburn, Melissa Haudburg, Lindsey Silverman, and Bill Pekala of Nikon U.S.A., Dan Steinhardt of Epson Corporation, Tom Curley of Fuji Photo Film U.S.A., Linda Vuolo of Sony Electronics, David Riley of Lowepro, Paul Peregrine of Lightware, Jean Carlberg of Arion Corporation, David Alexander and Magdi Szaktilla of A & I Color Lab, Mike Kirk and Jeff Kirk of Kirk Enterprises.

I've had the support of great friends like Dr. Charles Stanley, Chuck Summers, Ken Jenkins, Dr. Bill Campbell, David Middleton, John Shaw, Dr. Wayne Lynch, David Muench, Marc Muench, Bryan Peterson, Larry West, Marc Boris, Jack Dykinga, Bill Durrence, the late John Netherton, Bryan Peterson, Art Wolfe, Ian Dicker, George Theodore, Chico & Gloria Simich, Cliff Zenor, Neil & Susan Silverman, and Don Nelson.

I would also like to thank the wonderful photographers and friends who shared their work for the Portfolio pages in this book: Steven Valk, Steven & Sylvia Oboler, Jay Smith, L.F. Van Landingham, Bill Drury, Joanne Wells, Bill Gamble, and Craig Folce.

Just before I finished this book, I got the latest in a lifetime of blessings. I joined Nikon as a Nikon Professional Markets Technical Representative covering the Southern U.S. and the national nature market. I now have the pleasure of working with the best team of photography professionals in the industry: Bill Pekala, Scott Andrews, Fred Sisson, Sam Garcia, Mark Kettenhofen, Anne Cahill, Carol Fisher, Mike Phillips, Scott Frier, Ron Tanawaki, Stanley Menscher, Bob Carruthers, and Melissa Haudberg. I know in the years to come I will learn a great deal from each and every one of them. I'm honored to be a part of this team!

Lastly, I wouldn't even consider another such project without a great editor like Barbara Harold and a wonderful book designer like Russ Kuepper. The Creative Publishing/NorthWord Press team has been great to work with and has become a second family.

— *Bill Fortney*

INDEX

Acadia National Park, 23, 29, 32, 35, 38–39, 43, 86, 115
Action, 74
Adams, Ansel, 40
Aperture, 42, 55, 58, 59, 62, 63, 65, 70–71, 73, 74, 76, 77, 78, 79, 85
Apple, 159
Arches National Park, 73, 139, 159
Arlington National Cemetery, 55
Art, 27, 35–51, 105

Background, 33, 70, 77, 79, 101, 108, 109, 135
Backpack, 122, 139
Banff National Park, 65, 74, 105
Barnbaum, Bruce, 106
Bogen, 130
Bracket, 45, 155
Braun, Ernest, 40
Bull's-eye Syndrome, 107

Cable release, 131
Camera bag, 51, 122, 136, 139
Canon, 90, 145
Canyonlands National Park, 117, 120–121
CCD (charged-coupled device), 53
Center-weighted meter, 85, 89, 90
Close-up lens, 125
Composing for Dynamic Results, 105–115
Composition, 48, 105, 106, 107, 108, 112, 115
Craft, 27, 35–51
Cumberland Falls State Park, 75
Curves, 105, 112

Depth-of-field, 42, 48, 55, 58, 59, 60-61, 62, 65, 66-67, 68, 70, 73, 74, 75, 76, 77, 78, 135
Digital, 45, 53, 84, 103, 122, 125, 136, 141–159, 171
Diopter lens, 126
Dominant element, 115
Drury, Bill, 18
Dutch Hill, 130

Eifer, Bert, 35
Epson, 145
Equipment, 117, 118, 122, 125, 128, 139
Evans, Walker, 40
Exposure — Exposed, 81–91
Exposure, 45, 48, 65, 70, 74, 75, 82, 84, 90, 93, 96, 149
Extension tube, 91, 126

Film or Digital? Or Both?, 141–159
Film, 45, 53, 55, 62, 63, 65, 70, 84, 103, 126, 135, 136–137, 141–159, 171
Filter, 91, 103, 126, 129, 132, 134–135
 Polarizing, 65, 129, 132, 133
 Split neutral density, 132, 135
 Warming, 134
Final Thoughts, 179–183
Flash, 171
Focal length, 128, 131, 136, 137, 149
Focus, 33, 48, 53, 58, 68, 75, 107, 125, 126, 128
Folse, Craig, 21
Foreground, 33, 108, 135
Four Keys to Great Images, 29–33
Franck, Frederick, 40